Cool Hotels
Family & Kids

teNeues

© 2007 Edited and produced by fusion publishing GmbH, Stuttgart . Los Angeles
www.fusion-publishing.com

Team: Patricia Massó (Editor), Hanna Martin (Editorial management), Lea Bauer, Anne-Kathrin Meier (Editorial assistance), Katharina Feuer (Layout), Jan Hausberg, Martin Herterich (Imaging & prepress), Bärbel Holzberg (Introduction), Alphagriese Fachübersetzungen, Dusseldorf (Translations)

Special thanks to Katilena Alpe, Miriam Antretter, Maria J. Barquero, Samari Barriento, Sandra Beltran, Jeanette Berthelsen, Pierre Blanc, Elisabeth Brenner, Stephan Brückner, Sakkarin Chaiwongthong, Kelly Chamberlin, Marina Charalambous, Bree Corbett, Daniel Craig, Christine Crespo, Miguel Cunat, Diana de la Rue, Stephen di Renza, Simone Edlinger, Cathérine Engel, Sanam Etemadian, Callum Farnell, Erin Forber, Marlies Gabriel, Pascaline Goret, Valia Gounitsioti, Christiane Hannsmann, Katja Hekkala, Roland Hoede, Stephanie Hoehne, Nicole Hüsken, Ingo Jakob, Didier Jos, Arnelle Kendall, Fiona Kendall, Kavita Khiara, Katrin Kleinhans, Fanis Krommidas, Jochen Lemke, Renay Logan, Judith Medeira, Marion Meier, Marit Meineke, Rafael Micha, Annette Michel, Fabrizio Molinaro, Frauke Müller, Elena Nabau, Siriwan Nipatcharoen, Isabella Partasides, Shalini Perera, Andrea Peters, Richard Plattner, Holger Reinshagen, Benno Reitbauer, Christiane Reiter, Irene Reithner, Alexandra Rokossa, Florian Rottmann, Fedra Sayegh, Christiane Schartner-Wizeman, Elisabeth Scheiring, Renate Schepen, Sabina Schlosser, Marion Schumacher, Beatrice Schwarz, Mark Selwood, Myrjam Steiner, Imini Thushara, Viviane Vogels, Ursula von Platen, Warinee from Shanghai Inn, Marisa Zafran, Markus Zeber.

Published by teNeues Publishing Group

teNeues Verlag GmbH + Co. KG
Am Selder 37
47906 Kempen, Germany
Tel.: 0049-2152-916-0
Fax: 0049-2152-916-111

teNeues Publishing Company
16 West 22nd Street
New York, NY 10010, USA
Tel.: 001-212-627-9090
Fax: 001-212-627-9511

teNeues Publishing UK Ltd.
P.O. Box 402
West Byfleet, KT14 7ZF
Great Britain
Tel.: 0044-1932-403509
Fax: 0044-1932-403514

teNeues France S.A.R.L.
93, rue Bannier
45000 Orléans, France
Tel.: 0033-2-38541071
Fax: 0033-2-38625340

Press department: arehn@teneues.de
Tel: 0049-2152-916-202

www.teneues.com

ISBN: 978-3-8327-9203-9

© 2007 teNeues Verlag GmbH + Co. KG, Kempen

Printed in Italy

Bibliographic information published by Die Deutsche Bibliothek.
Die Deutsche Bibliothek lists this publication in the Deutsche Nationalbibliografie; detailed bibliographic data is available in the Internet at http://dnb.ddb.de

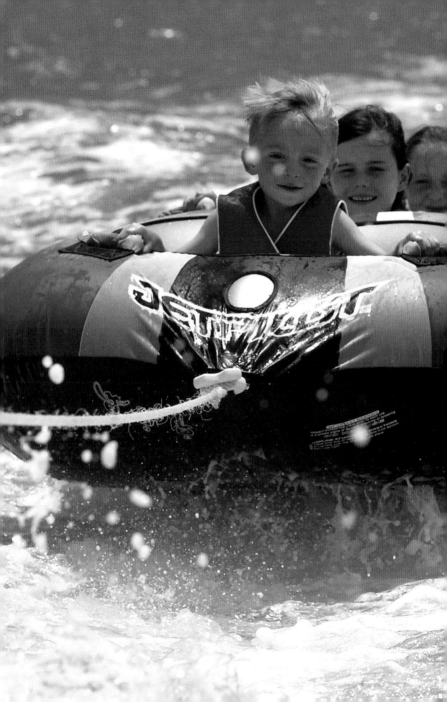

Content

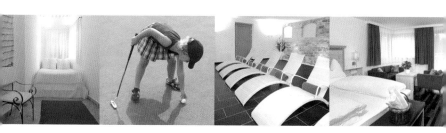

Africa & Middle East

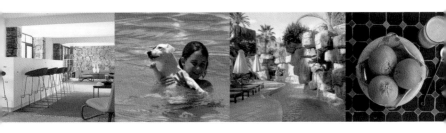

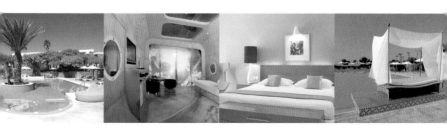

Introduction

The formula for a successful vacation with the family is very simple: If the children have fun, the parents can find what they usually need the most during a vacation, which is relaxation and peace. Even though this sounds rather simple, the reality is often quite different. Mountain hikes with small children are strenuous and most 14-year-olds think that climbing is just plain dull. Digging in the sand on a white beach may be an hour-filling program for three-year-olds, but ten-year-olds will start to whine if mom finally wants things quiet while she reads the rest of her book on the lounger in the sun. With constant haggling about mutual activities and endless discussions, compromises are painstakingly negotiated that ultimately do not please anyone – neither the children nor the parents.

Hotels are increasingly discovering families as a target group and offer custom-made programs not only for babies and toddlers, but also for teenagers. What parents certainly do not want is that someone just babysits their children, that they are left to themselves in basement rooms equipped with playstations or parked in front of the television set. Instead, parents measure the quality of a hotel by how varied and ambitious the children's programs are. They value an offer of creative activities that—in the best case—promote the talents of their children or offer them the opportunity of trying out a new hobby. In short, they want them to have experiences that go beyond their everyday lives, but without any pressure and obligations.

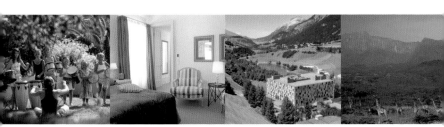

Hotels with very special and highly diversified offers were selected for *Cool Hotels Family & Kids*. The spectrum ranges from the more traditional children's hotel in Austria to the cool city hotel and the exotic resort in the most remote areas of this planet. For example, children can experience the endless expanse and silence of the desert at the Tented Camp of Wolwedans in Namibia and meet African young people in the neighboring Education Camp. On Borneo at the Shangri-La's Rasa Ria Resort, the hotel's own jungle reserve allows guests to observe the rearing of baby orang-utans that are only native to this area. But there are also hotels in Europe with unusual events that are designed especially for families. An especially sophisticated and varied program is offered by the recently reopened Schloss Elmau (Elmau Castle) in the Alps. In addition to adventure vacations that always have a special motto, the Culture Hideaway organizes literature or philosophy weeks with top-flight presenters.

Bärbel Holzberg

Einleitung

Die Erfolgsformel für gelungene Ferien mit der Familie ist ganz einfach: Haben die Kinder Spaß, finden die Eltern das, was sie im Urlaub am meisten suchen, nämlich Entspannung und Ruhe. Was so simpel klingt, sieht in der Realität oft genug ganz anders aus. Bergwanderungen mit Kleinkindern sind anstrengend, die meisten 14-Jährigen finden das Kraxeln schlichtweg öde. Am weißen Strand im Sand buddeln mag für Dreijährige noch ein Stunden füllendes Programm sein, Zehnjährige fangen an zu nörgeln, wenn Mami auf der Sonnenliege in Ruhe ihr Buch zu Ende lesen will. Ständig wird um gemeinsame Aktivitäten neu gefeilscht und endlos diskutiert, werden Kompromisse mühsam ausgehandelt, die am Ende keinen, weder Kinder noch Eltern, zufrieden stellen.

Zunehmend entdecken Hotels Familien als Zielgruppe und bieten maßgeschneiderte Programme nicht nur für Babys und Kleinkinder, sondern auch für Jugendliche an. Was Eltern nämlich garantiert nicht wollen, ist, dass ihre Kinder lediglich beaufsichtigt werden, in Kellerräumen bestückt mit Playstations sich selbst überlassen oder vor dem Fernseher geparkt werden. Vielmehr messen Eltern die Qualität eines Hotels daran, wie vielseitig und anspruchsvoll die Kinderprogramme sind. Sie schätzen ein kreatives Angebot, das im besten Falle die Talente ihrer Kinder fördert oder ihnen die Möglichkeit bietet, sich in einem neuen Hobby zu erproben. Kurzum, Erfahrungen zu machen, die über ihren Alltag hinausgehen, aber ohne Zwang und ohne Verpflichtung.

Für *Cool Hotels Family & Kids* wurden Hotels mit ganz besonderen und sehr unterschiedlichen Angeboten ausgewählt. Das Spektrum reicht vom eher traditionellen Kinderhotel in Österreich über das coole Stadthotel bis zu exotischen Resorts in den abgelegensten Gegenden dieser Erde. So können Kinder im Tented Camp von Wolwedans in Namibia die unendliche Weite und Stille der Wüste erfahren und im benachbarten Education Camp afrikanische Jugendliche treffen. Auf Borneo im Shangri-La's Rasa Ria Resort lässt sich im hoteleigenen Dschungel-Reservat die Aufzucht der nur hier heimischen Baby-Orang-Utans beobachten. Aber auch in Europa finden sich Hotels, deren außergewöhnliche Veranstaltungen speziell auf Familien zugeschnitten sind. Ein besonders anspruchsvolles und vielseitiges Programm bietet das wieder eröffnete Schloss Elmau in den Alpen. Neben Abenteuerferien, die immer unter einem besonderen Motto stehen, werden in dem Culture Hideaway Literatur- oder Philosophiewochen mit hochkarätiger Besetzung veranstaltet.

Bärbel Holzberg

Introduction

La formule des vacances en famille réussies est simple : si les enfants s'amusent, les parents peuvent trouver ce dont ils ont généralement le plus besoin pendant les vacances, c'est à dire la détente et la tranquillité. Mais même si cela semble assez facile, la vérité est souvent assez différente. Les balades en montagne avec de petits enfants sont exténuantes, et la plupart des adolescents de 14 ans trouvent l'escalade sans aucun intérêt. Les petits de trois ans peuvent consacrer des heures à creuser des trous dans une plage de sable blanc, mais des enfants de dix ans se mettront à pleurnicher si leur maman veut qu'ils soient calmes pendant qu'elle finit son livre au soleil sur sa chaise longue. A force de négociations et de discussions incessantes pour définir des activités communes, on trouve des compromis laborieux qui finalement ne font plaisir à personne – ni aux enfants, ni aux parents.

Les hôtels considèrent de plus en plus les familles comme une partie de leur clientèle à privilégier, et offrent des programmes sur mesure non seulement pour les bébés et les enfants en bas âge, mais aussi pour les adolescents. Ce que les parents ne veulent assurément pas, c'est que leurs enfants soient simplement surveillés ou livrés à eux-mêmes dans des sous-sols équipés de playstation, ou encore parqués devant le poste de télé. Les parents mesurent plutôt la qualité d'un hôtel à la variété et à l'ambition des programmes qu'ils proposent pour les enfants. Ils préfèrent les possibilités d'activités créatives qui – dans le meilleur des cas – valorisent les talents de leurs enfants ou leur offrent la chance d'essayer un nouveau hobby. En bref, ils veulent qu'ils puissent vivre des expériences nouvelles, loin de leurs vies quotidiennes, mais sans aucune pression ni obligation.

Les hôtels sélectionnés pour *Cool Hotels Family & Kids* proposent des offres spécialisées et diversifiées. L'éventail va du traditionnel hôtel pour enfants en Autriche, à l'hôtel élégant de centre ville, via les établissements exotiques dans les régions les plus reculées de la planète. Par exemple, les enfants peuvent faire l'expérience du silence et de l'espace infinis du désert au Tented Camp de Wolwedans en Namibie et rencontrer les jeunes africains de l'Education Camp voisin. A Bornéo, au Shangri-La's Rasa Ria Resort, la réserve privée de l'hôtel, en pleine jungle, permet aux clients d'observer les bébés orang-outang qui ne vivent que dans cette région. Mais en Europe aussi, des hôtels organisent des événements spéciaux spécialement pour les familles. Un programme particulièrement sophistiqué et varié est proposé par le Schloss Elmau (Château Elmau) dans les Alpes, récemment rouvert. Outre les séjours aventures qui ont toujours une devise particulière, le Culture Hideaway organise des semaines thématiques consacrées à la littérature ou à la philosophie avec des intervenants de haut vol.

Bärbel Holzberg

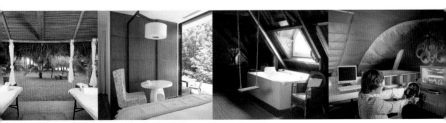

Introducción

Al parecer, el concepto de vacaciones felices para toda la familia es muy sencillo: que lo niños se los pasen bien y que los padres encuentren lo que generalmente se busca en unas vacaciones, es decir, relax y tranquilidad. Todo muy simple, pero en la realidad las cosas a menudo son bien diferentes. Un paseo por lo montes con niños pequeños suele ser cansado, y para un catorceañero el alpinismo será algo totalmente aburrido. En la playa, cavar en la arena puede llenar un programa de varias horas si tenemos tres años, pero a los diez ya empezaremos a regañar si mamá solo quiere tumbarse bajo el sol y terminar su libro en paz. Sin duda las actividades comunes causarán discusiones y regateos interminables, hasta llegar a acuerdos que no suelen dejar contento a nadie, ni a los padres ni a los hijos.

Los hoteles descubren más y más la familia como objetivo, ofreciendo programas construidos a medida no solo de los bebés y de los niños, sino también de los jóvenes. Lo que los padres no quieren garantizarse, en este sentido, es que sus hijos sean simplemente vigilados, dejándose tirados en algún sótano armados de Playstation o aparcados delante de la tele. A menudo los padres evalúan la calidad de un hotel según la variedad y los requisitos de los programas para niños, valorando ofertas creativas, que en los casos mejores hasta favorecen los talentos de sus hijos o le permiten experimentar nuevas aficiones, o bien de participar en cursos y otras experiencias que salgan de lo cotidiano, pero sin obligaciones ni compromisos.

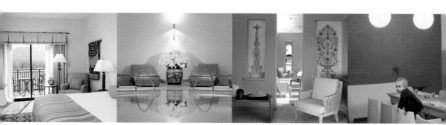

En *Cool Hotels Family & Kids* se han seleccionado hoteles con ofertas muy especiales y diferenciadas entre ellas. La gama varía entre los tradicionales *kinderhotel* austriacos, pasando por los más *cool* hoteles de ciudad, hasta exóticas estaciones en los parajes más perdidos de nuestra tierra. De esta forma, los niños pueden experimentar la infinita amplitud y el silencio del desierto en el Tented Camp de Wolwedans en Namibia, coincidiendo con sus coetáneos africanos en el adyacente Education Camp. Las instalaciones de Shangri-La's Rasa Ria Resort en el Borneo incluyen una jungla-reserva perteneciente al mismo hotel, donde es posible observar la cría de una especie única de baby-orangutanes, que viven solamente aquí en su ambiente natural. También en Europa, sin embargo, es posible encontrar hoteles que presenten actividades no ordinarias y echas específicamente a medida para toda la familia. El reabierto Castillo Elmau en los Alpes, por ejemplo, brinda un programa especialmente variado y adapto para todas las exigencias. A lado de vacaciones de aventura, siempre reunidas bajo un mote especial, en el Culture Hideaway se organizan semanas literarias o filosóficas, con participaciones de alta categoría.

Bärbel Holzberg

Introduzione

La formula di successo per delle vacanze riuscite con l'intera famiglia è semplicissima: i bambini si divertono, mentre i genitori trovano ciò che generalmente cercano in una vacanza, vale a dire relax e tranquillità. Niente di difficile in teoria, ma spesso nella realtà le cose si svolgono in modo ben diverso. Una passeggiata in montagna con dei bambini piccoli può rivelarsi faticosa, e per un quattordicenne un'arrampicata sarà una noia totale. In spiaggia, scavare nella sabbia può anche costituire un programma tale da riempire ore se si ha tre anni, ma a dieci già si comincia a brontolare se mamma vuole stare in tranquillità sotto il sole a finire il suo libro. Inevitabilmente le attività comuni comportano infinite discussioni e continui tira-e-molla, finché si raggiungono faticosamente dei compromessi che alla fine non soddisfano nessuno, né figli né genitori.

Sono sempre più numerosi gli hotel che scoprono la famiglia come target, offrendo programmi confezionati su misura non solo per bambini ma anche per ragazzi. Ciò che i genitori non desiderano garantirsi, infatti, è che i propri figli siano semplicemente sorvegliati, abbandonandosi in qualche scantinato armati di Playstation o parcheggiati davanti a un televisore.

Spesso i genitori valutano la qualità di un hotel in base alla varietà e alla consistenza dei programmi per i bambini, apprezzando offerte creative, che nel migliore dei casi favoriscono il talento dei loro figli oppure danno loro la possibilità di sperimentare un nuovo hobby, o di assistere a corsi e altre esperienze che escono dalle normali attività quotidiane, ma senza obblighi né costrizioni.

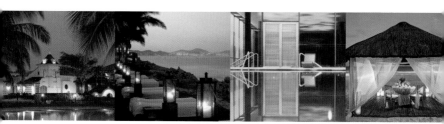

Per *Cool Hotels Family & Kids* sono stati selezionati hotel caratterizzati da offerte assai speciali e ben differenziate. L'assortimento spazia dai tradizionali *kinderhotel* austriaci agli alberghi cittadini più *cool* fino a esotici impianti nelle regioni più sperdute della nostra terra. In questo modo i bambini possono sperimentare la sterminata vastità e il silenzio del deserto nel Tented Camp di Wolwedans in Namibia, incontrandosi con i loro coetanei africani nell'adiacente Education Camp. Nel villaggio Shangri-La's Rasa Ria Resort nel Borneo è possibile osservare l'allevamento dei piccoli di orangutan, che solo qui trovano il loro ambiente naturale, nella giungla-riserva appartenente all'hotel stesso. Anche in Europa è possibile trovare hotel delle attività poco consuete e pensate appositamente per la famiglia. Particolarmente vario e completo è il programma offerto dal riaperto Castello Elmau nelle Alpi. Oltre a vacanze d'avventura, sempre contraddistinte da uno slogan speciale, nel Culture Hideaway vi si organizzano settimane letterarie o filosofiche con partecipazioni di alta caratura.

Bärbel Holzberg

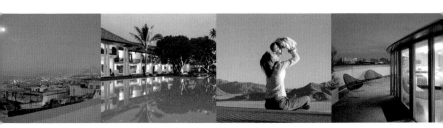

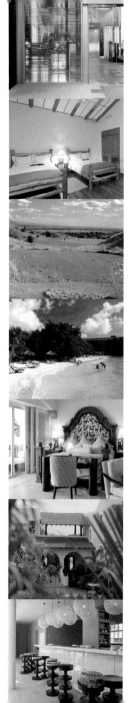

Americas

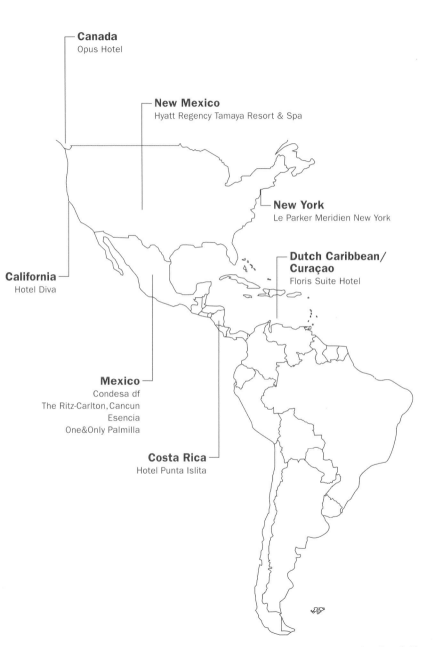

Canada
Opus Hotel

New Mexico
Hyatt Regency Tamaya Resort & Spa

New York
Le Parker Meridien New York

Dutch Caribbean/ Curaçao
Floris Suite Hotel

California
Hotel Diva

Mexico
Condesa df
The Ritz-Carlton, Cancun
Esencia
One&Only Palmilla

Costa Rica
Hotel Punta Islita

Opus Hotel

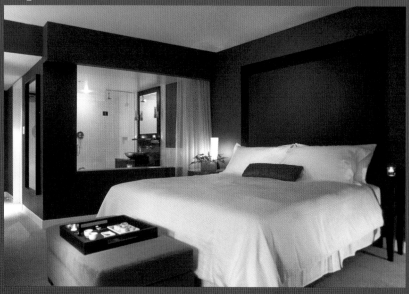

Address: 322 Davie Street, Vancouver
British Columbia, Canada V6B 5Z6
Phone: +1 604 642 6787
Fax: +1 604 642 6780
Website: www.opushotel.com

Located: In the stylish Yaletown district of downtown Vancouver, an 8 square block heritage preservation zone within walking distance of the city's financial and retail centers
Style: Contemporary design, guestrooms feature 5 unique décor schemes
Family & kids tips: Babysitting services, great big park in the middle of downtown with a seawall for biking, walking and running that encircles the park
Special features: Restaurant, bar, fitness room, non-smoking rooms, pets welcome with day care and walking services
Rooms: 96 luxury guestrooms

Opening date: 2002

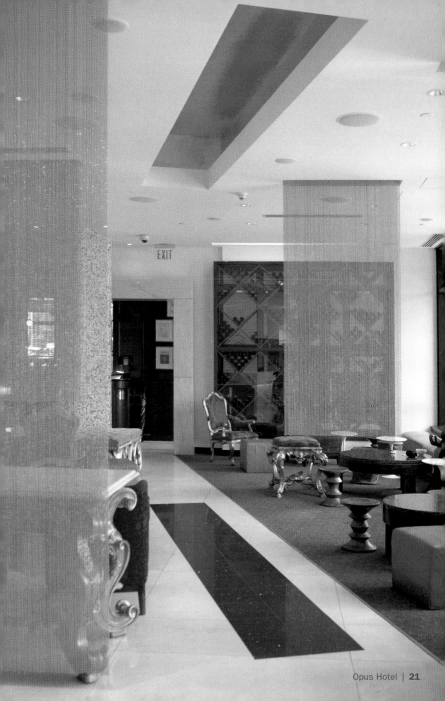

Hotel Diva

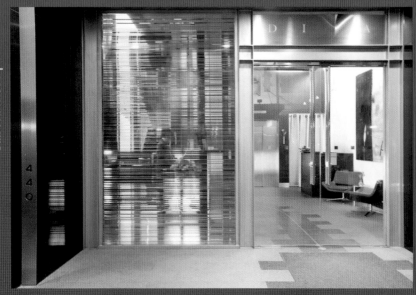

Address:	440 Geary Street San Francisco, CA 94102, USA
Phone:	+1 800 553 1900
Fax:	+1 415 346 6613
Website:	www.hoteldiva.com
Located:	In the hub of Union Square, surrounded by San Francisco's best shopping area, theaters, and just a couple of blocks from Moscone Convention Center, Chinatown, and the Embarcadero
Style:	Sleek and sexy, cutting-edge style
Family & kids tips:	Kids Suite "Little Divas Suite" with a modern bunk bed, a colorful futon, "Donut pouf" cushions, a computer and a large drawing table, kids have their own check-in, smoke-free hotel
Special features:	4 lounges, complimentary business center 24 hours a day, complimentary cardio workout room, Wi-Fi throughout the hotel, pet friendly
Rooms:	116 rooms
Opening date:	1985, renovated 2007

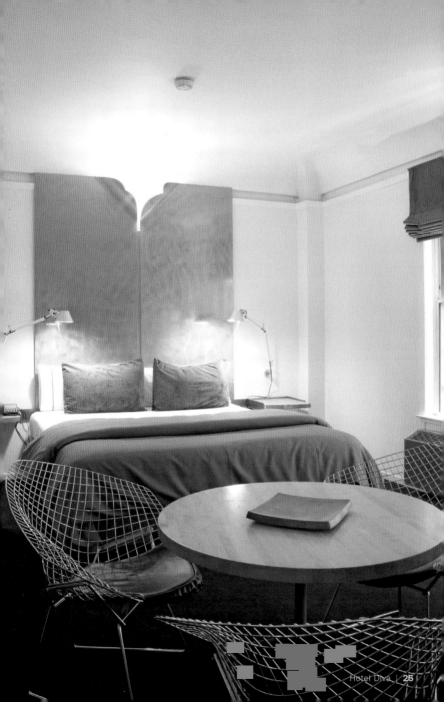

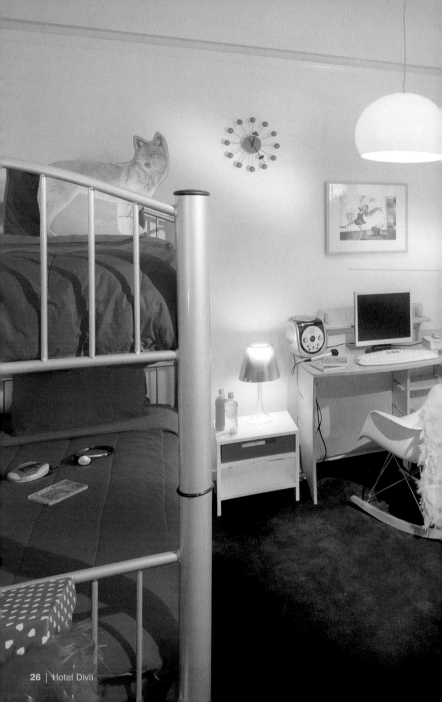

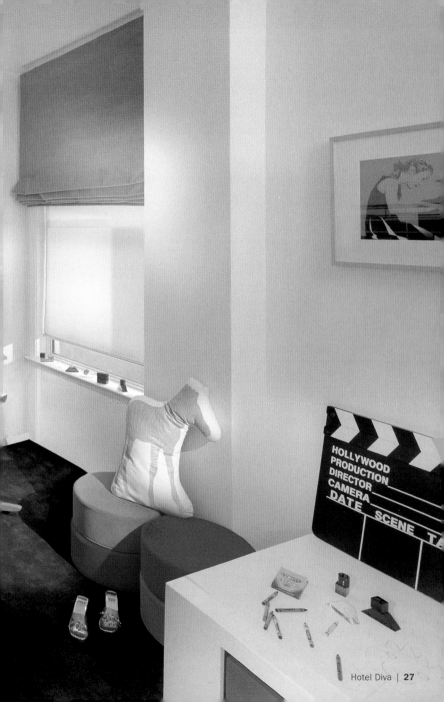

Le Parker Meridien New York

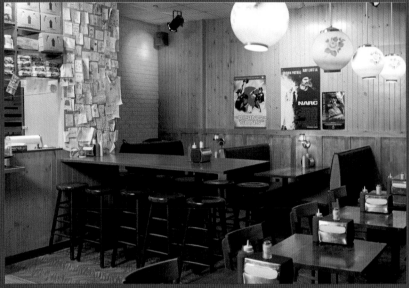

Address: 118 West 57th Street
New York, NY 10019–3318, USA
Phone: +1 212 245 5000
Fax: +1 212 307 1776
Website: www.parkermeridien.com

Located: Just steps away from Central Park, MoMA, Carnegie Hall, Broadway theaters and Fifth Avenue's famous shops
Style: Modern
Family & kids tips: Custom coloring-book at check-in, razor scooter to loan in the lobby, burger joint, gravity kids classes such as junior jazz
Special features: 3 restaurants, roof-top pool, gym and spa, service "newyorksmartaleck"
Rooms: 731 rooms and suites

Opening date: 1981

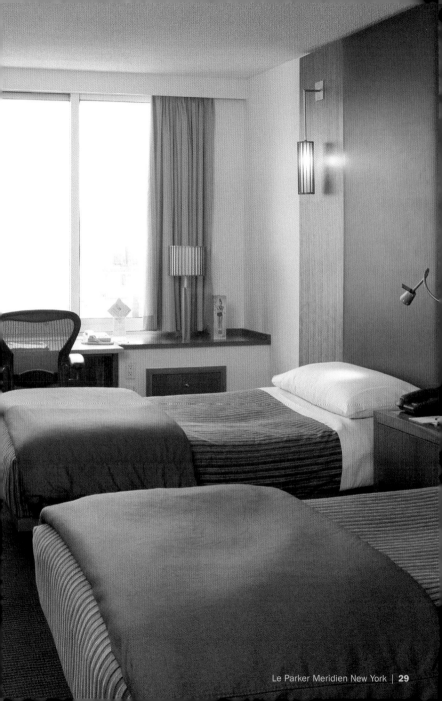

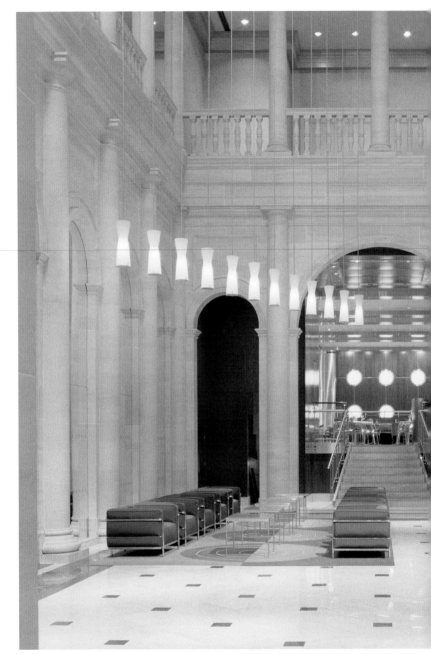

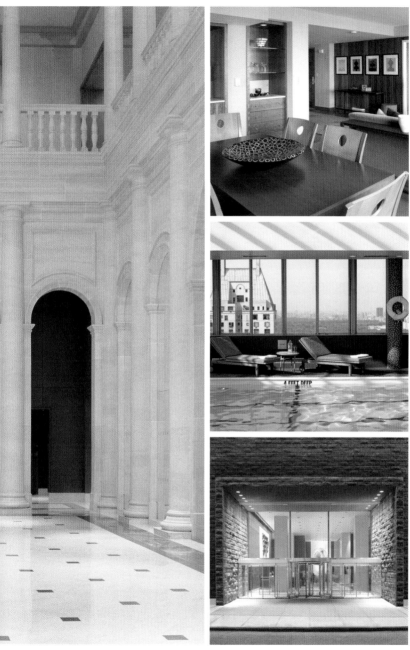

Le Parker Meridien New York | **31**

Hyatt Regency Tamaya Resort & Spa

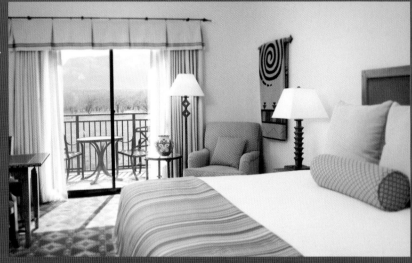

Address:	1300 Tuyuna Trail
	Santa Ana Pueblo, NM 87004, USA
Phone:	+1 505 867 1234
Fax:	+1 505 771 6180
Website:	www.tamaya.hyatt.com
Located:	Near Santa Fe and Albuquerque
Style:	Southwestern
Family & kids tips:	Camp Hyatt and babysitting services, many interactive family activities, guided horseback rides
Special features:	Spa, golf club, restaurant, lounge
Rooms:	350 guestrooms including 23 suites
Opening date:	2001

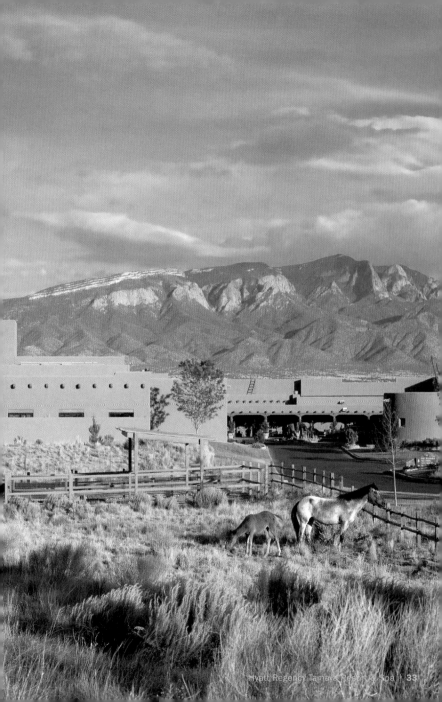

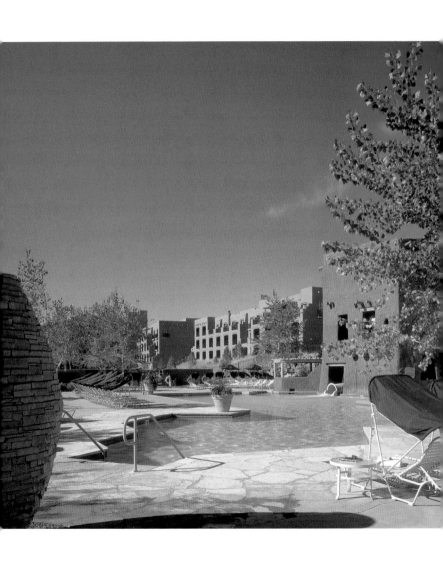

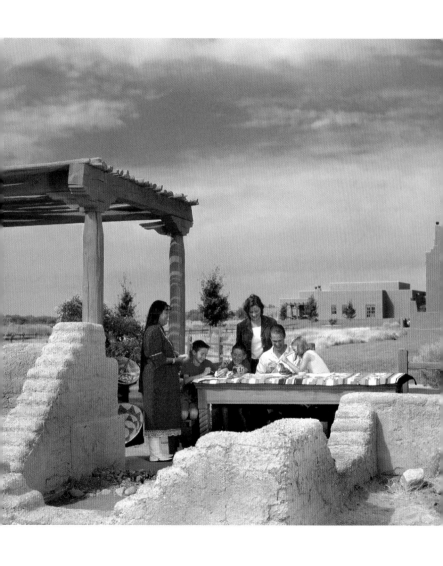

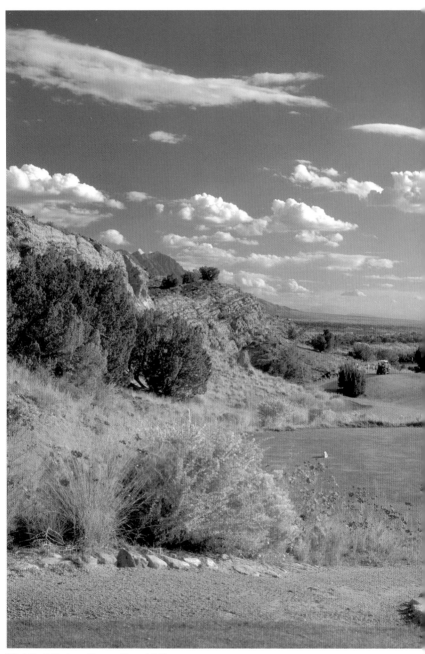

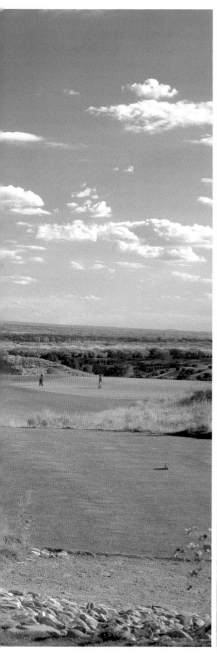

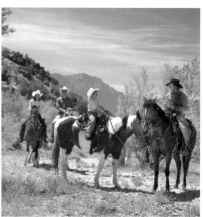

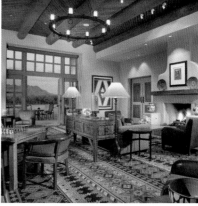

Hotel Punta Islita

Address:	Nicoya Peninsula Guanacaste, Costa Rica
Phone:	+11 506 231 6122
Fax:	+11 506 231 0715
Website:	www.hotelpuntaislita.com
Located:	Inlaid in a pristine mountain outpost of Costa Rica's Pacific coast
Style:	High-end rustic
Family & kids tips:	Family program, activities, horseback riding, river kayaking, special Casa Spa family treatments, turtle watching, monkey safari, golf, and surfing
Special features:	2 swimming pools, 3 restaurants, Casa Spa, executive golf course, Art Museum, responsible tourism programs
Rooms:	50
Opening date:	1994

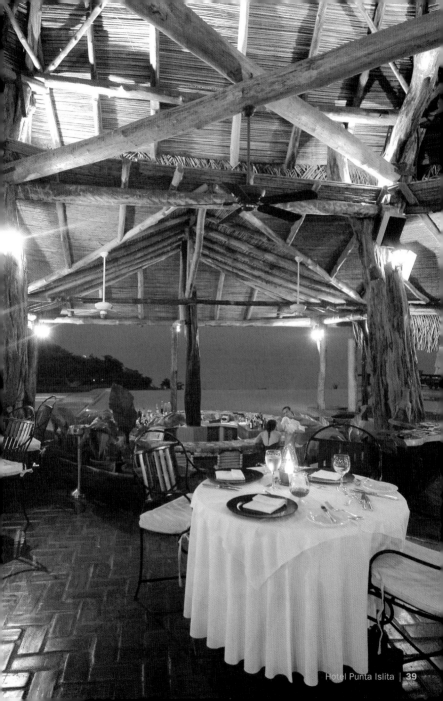

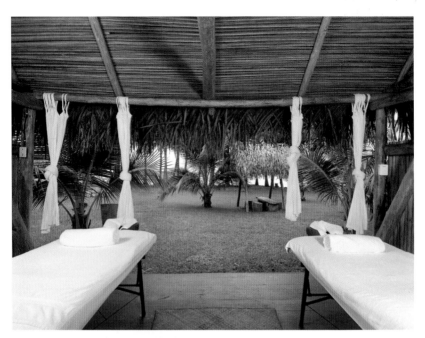

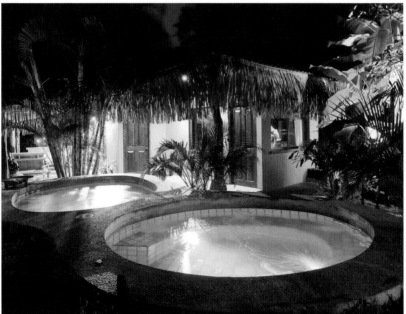

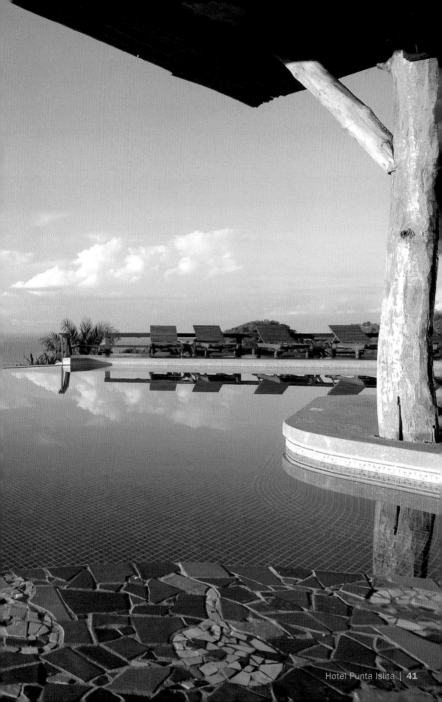

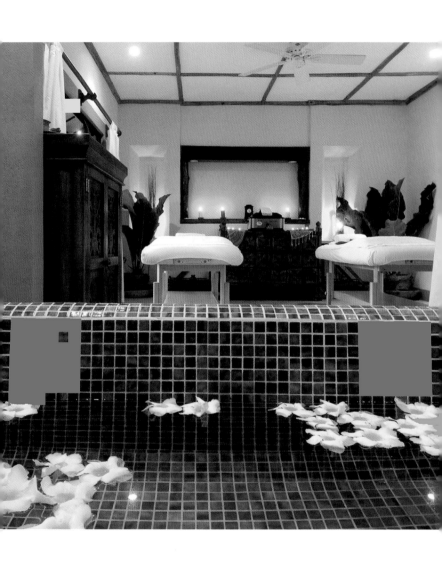

Condesa df

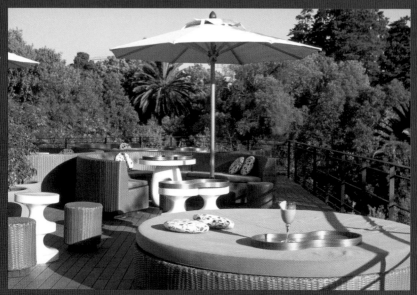

Address: Avenida Veracruz N.102, Colonia Condesa
Mexico City, D.F. 06700, Mexico
Phone: +52 555 241 2600
Fax: +52 555 241 2640
Website: www.condesadf.com

Located: Mexico City
Style: Classical contemporary design
Family & kids tips: Kids cineclub, chocolate labrador, bikes for the
guests to use, free of charge, XBOX 360
Special features: Restaurant, bar, cinema, private terrace or balcony
Rooms: 32 rooms, 4 suites

Opening date: 2005

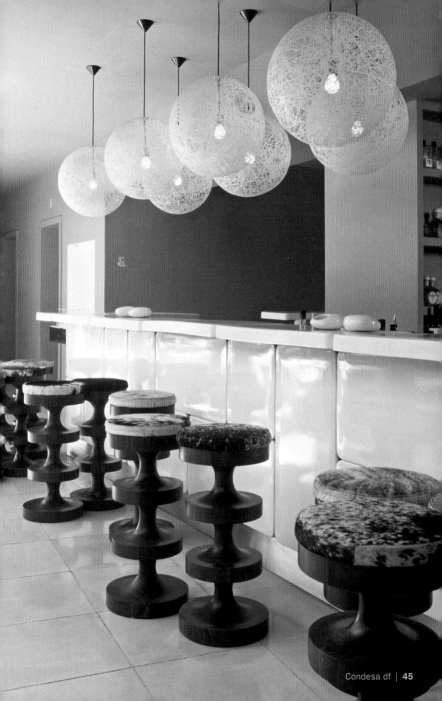

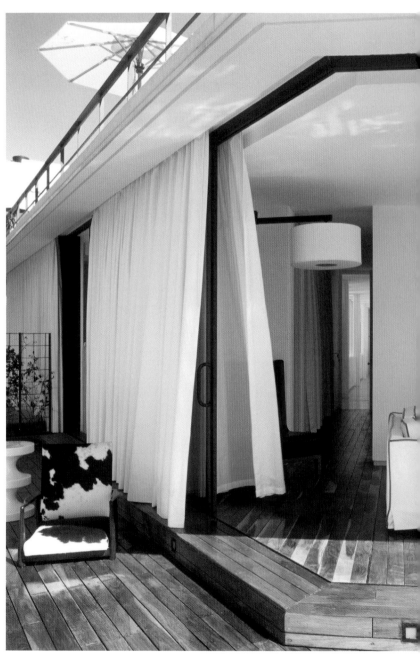

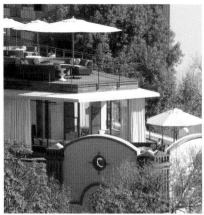

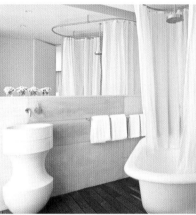

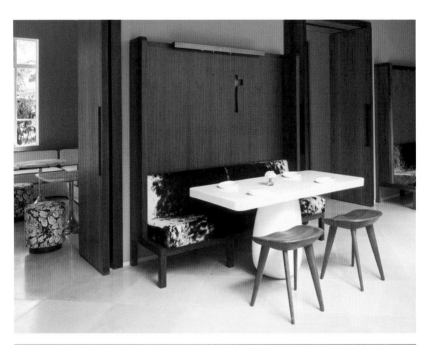

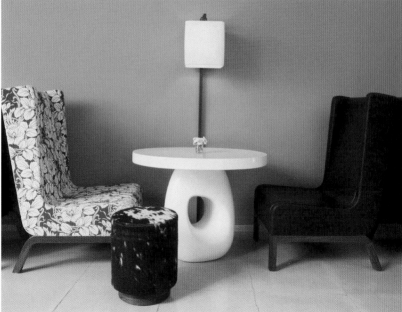

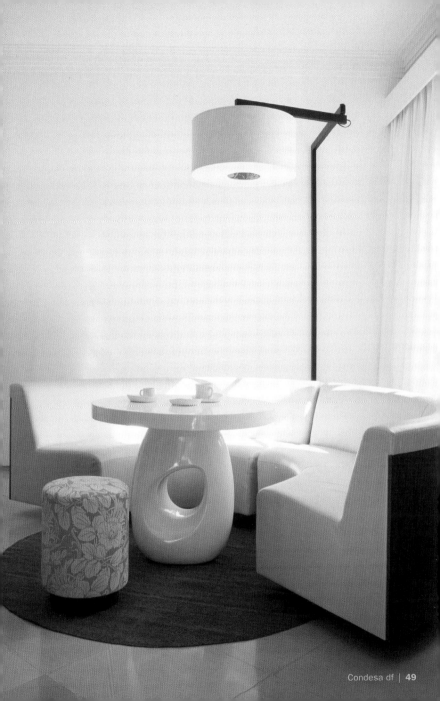

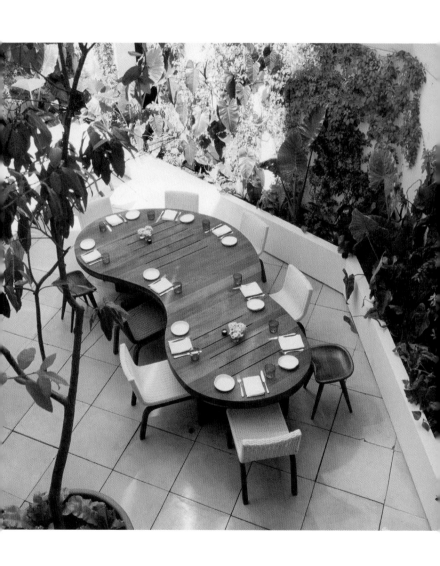

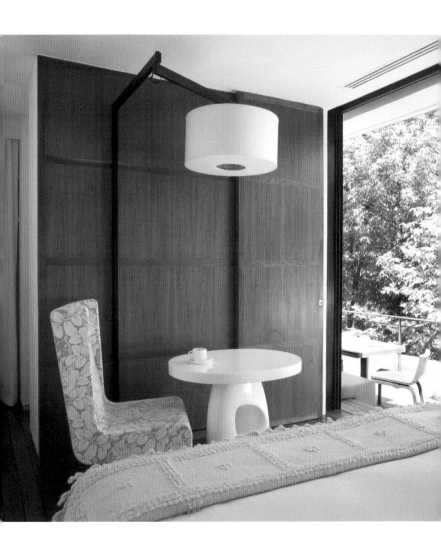

The Ritz-Carlton, Cancun

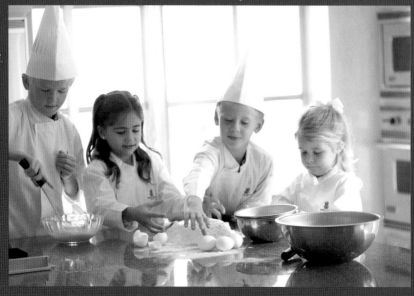

Address:	Retorno del Rey #36, Zona Hotelera Cancun, Quintana Roo 77500, Mexico
Phone:	+52 998 881 0808
Fax:	+52 998 881 0815
Website:	www.ritzcarlton.com
Located:	In the northern region of Mexico's Yucatan Peninsula
Style:	Classic elegance
Family & kids tips:	Kids Camp children's activity program, babysitting services, children's menu, kids night out with Bubble Party and karaoke time, musical chairs, arts & crafts, kids cooking classes, Ritz Kids Club
Special features:	2 outdoor swimming pools, 4 restaurants, 2 bars and lounges, oceanfront whirlpool, 3 equipped baby-friendly family rooms, Culinary Center
Rooms:	365 guestrooms including 50 suites and 46 Club Level rooms
Opening date:	1993, total renovation 2006

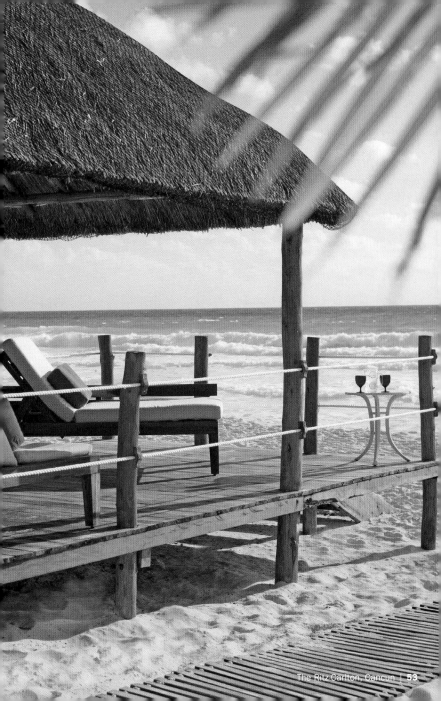

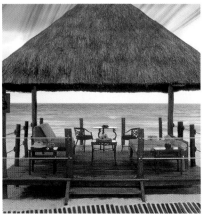

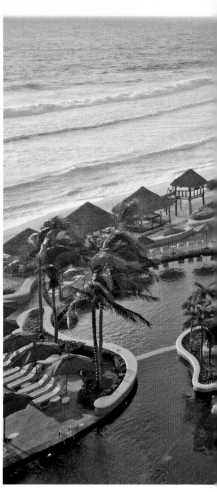

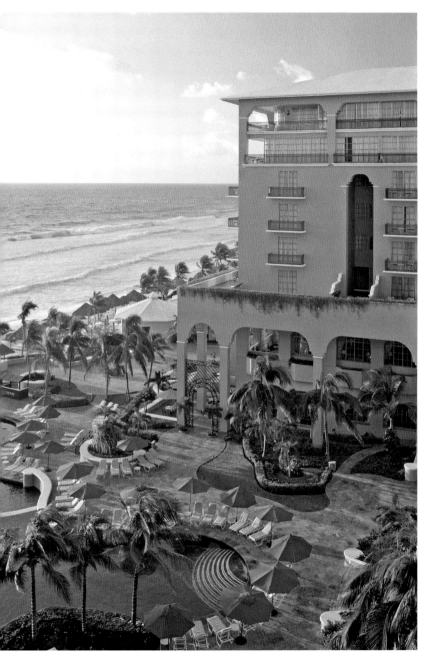

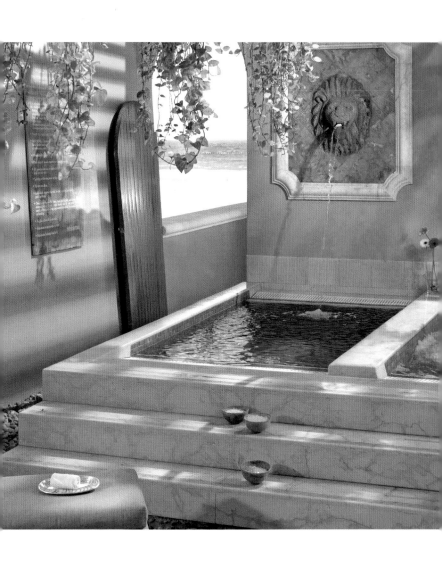

Esencia

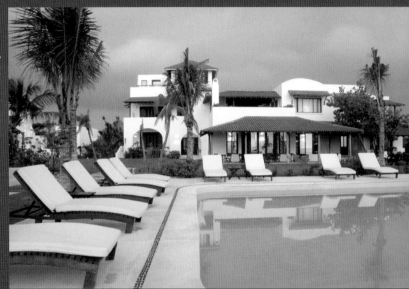

Address:	Carretera Cancun Tulum, Predio Rustico Xpu-Ha Lote 18 Riviera Maya 77710, Mexico
Phone:	+52 984 873 4830
Fax:	+52 984 873 4836
Website:	www.hotelesencia.com
Located:	On Playa Xpu-ha, approximately 45 minutes south of Cancun, on 2 miles of white sand beach, one of the best beaches in the Riviera Maya and 50 acres of lush green gardens
Style:	Mediterranean
Family & kids tips:	Multi-lingual staff including personal butlers, nannies and chefs, activities such as jungle tours and horseback riding, family treatments at the resort's organic spa
Special features:	Restaurant, family pool
Rooms:	29 guest rooms, suites and cottages
Opening date:	2006

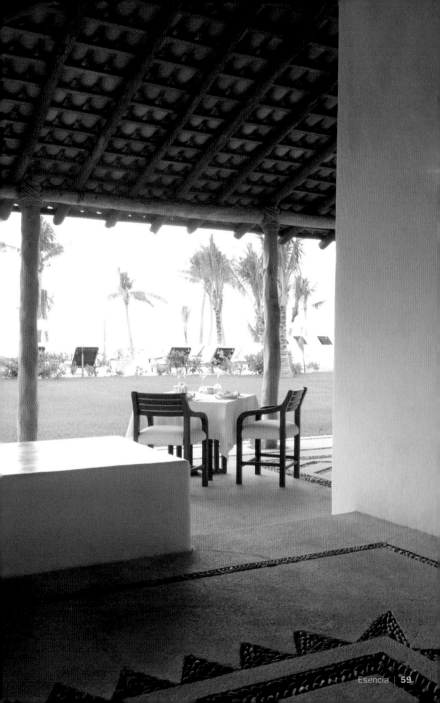

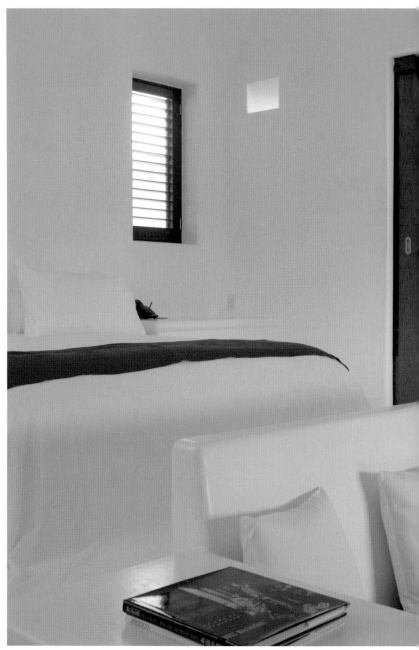

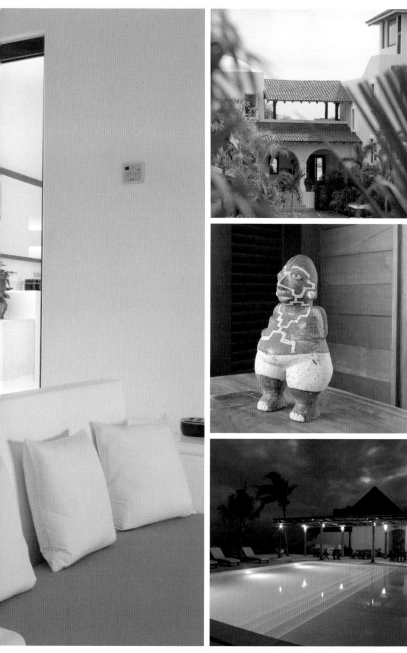

One&Only Palmilla

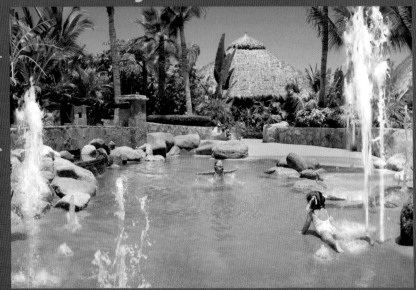

Address:	KM 7.5 Carretera Transpeninsular, San Jose del Cabo
	Baja California Sur 23400, Mexico
Phone:	+52 642 146 7000
Fax:	+52 642 146 7001
Website:	www.oneandonlyresorts.com
Located:	San Jose del Cabo
Style:	Mexican contemporary hacienda
Family & kids tips:	KidsOnly program for kids aged 4 to 11 years including games, golf or tennis courses, cooking classes, Spanish lessons, dedicated clubhouse for kids, special program for teens, professional babysitting and nanny service available
Special features:	Restaurant, children's pool
Rooms:	172 rooms and suites
Opening date:	2004

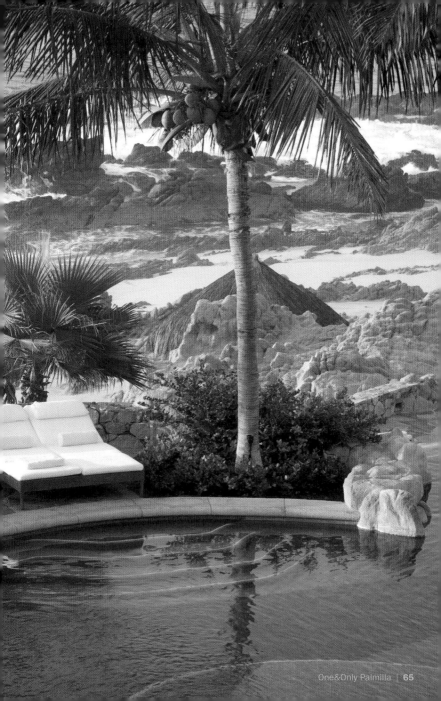

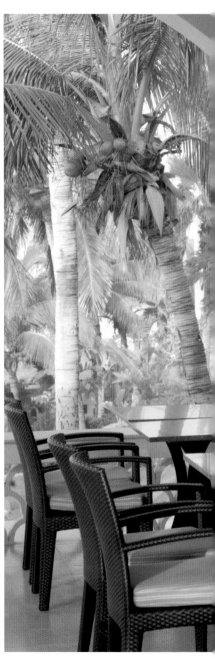

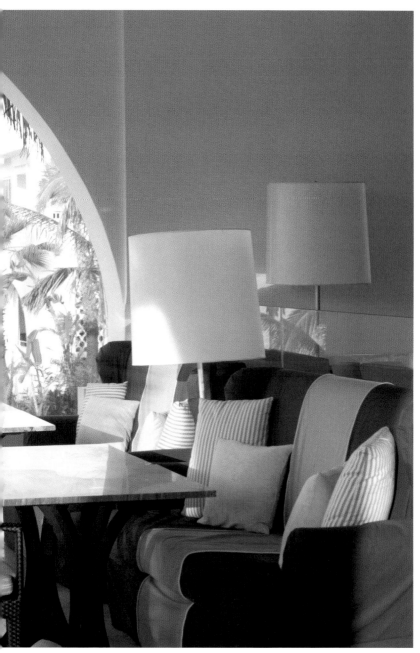

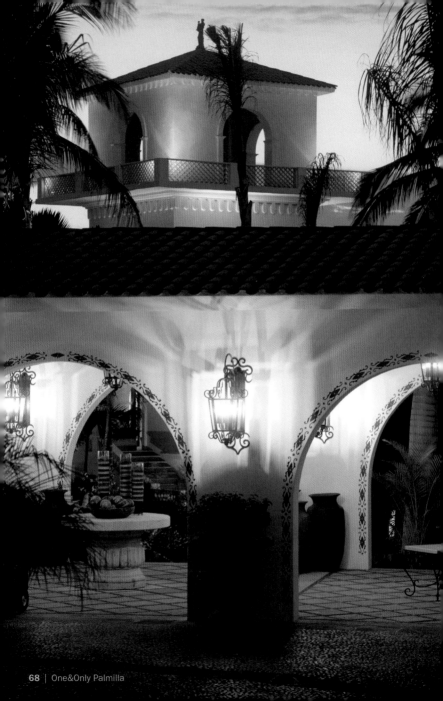

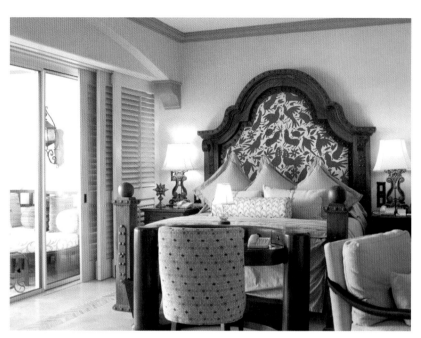

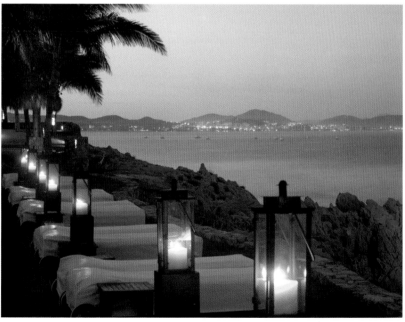

Floris Suite Hotel

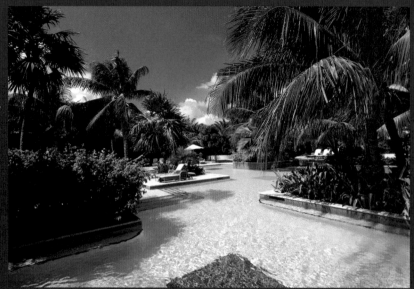

Address:	Piscadera Bay, P.O. Box 6246
	Curaçao, Dutch Caribbean
Phone:	+5999 462 6111
Fax:	+5999 462 6211
Website:	www.florissuitehotel.com

Located:	On the Dutch Caribbean island of Curaçao
Style:	Contemporary design
Family & kids tips:	Pool and beach is suitable for children, kids till 12 stay for free, there are babycribs available for $ 10 a day, babysitting is available 24 hours a day
Special features:	Restaurant, private beach, fitness room, spa
Rooms:	72 rooms
Opening date:	2001

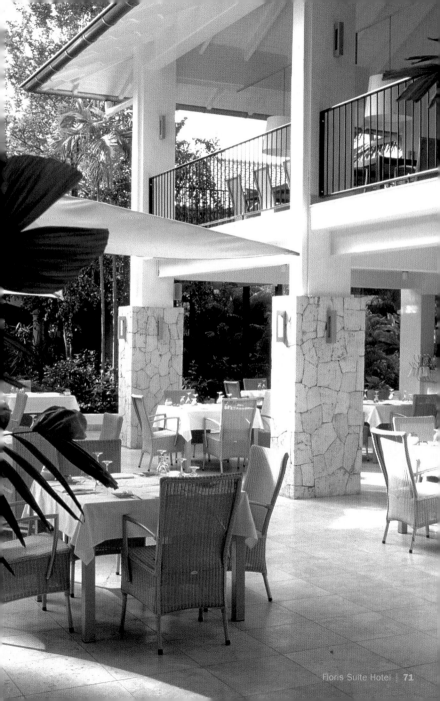

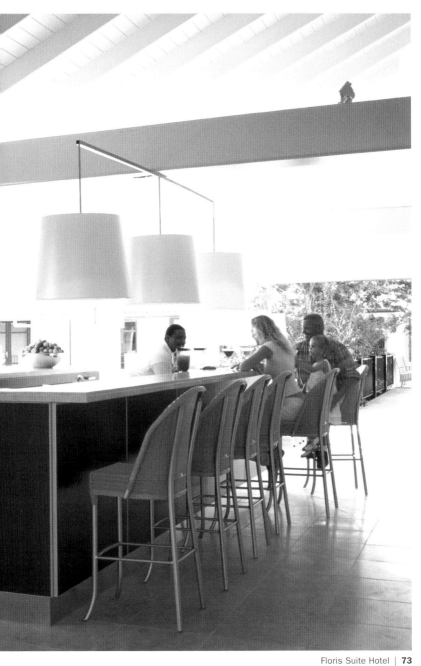

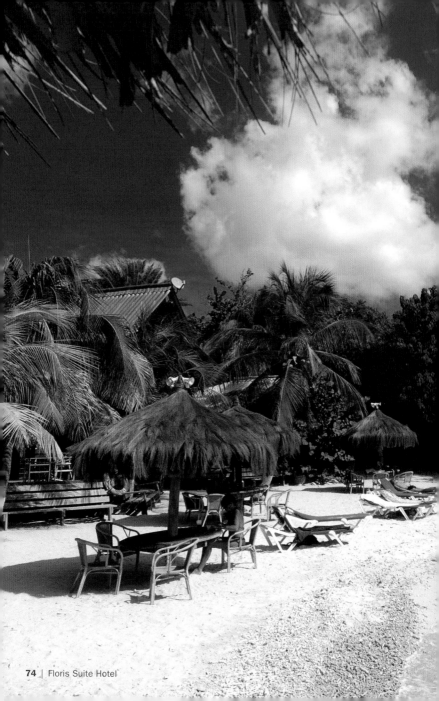

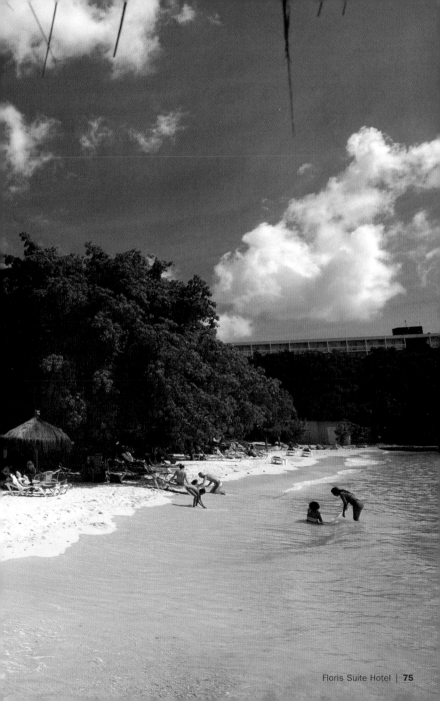

Europe

Germany
Kempinski Grand Hotel Heiligendamm
Yoho Hotel
Vier Jahreszeiten Zingst
Schloss Elmau – Cultural Hideaway & Luxury Spas

Denmark
Danhostel

Belgium
Monty Small Design Hotel

Austria
ALPENIGLU® Dorf Kitzbühel
Garten- und Aparthotel Theresia
Avance Hotel in the Reiter's Burgenland Resort
amiamo – Familotel Zell am See

The Netherlands
Lloyd Hotel &
Cultural Embassy

United Kingdom
base2stay
The Zetter

**Portugal/
Madeira**
Choupana Hills

Greece
Mykonos Theoxenia
Porto Sani Village

Italy/South Tyrol
Erika

Switzerland
Cube Savognin
Suvretta House
Park Hotel Waldhaus
Hotel Castell

Cyprus
Almyra
The Annabelle

France
Hotel Beaumarchais
Vienna International Dream Castle Hotel
Chateau de la Couronne

Turkey
Club Orient Holiday Resort
Hillside Beach Club

Spain
Market Hotel
Blau Porto Petro
ArabellaSheraton Golf Hotel Son Vida
Mardavall Hotel & Spa

Danhostel

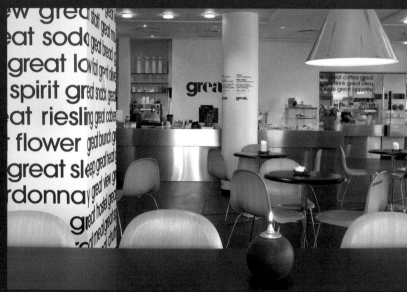

Address: H.C.Andersen Boulevard 50
1553 Copenhagen, Denmark
Phone: +45 33 11 85 85
Fax: +45 33 11 85 88
Website: www.danhostel.com

Located: City center
Style: Danish design by GUBI
Family & kids tips: Guest kitchen, games, non-smoking hostel
Special features: Internet cafe, lounge with TV, restaurant, bar/café
with TV, all rooms with private bathrooms
Rooms: 192 rooms

Opening date: 2005

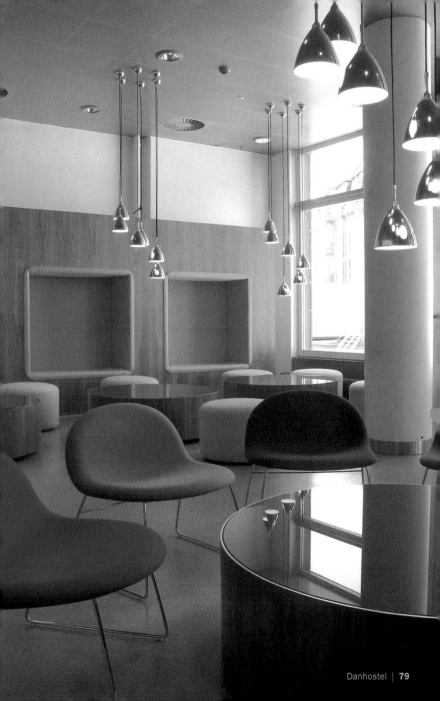

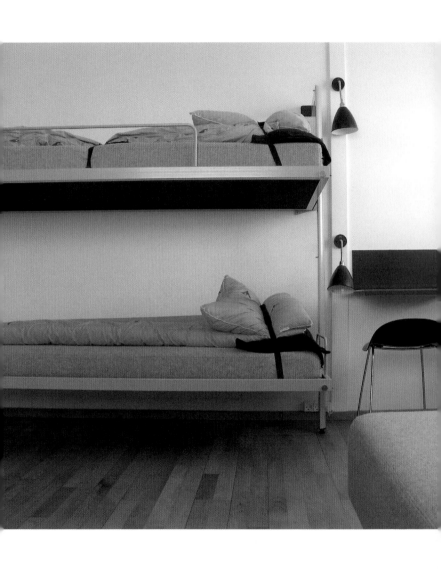

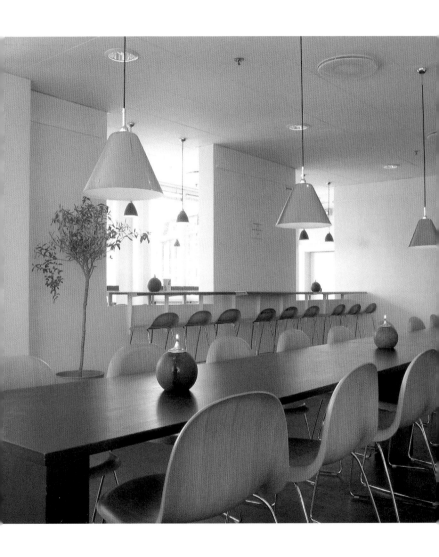

Monty Small Design Hotel

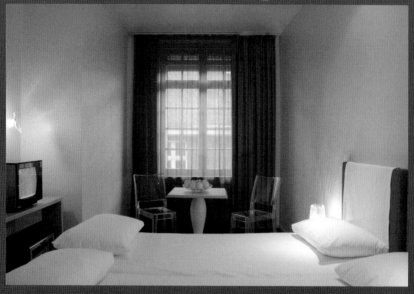

Address:	101 Brand Whitlock bd 1200 Brussels, Belgium
Phone:	+32 2 734 5636
Fax:	+32 2 734 5005
Email:	info@monty-hotel.be
Website:	www.monty-hotel.be
Located:	10 minutes by train from the historic center of Brussels
Style:	1930's patrician house with design interior: lights by Ingo Maurer, furniture by Starck, Eames
Family & kids tips:	Interior courtyard and terrace, babysitting service, bicycles
Special features:	Lounge bar, free Wi-Fi and computer access, free coffee and tea during guest stay, special weekend packages for families, pets allowed
Rooms:	18 rooms with ensuite bathroom, minibar, cable television and many design features
Opening date:	2003

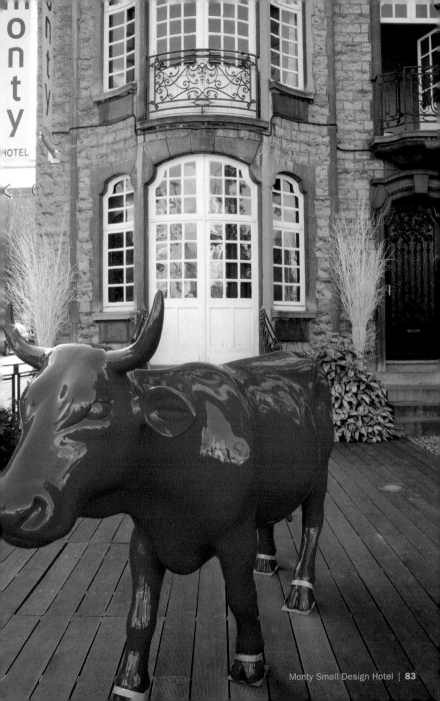

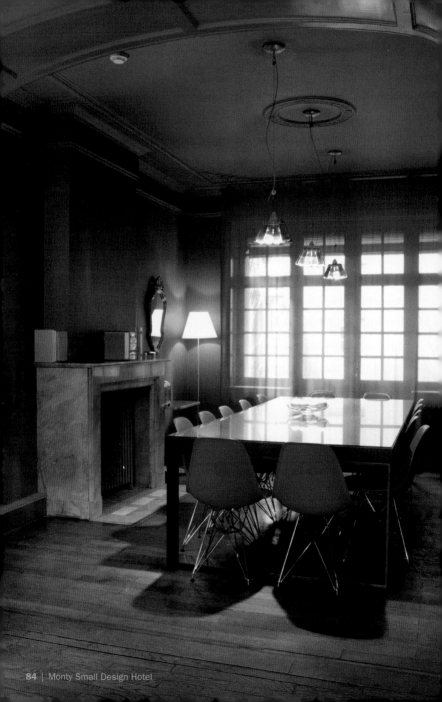

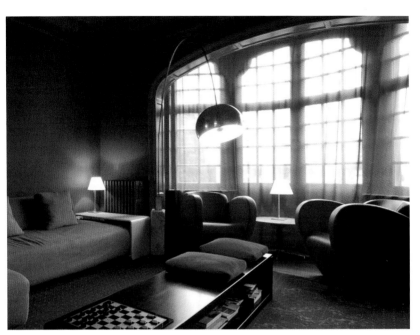

Lloyd Hotel & Cultural Embassy

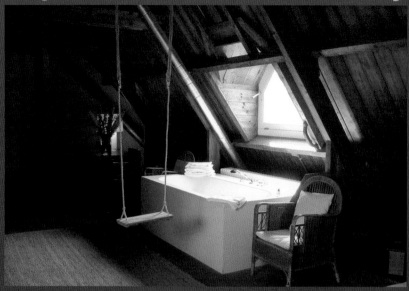

Address:	Oostelijke Handelskade 34
	Amsterdam 1019, The Netherlands
Phone:	+31 20 561 3636
Fax:	+31 20 561 3600
Website:	www.lloydhotel.com
Located:	In the docklands area, a 10-minute drive to the central station
Style:	Modern classic
Family & kids tips:	Child care, children's beds and toys on request
Special features:	Restaurant, bar, library, meeting room
Rooms:	117 rooms
Opening date:	2004

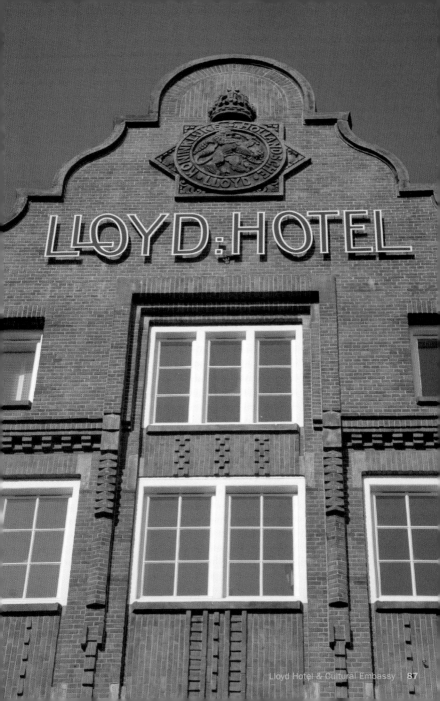

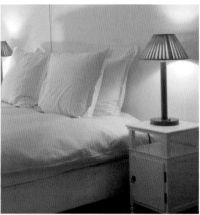

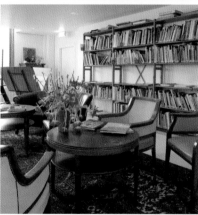

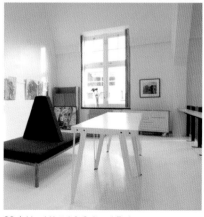

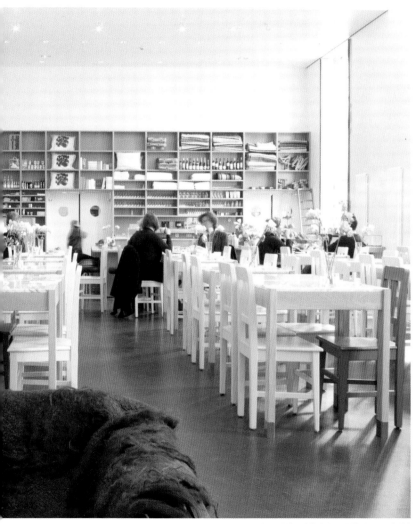

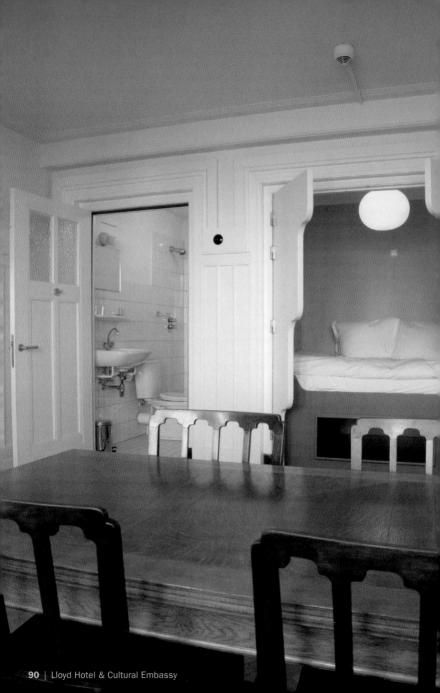

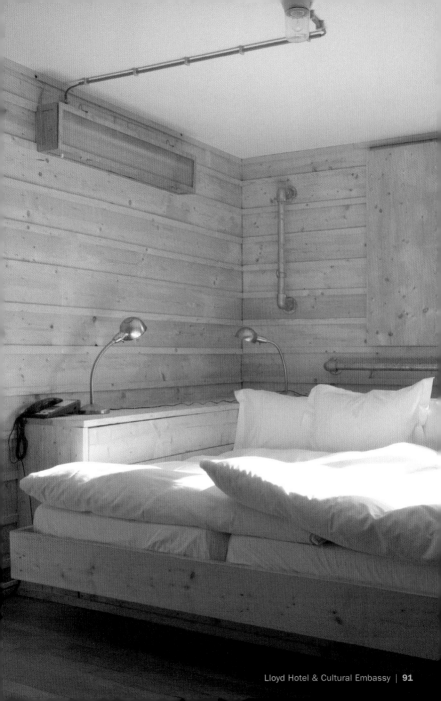

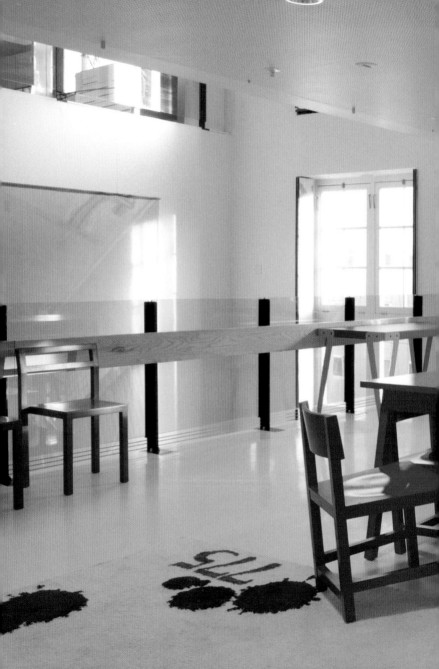

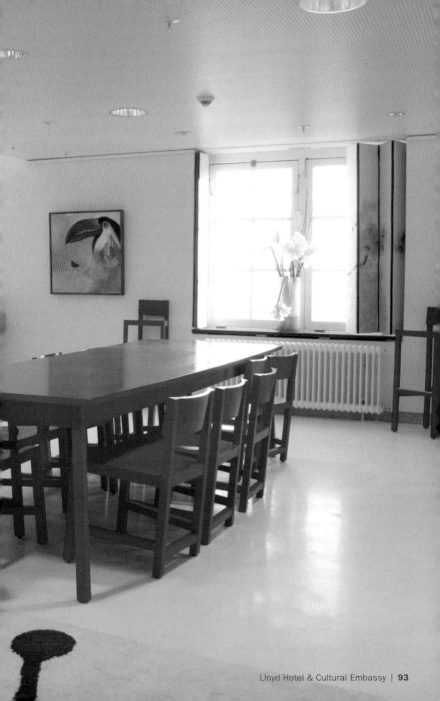

ALPENIGLU® Dorf Kitzbühel

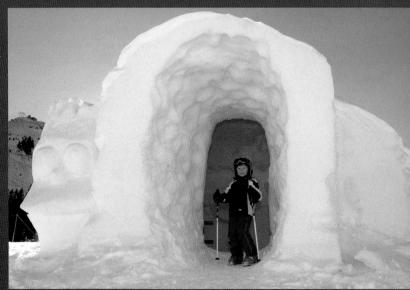

Address: Am Hahnenkamm
6370 Kitzbühel, Austria
Phone: +49 711 341 690 90
Fax: +49 711 341 690 99
Website: www.alpeniglu.com

Located: Directly at the entrance of the Sonnenrastlift
Style: Iglu
Family & kids tips: Activities for kids, snow sculptures, kids iglu, snow shoes safari, flambeau walk, playground, kids fun park
Special features: Iglu lounge, iglu church, iglu bar, pets allowed
Rooms: 6 sleeping iglus

Opening date: 2006

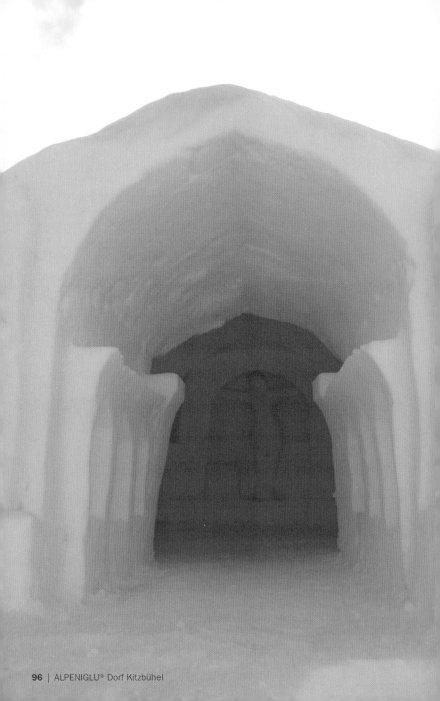

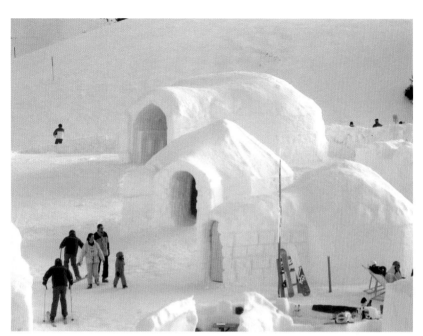

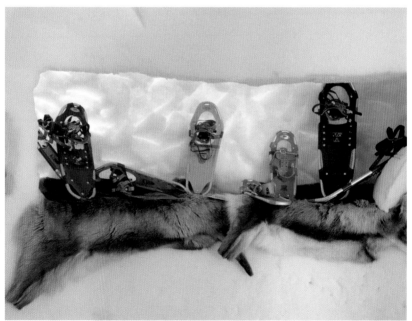

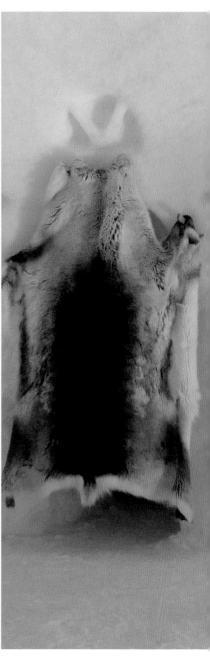

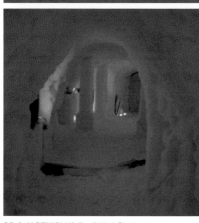

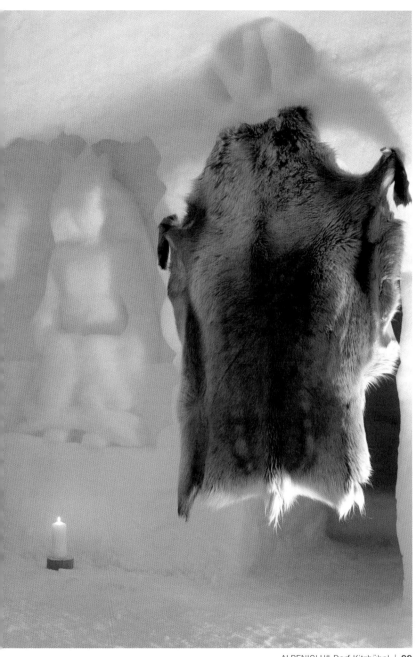

Garten- und Aparthotel Theresia

Address: Glemmtaler Landesstraße 208
5754 Saalbach-Hinterglemm, Austria
Phone: +43 6541 7414 0
Fax: +43 6541 7414 121
Website: www.hotel-theresia.co.at

Located: On the south side of the Glemm valley at the out-
skirts of Hinterglemm only an 8-minute walk away
from the village center
Style: Traditional and modern design
Family & kids tips: Children's wellness inclusive pension, Bimbulli-Club,
Junior-Club, magician school, sports field and
playground, kids menu, babysitter-service, bikes,
play and sports program
Special features: Bar, 5 restaurants, tennis, horse riding, wellness
check, paragliding, canyoning
Rooms: 58 rooms and 10 apartments

Opening date: 1981

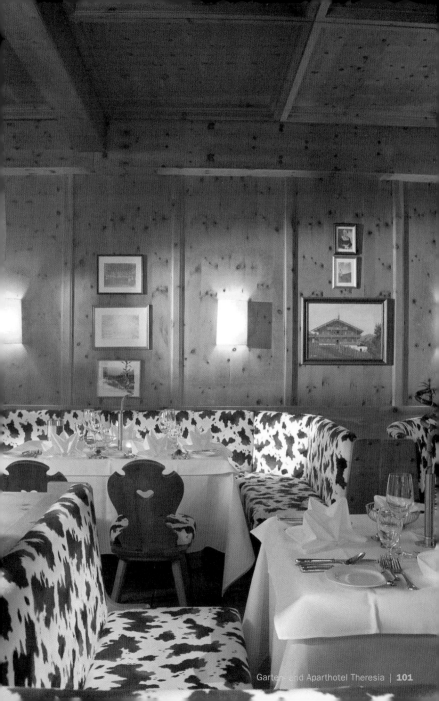

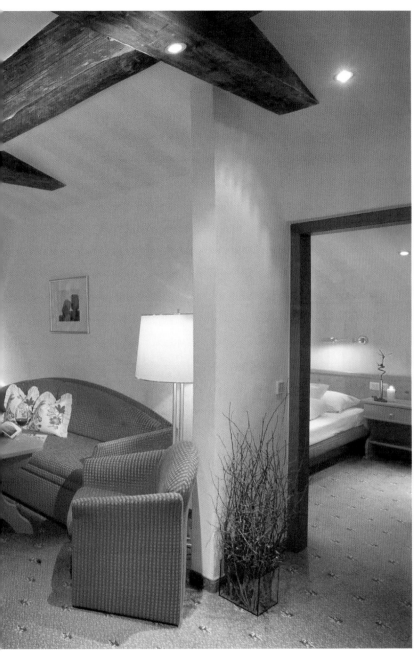

Avance Hotel in the Reiter's Burgenland Resort

Address:	Am Golfplatz 1–4
	7431 Bad Tatzmannsdorf, Austria
Phone:	+43 3353 884 1607
Fax:	+43 3353 884 1138
Website:	www.reitersburgenlandresort.at

Located:	In the Burgenland, about 115 km from Vienna
Style:	Modern design
Family & kids tips:	Lippizaner horse riding, tennis, golf, riding- and golf course for kids, Kasimir's Kidsworld, safari-lodge, kids-restaurant, kids-bar, all-embracing child care
Special features:	1 restaurant, 2 bars, spa, pets allowed
Rooms:	167 rooms, 2 suites
Opening date:	1995

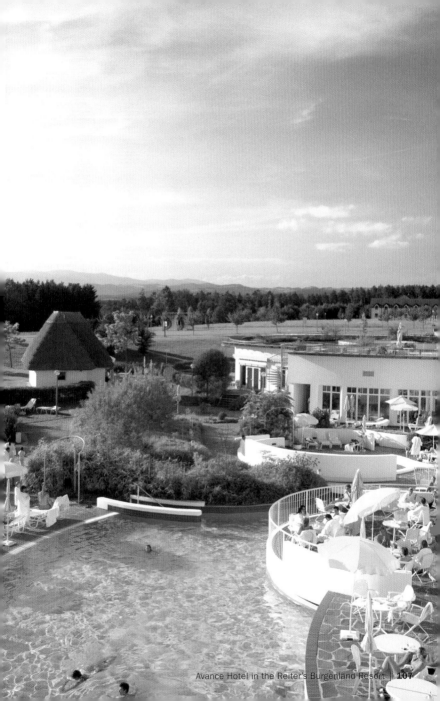

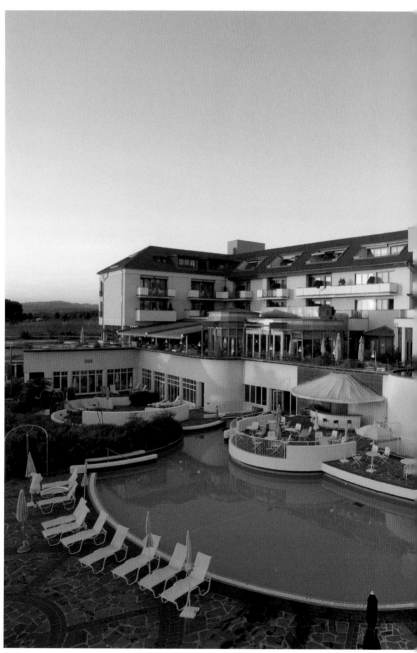

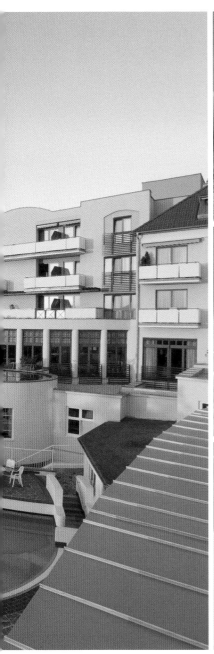

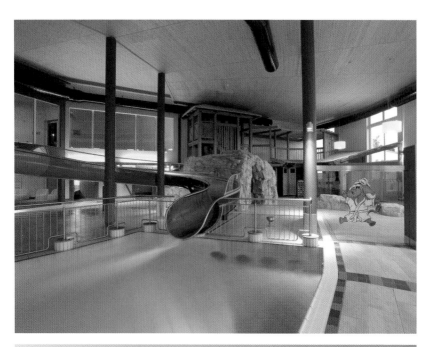

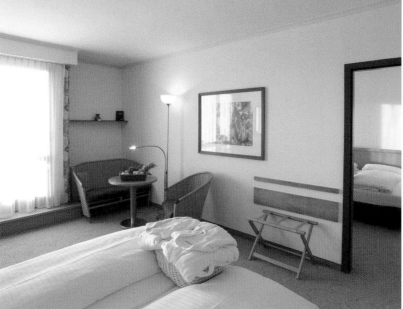

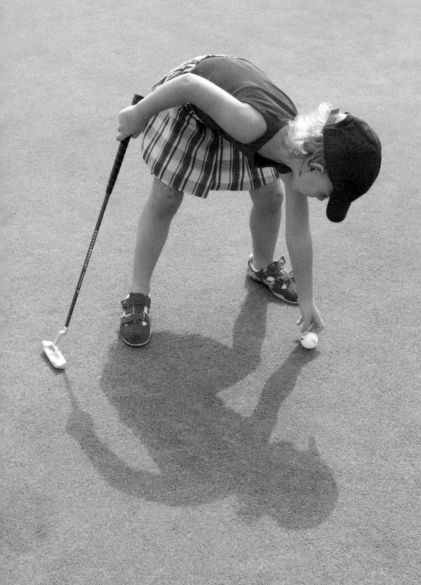

amiamo – Familotel Zell am See

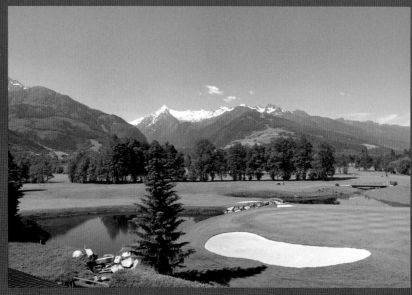

Address:	Am Schüttgut
	5700 Zell am See, Austria
Phone:	+43 6542 553 55
Fax:	+43 6542 553 5534
Website:	www.amiamo.at
Located:	In the beautiful region Zell am See – Kaprun
Style:	Mix of Austrian and Mediterranean Style
Family & kids tips:	All-round animation program for kids,
	300 square meters kidsworld with theater
Special features:	Pool, sauna, Babynarium, beauty studio, own beach
	on the Zeller See
Rooms:	40
Opening date:	1960, re-opened 2006

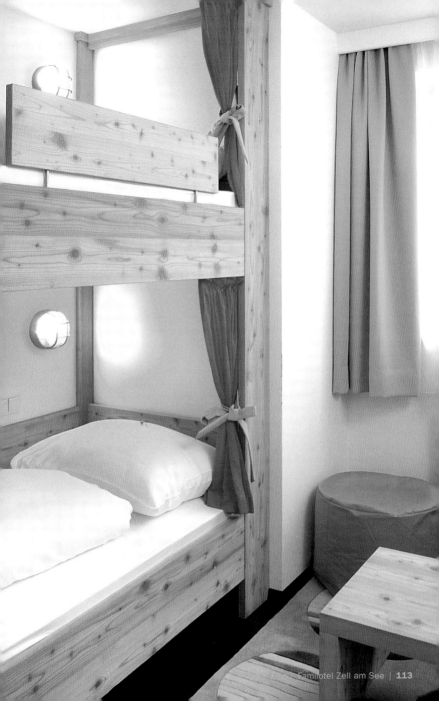

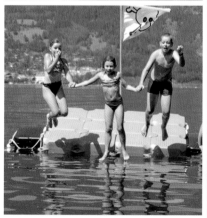

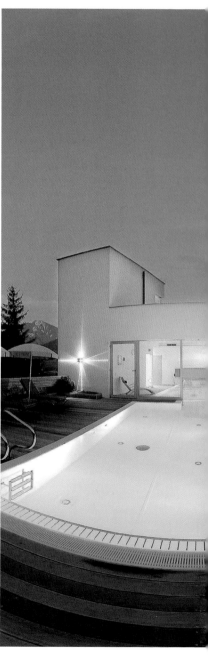

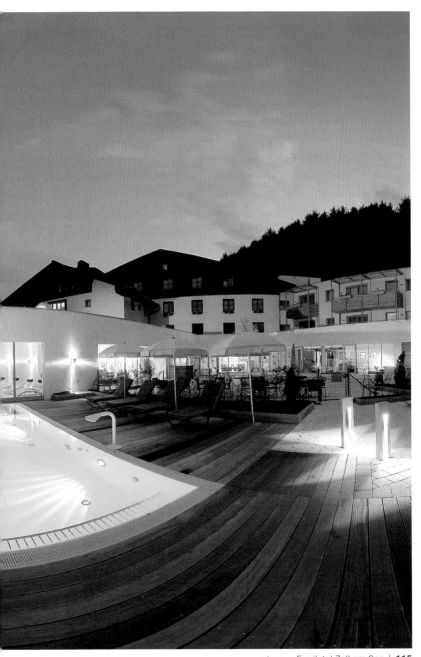

Kempinski Grand Hotel Heiligendamm

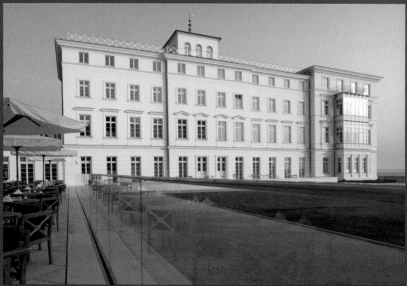

Address:	Heiligendamm
	18209 Heiligendamm, Germany
Phone:	+49 38203 740 0
Fax:	+49 38203 740 7474
Website:	www.kempinski-heiligendamm.com
Located:	At the east coast of Germany 20 km from Rostock
Style:	Contemporary elegant
Family & kids tips:	Polar Bear Children's Club, pony riding, children's villa, beach activities, baking pizzas with the chef de cuisine, pirate parties, story telling for children in the library, children's yoga, children's cinema
Special features:	3 restaurants, 2 bars and Spa Lounge, 3000 square meters Heiligendamm Spa with luxurious Spa Suite (indoor pool, sauna world, yoga teacher), golf course a 5-minute drive from the hotel
Rooms:	225 rooms and suites
Opening date:	2003

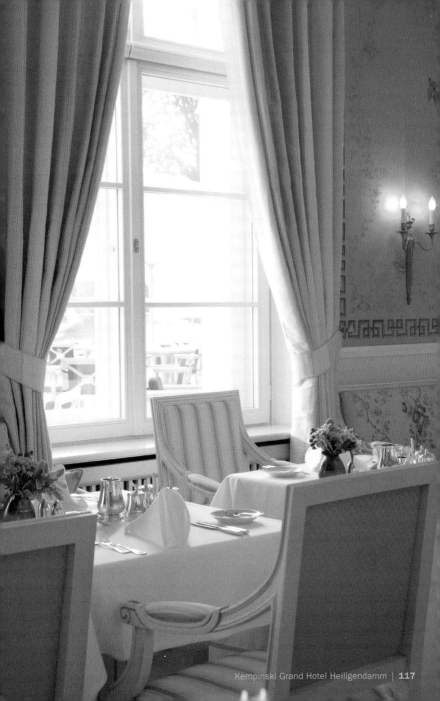

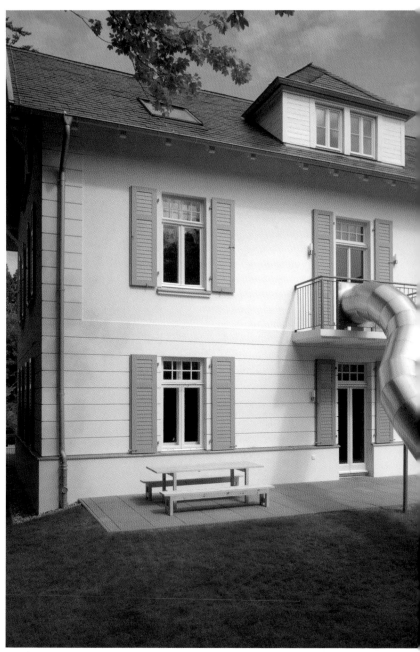

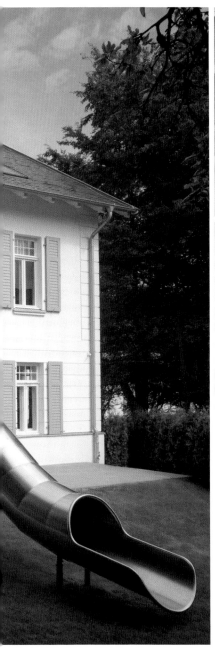

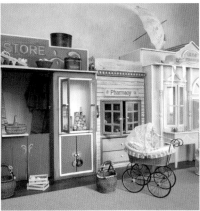

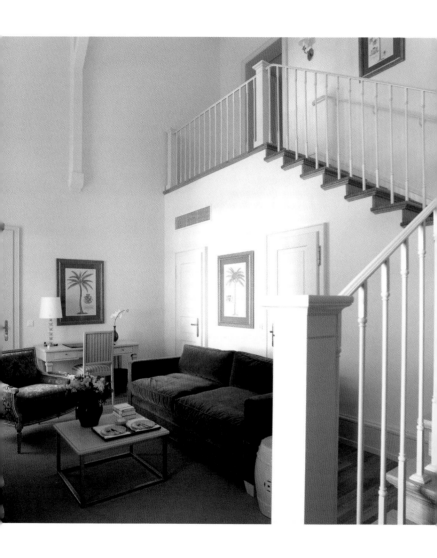

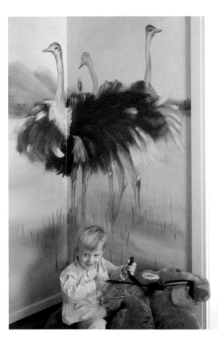
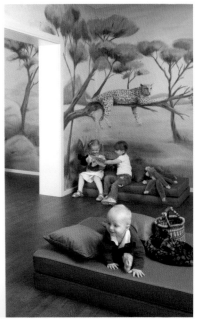
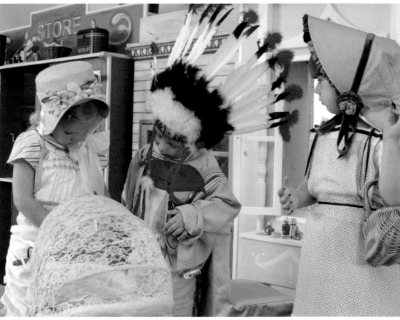

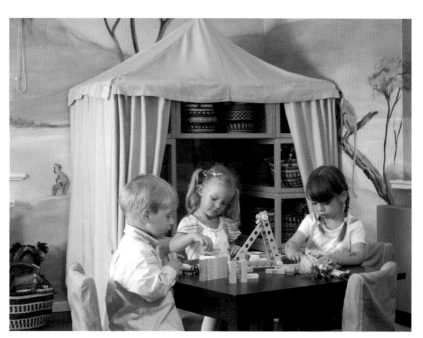

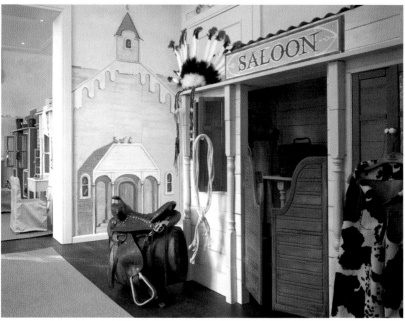

Yoho Hotel

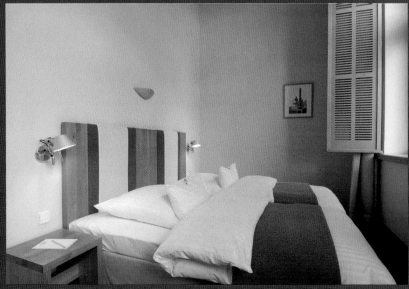

Address:	Moorkamp 5
	20357 Hamburg, Germany
Phone:	+49 40 2841 910
Fax:	+49 40 2841 9141
Website:	www.yoho-hamburg.de
Located:	Between the hip Schanzenviertel district and Eimsbüttel
Style:	Contemporary design
Family & kids tips:	Children under 18 years sleeping free of cost, baby cribs, children's bedlinen with kids design, colored nighlights for sockets, books, sleeping bags, breakfast free for kids until 12, bottle warmers, relaxed atmosphere
Special features:	Restaurant, conference rooms, ball room
Rooms:	30 rooms
Opening date:	2000

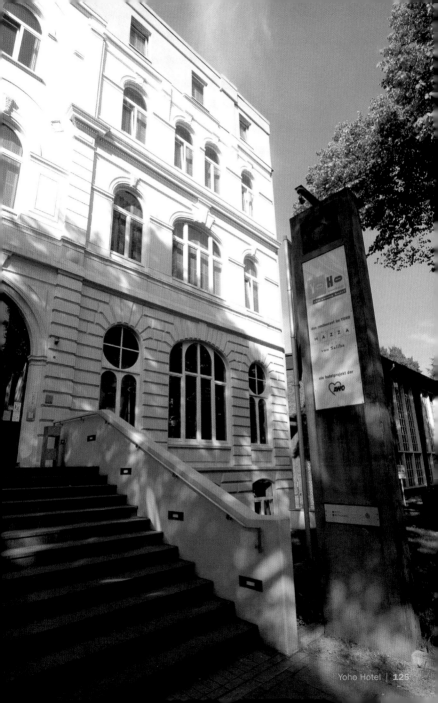

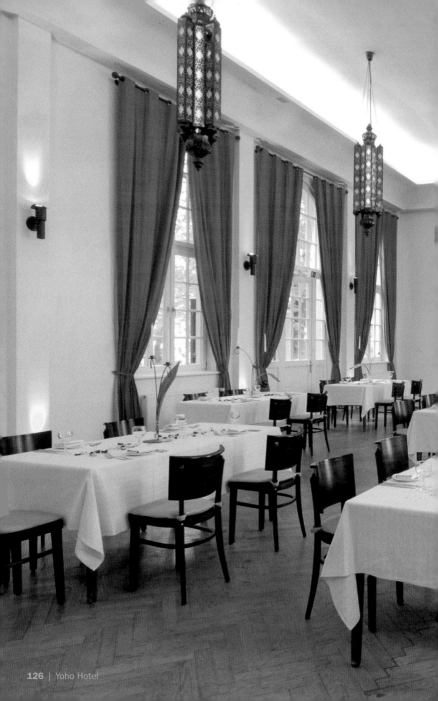

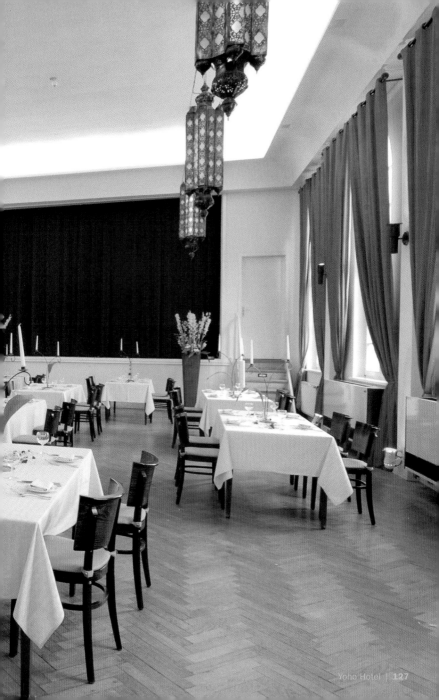

Vier Jahreszeiten Zingst

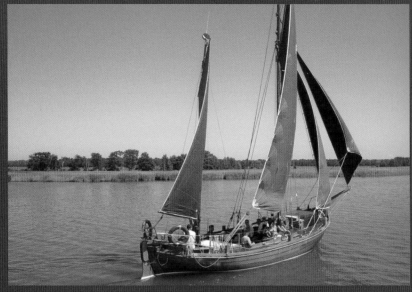

Address: Boddenweg 2
18374 Zingst, Germany
Phone: +49 38232 1740
Fax: +49 38232 17474
Website: www.vier-jahreszeiten.eu

Located: Ostseeheilbad Zingst, Mecklenburg Vorpommern, east coast of Germany, 60 km from Rostock
Style: Contemporary design
Family & kids tips: Indoor and outdoor playground, minigolf, indoor beach-hall, kids animation, child care
Special features: 3 restaurants, Piazzabar, 1500 square meters wellness and spa area, beauty parlor, pool
Rooms: 95 rooms and suites

Opening date: 2004

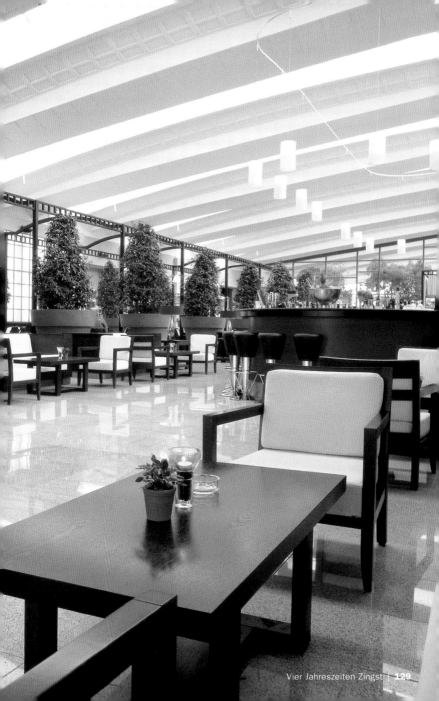

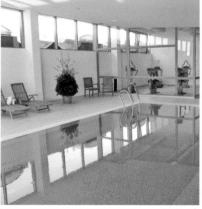
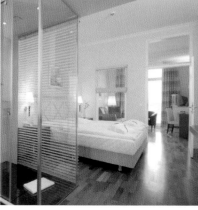
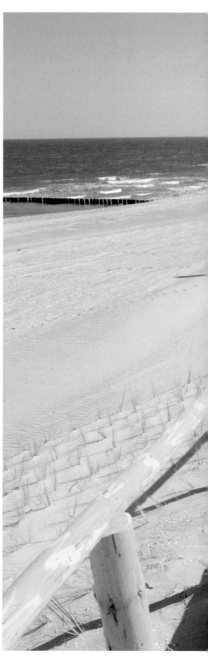

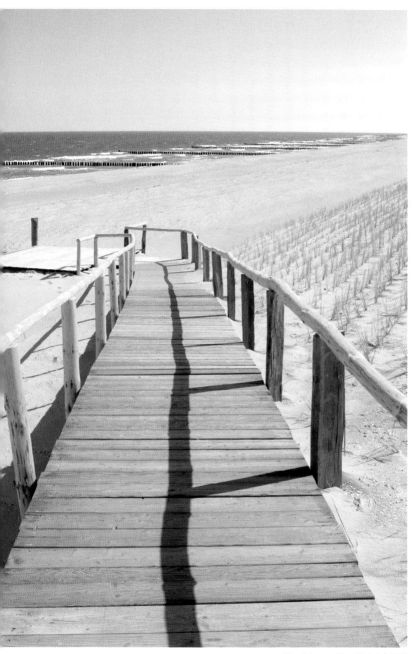

Schloss Elmau – Cultural Hideaway & Luxury Spas

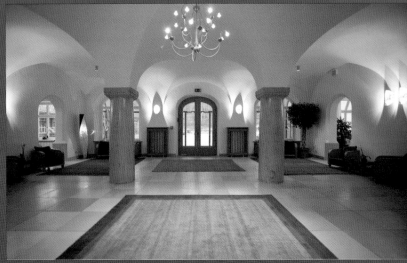

Address:	Schloss Elmau – Cultural Hideaway & Luxury Spas 82493 Elmau, Germany
Phone:	+49 8823 180
Fax:	+49 8823 18177
Website:	www.schloss-elmau.de
Located:	Between Garmisch-Partenkirchen and Mittenwald, 110 km from Munich
Style:	Contemporary luxury
Family & kids tips:	Edutainment for children, family spa, 2 kindergardens, adventure playground, kids restaurant, horse riding, kids menu
Special features:	7 restaurants, bars and lounges, High Culture for cosmopolitans (about 150 cultural events a year), fusion cuisine for gourmets and cooking courses, 3 spas, a wide range of sports facilities (mountain biking, skiing, boccia, tennis, volleyball)
Rooms:	140 rooms and suites
Opening date:	July 2007

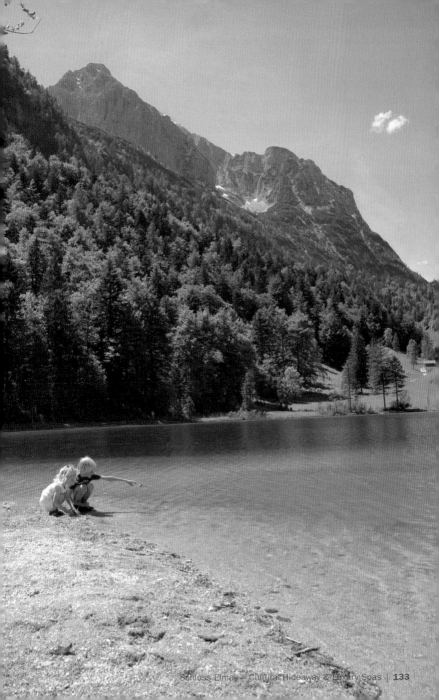

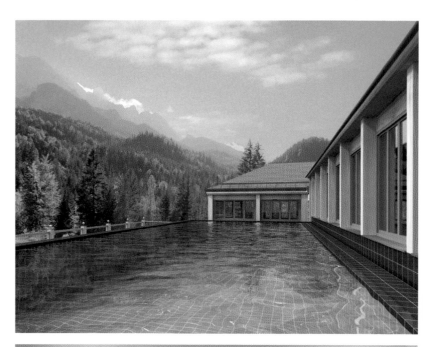

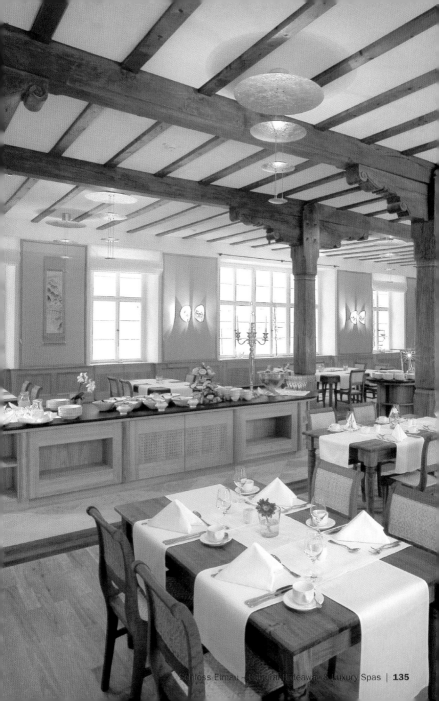

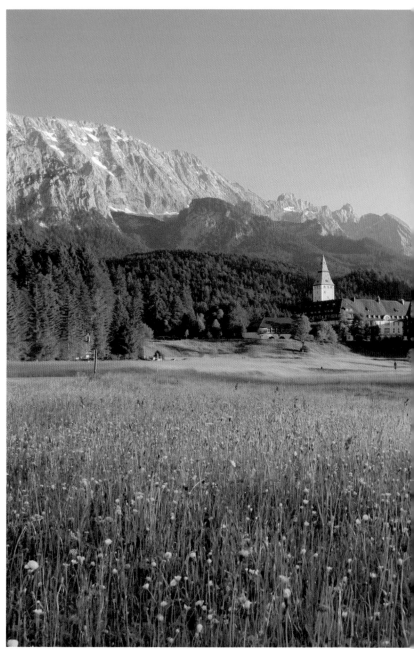

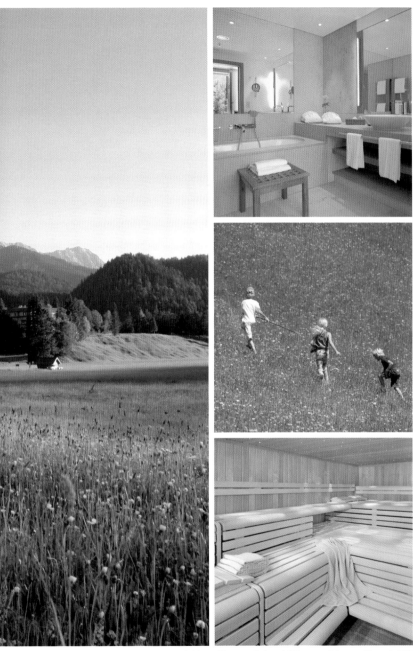

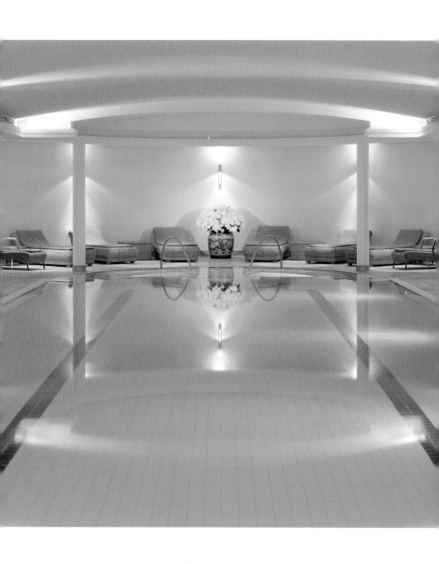

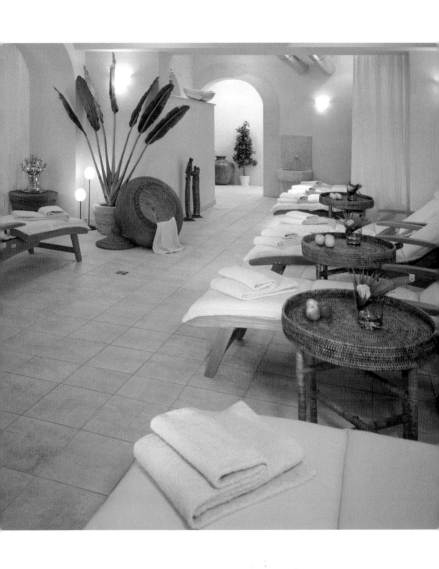

Cube Savognin

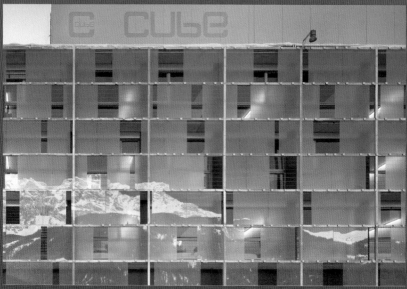

Address: Veia Grava 15
7460 Savognin, Switzerland
Phone: +41 81 659 1414
Fax: +41 81 659 1415
Website: www.cube-hotels.com

Located: 40 minutes from Chur and St. Moritz on a plateau, only 10 minutes within walking distance from restaurants, shops, next to mountain railway
Style: Loft style
Family & kids tips: Pinoccioclub, tabletop football, indoor climbing, billiard, singstar playstation, fun sports, family rooms
Special features: CUBE club
Rooms: 76 rooms

Opening date: 2005

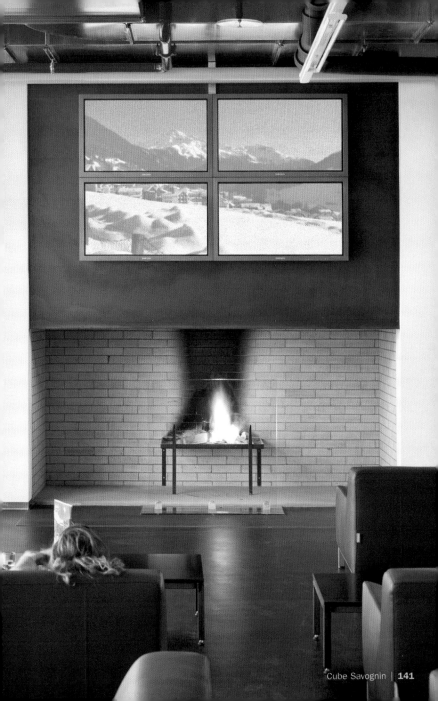

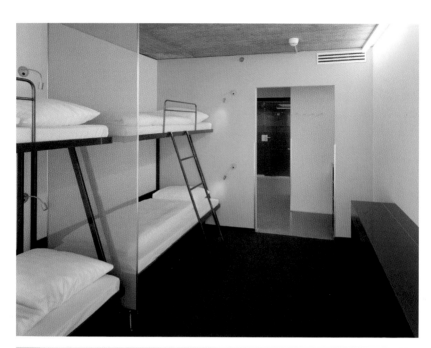

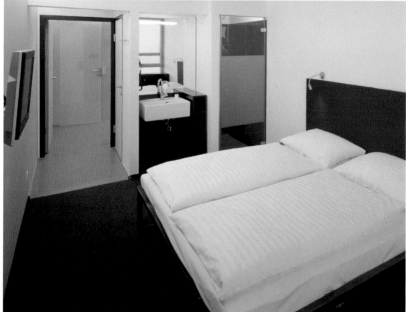

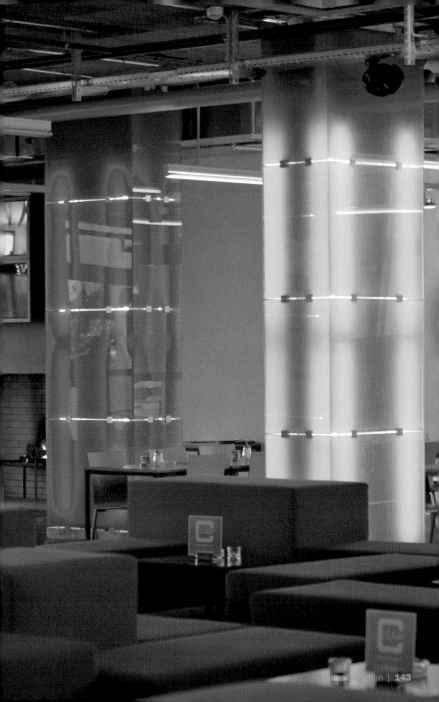

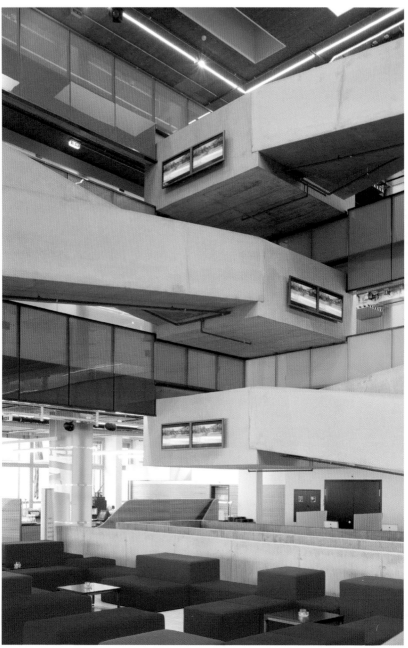

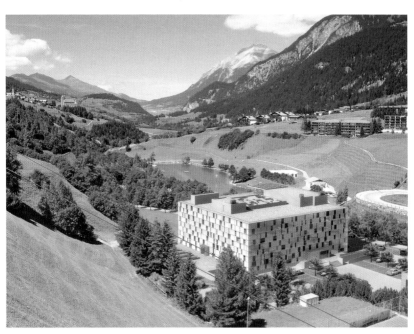

Suvretta House

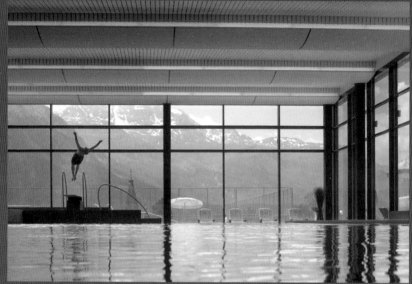

Address:	Via Chasellas 1
	7500 St. Moritz, Switzerland
Phone:	+41 81 836 3636
Fax:	+41 81 836 3737
Website:	www.suvrettahouse.ch
Located:	Suvretta House lies in a natural park landscape by the Suvretta-Corviglia winter sport and hiking region and a mere 2 km to the west of St. Moritz
Style:	Traditional, classic
Family & kids tips:	Inhouse kindergarden, children's restaurant Teddy Club, playground, cinema with movies for kids
Special features:	2 restaurants, 2 bars, hotel own ski lift, ski school and ski shop
Rooms:	184 rooms, 4 suites
Opening date:	1912

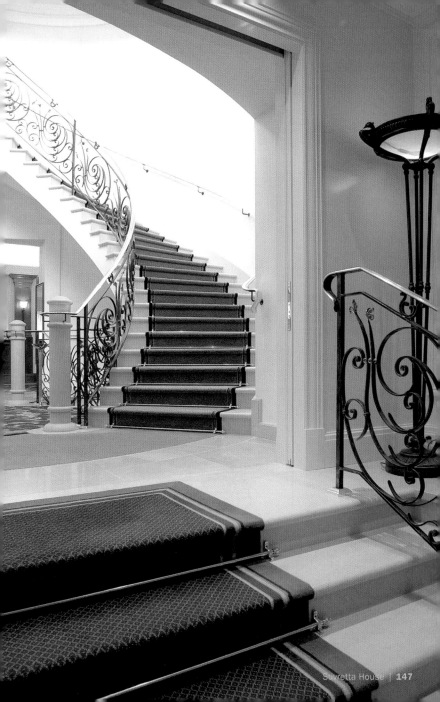

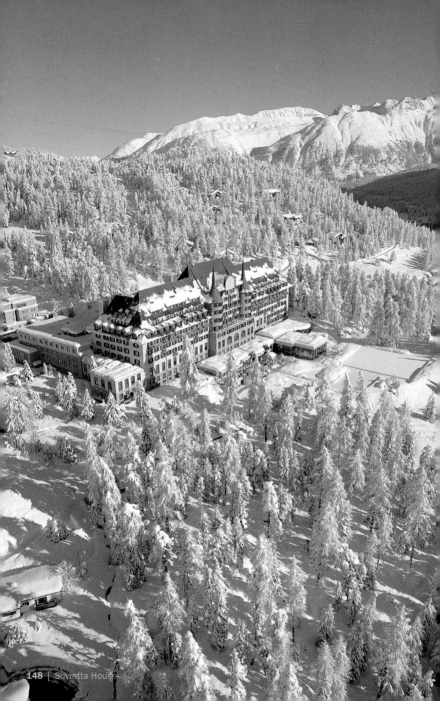

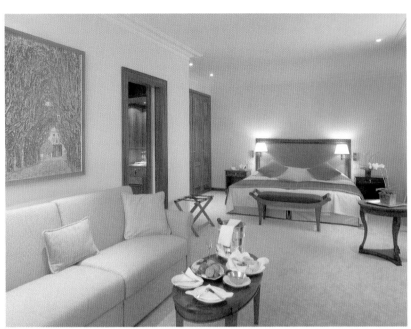

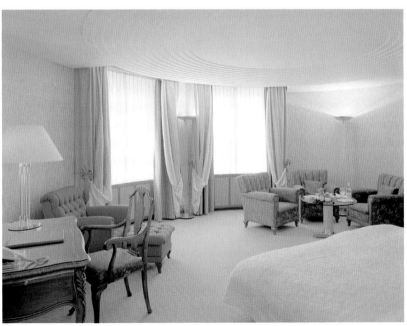

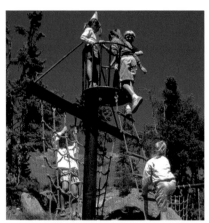

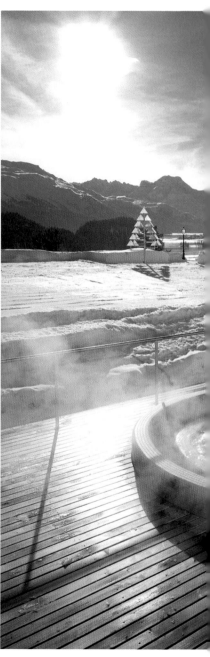

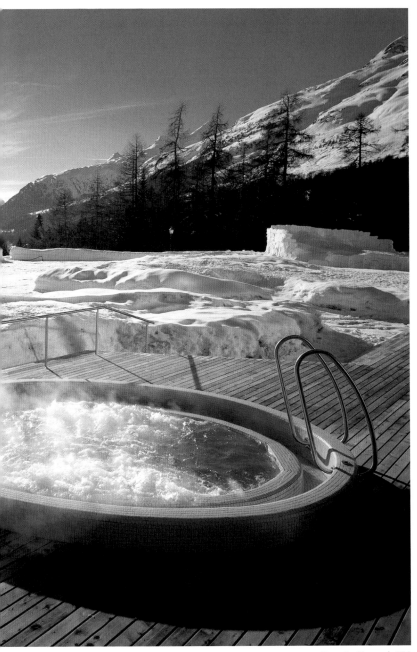

Park Hotel Waldhaus

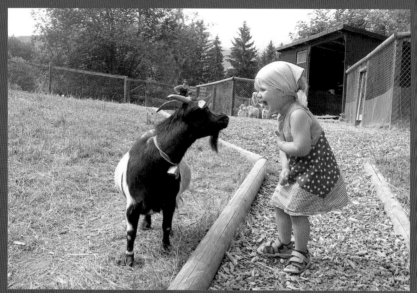

Address:	Via dil parc 3
	7018 Flims, Switzerland
Phone:	+41 81 928 4848
Fax:	+41 81 928 4858
Email:	info@parkhotel-waldhaus.ch
Website:	www.parkhotel-waldhaus.ch
Located:	Located in the wood of Flims, a 60-minute drive to Zurich, in the midst of the mountains of Flims/Laax
Style:	Elegance and grand air of the "Belle Epoque"
Family & kids tips:	Full-time child care free of cost, playrooms, playgrounds, petting zoo, wellness program for kids, kids restaurant with kids menu, youth camp in July/August, tightrope adventure garden
Special features:	6 restaurants, 4 bars, large spa center with hammam, saunas, wellness suites, own hotel museum
Rooms:	150 rooms and suites
Opening date:	1877, last renovation 2006

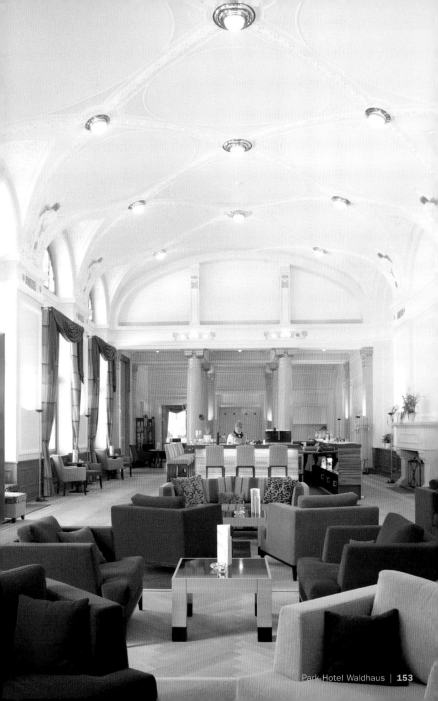

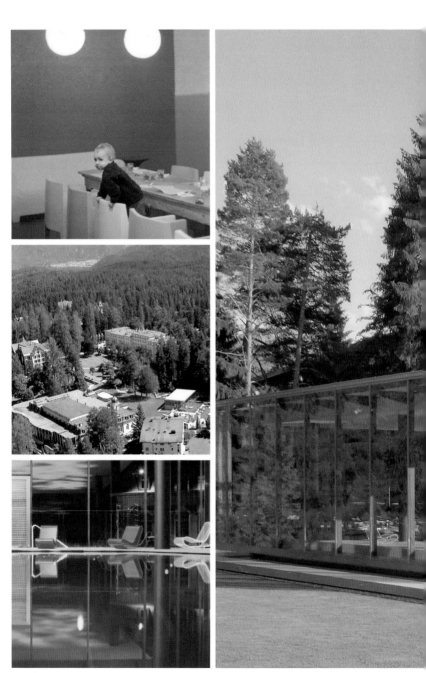

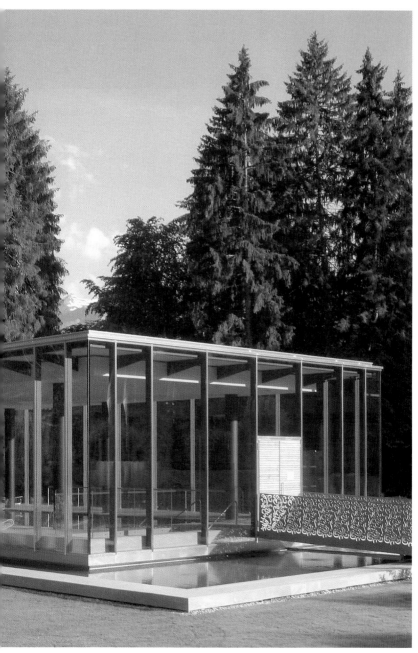

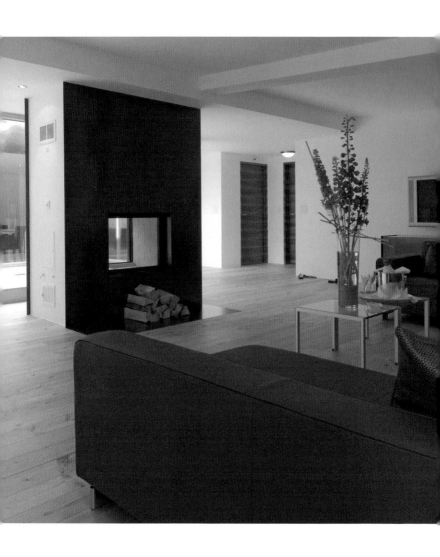

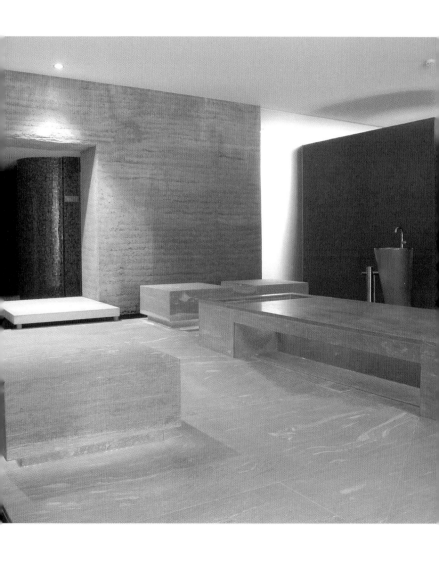

Hotel Castell

Address:	Hotel Castell
	7524 Zuoz, Switzerland
Phone:	+41 81 851 5253
Fax:	+41 81 851 5254
Website:	www.hotelcastell.ch
Located:	Nestled in the natural landscape of the Engadine in the triangle of Zurich, Milan and Munich close to the ski lift and the golf course, 1 km from the railway station of Zuoz
Style:	Contemporary design with modern art collection
Family & kids tips:	Special prices for kids, family rooms, playground, kids club, hammam for kids, babysitting, kids menu, bed for children 6 or younger free of charge
Special features:	Restaurant, bar with fireplace, wellness area with hammam and rock water sauna, garden, billiard table, bicycle rental, art events, table for children
Rooms:	66 rooms
Opening date:	1912, rebuilt 2004

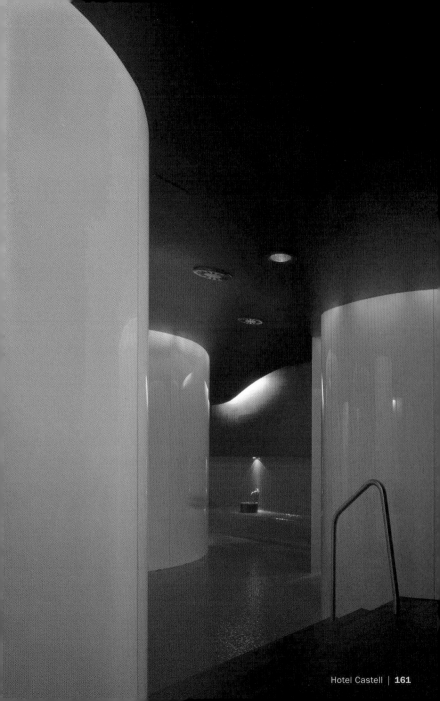

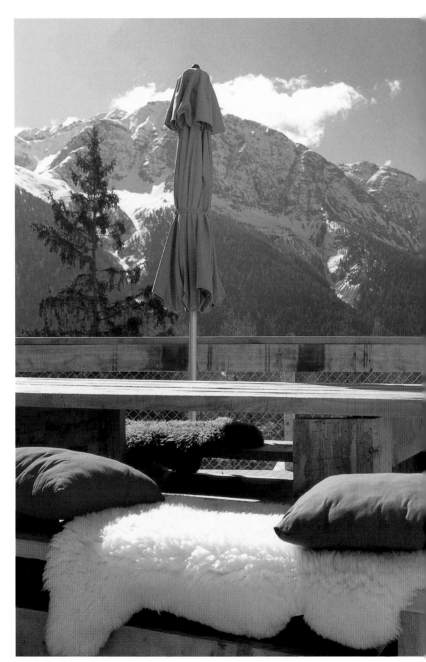

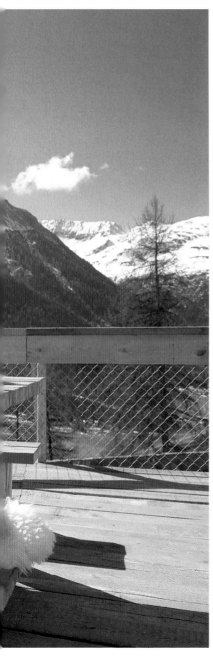

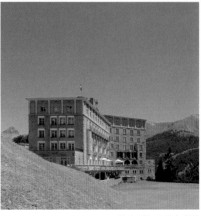

Erika

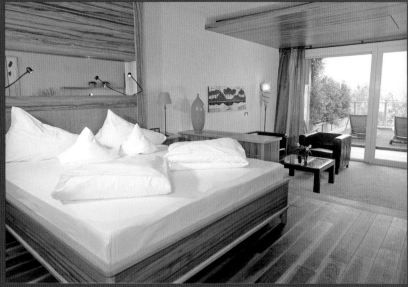

Address:	Hauptstraße 39
	39019 Dorf Tirol, South Tyrol, Italy
Phone:	+39 0473 926 111
Fax:	+39 0473 926 100
Website:	www.erika.it
Located:	South Tyrol, overlooking Meran
Style:	Ecological style, natural building materials
Family & kids tips:	Kids fashion show, wellness holidays for kids, climbing wall, tabletop soccer, extra room for handicrafts, archery, complimentary Internet
Special features:	7 outdoor saunas, a relaxation garden, an olive-wood terrace, palm trees garden
Rooms:	45 rooms, 18 suites
Opening date:	1975

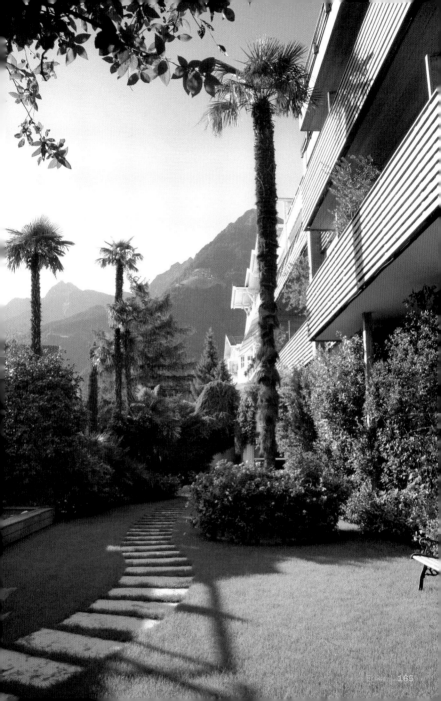

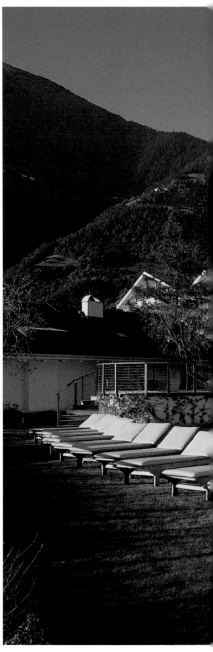

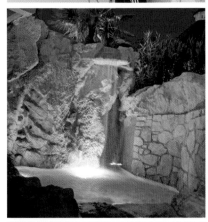

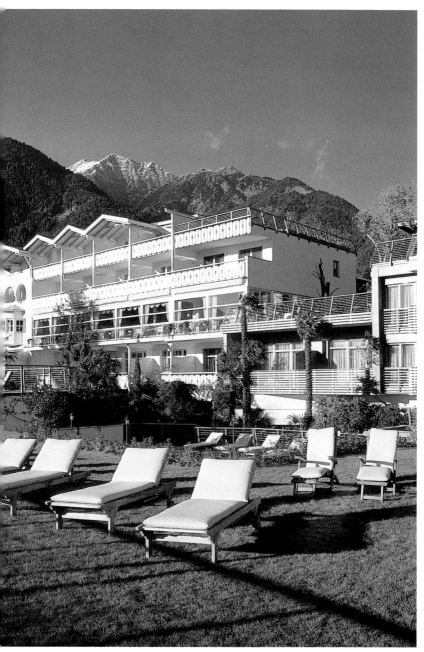

Hotel Beaumarchais

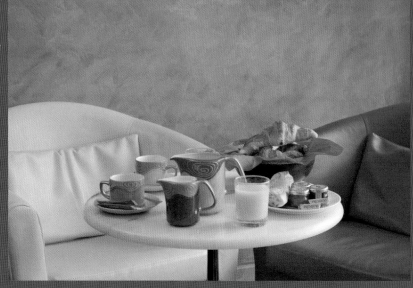

Address:	3, rue Oberkampf 75011 Paris, France
Phone:	+33 153 368 686
Fax:	+33 143 383 286
Website:	www.hotelbeaumarchais.com
Located:	Close to the Marais district full of small boutiques, shops and restaurants
Style:	Contemporary design
Family & kids tips:	Baby crip (0 to 4 years) and kids bed (5 to 15 years) complimentary, connecting rooms, complimentary breakfast for children under 6 years, heating of baby bottles and meals for free
Special features:	Art gallery, free Internet access, flowery patio
Rooms:	31 rooms
Opening date:	First opening 1950

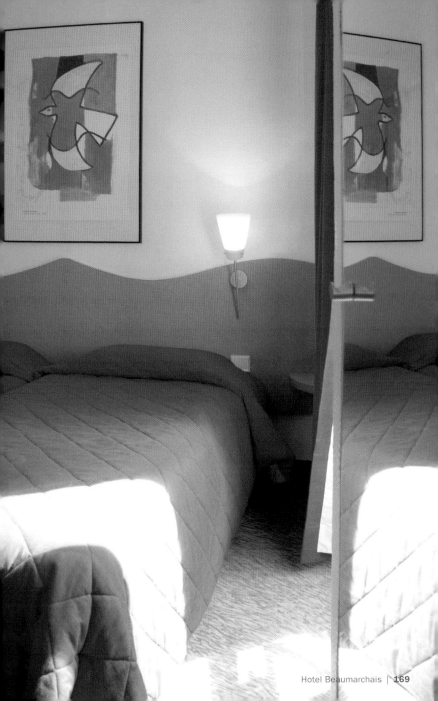

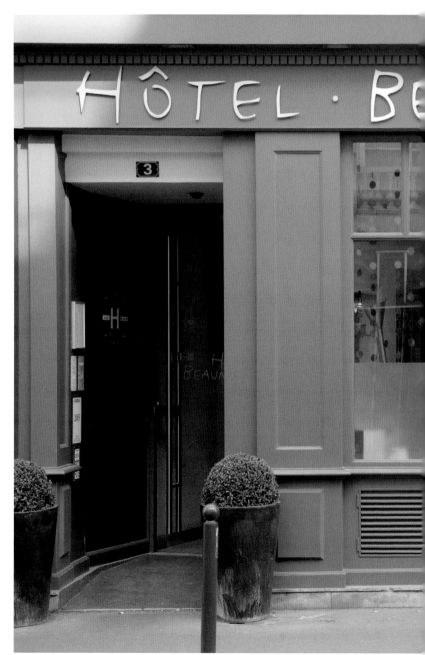

Vienna International Dream Castle Hotel

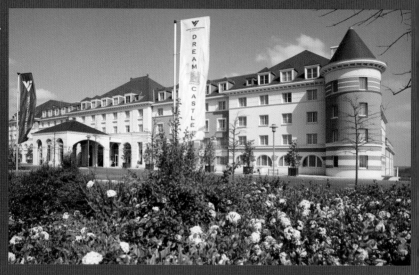

Address:	40, avenue de la Fosse des Pressoirs 77703 Marne-la-Vallee (Paris), France
Phone:	+33 164 179 000
Fax:	+33 164 179 010
Website:	www.dreamcastle-hotel.com
Located:	Next to Disneyland® Resort Paris 35 minutes from Paris or 45 minutes from the Champagne Valley
Style:	Castle
Family & kids tips:	"Dragoon Lagoon", Children Fun & Splash Pool, a room full of video games, play areas in the lobby, "Musketeers" restaurant, outdoor playground in the beautiful French garden
Special features:	Excalibur-Bar, fitness center, 6 meeting rooms, indoor and outdoor play areas, service concierge, spa and beauty center, quiet surroundings with gardens and lake
Rooms:	386 rooms, 14 suites
Opening date:	2004

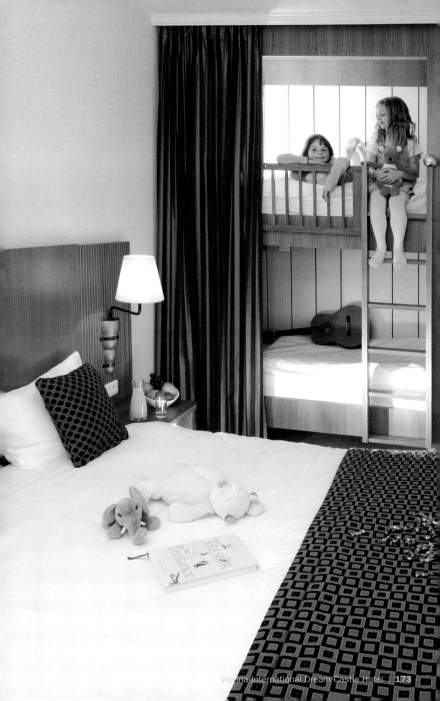

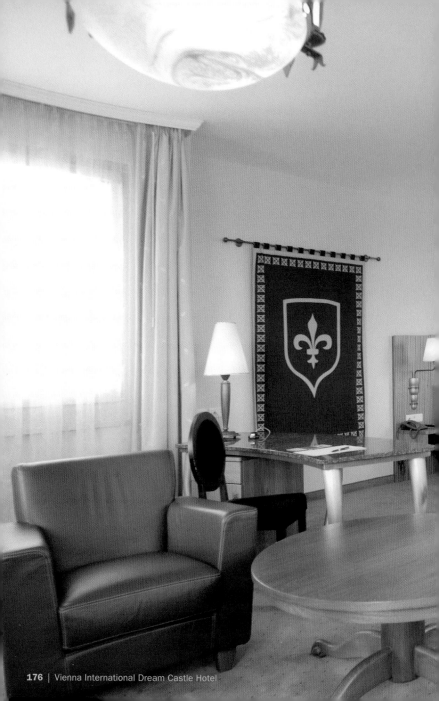

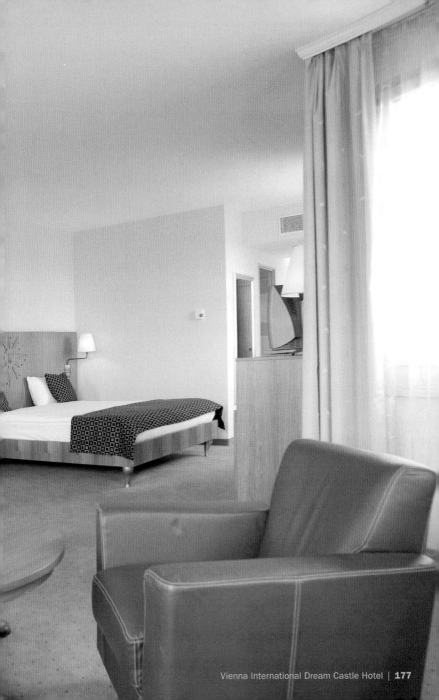

Chateau de la Couronne

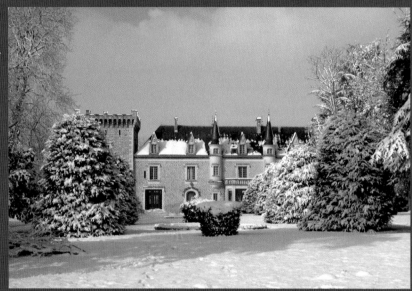

Address:	Chateau de la Couronne
	16380 Mathon, France
Phone:	+33 545 622 996
Email:	info@chateaudelacouronne.com
Website:	www.chateaudelacouronne.com
Located:	Dordogne, Charente border
Style:	Contemporary boutique hotel in an ancient chateau
Family & kids tips:	Special kids den with sleeping and chill out areas fully equipped with TV, DVD, Playstation, games and other fun items, 5 acre private park, football pitch, table tennis
Special features:	Private cinema, 14.5 meters swimming pool, dining hall, billiard room
Rooms:	7
Opening date:	2006

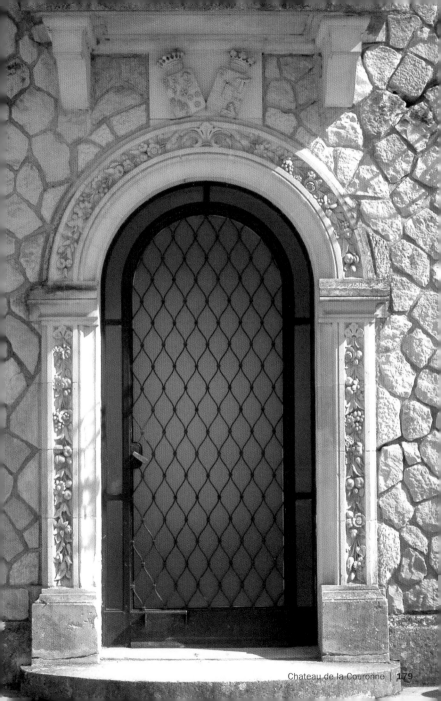

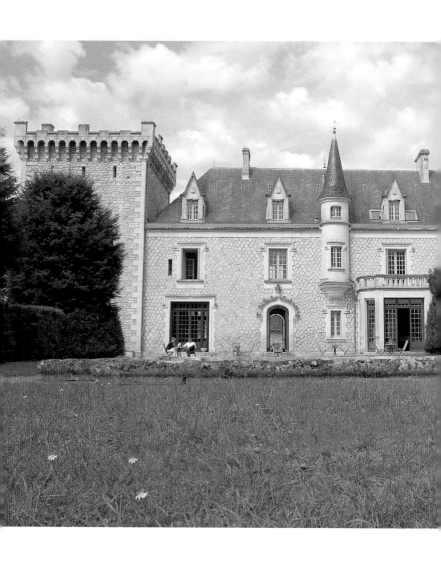

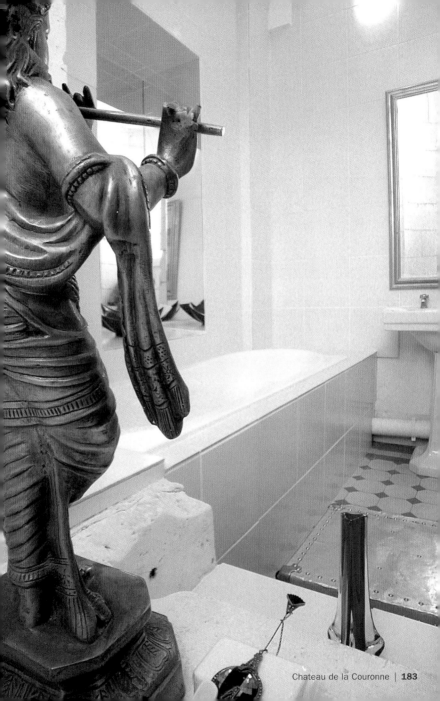

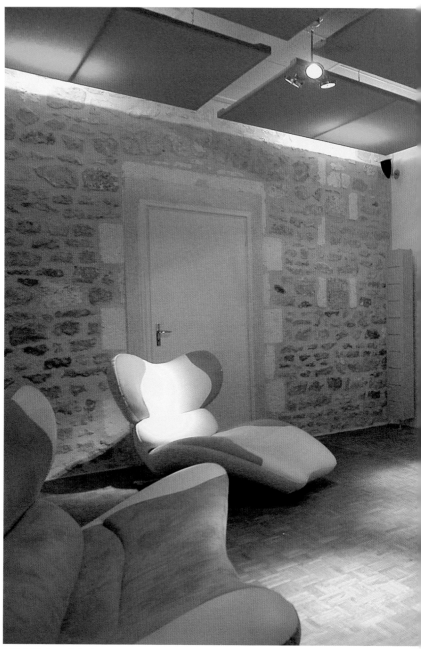

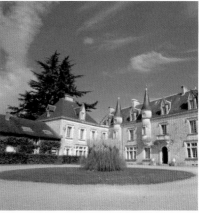
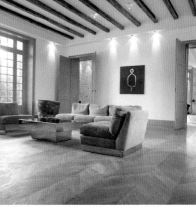

Market Hotel

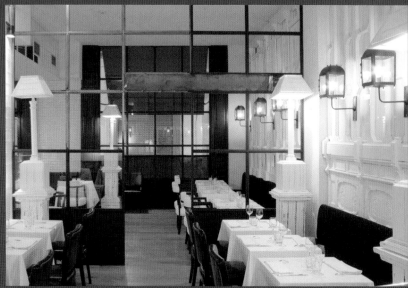

Address: Passatge Sant Antoni Abad 10
08015 Barcelona, Spain
Phone: +34 93 3251 205
Fax: +34 93 4242 965
Website: www.markethotel.com.es

Located: In the heart of Barcelona's Eixample area, next to San Antonio market and close to shopping areas and sights
Style: Contemporary design
Family & kids tips: Affordable small boutique hotel with a great individual service, baby cribs
Special features: Restaurant opened for lunch and dinner
Rooms: 37 rooms with Internet access, flat screen and aircondition

Opening date: 2006

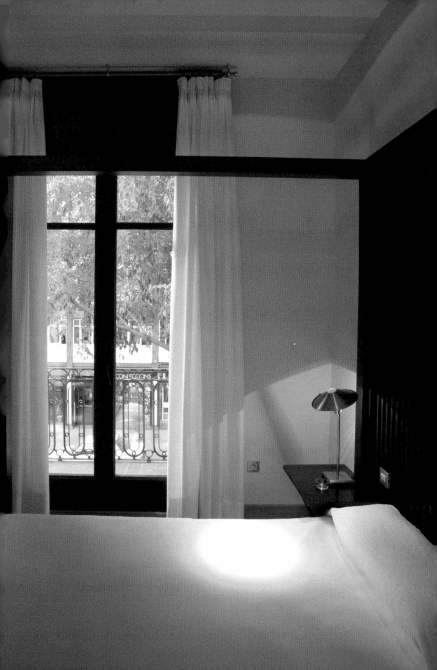

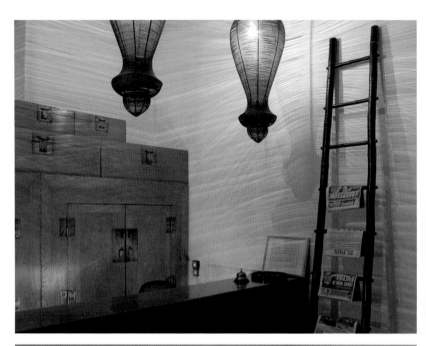

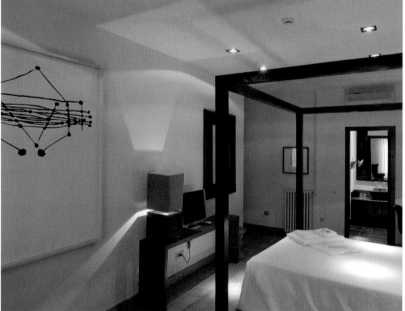

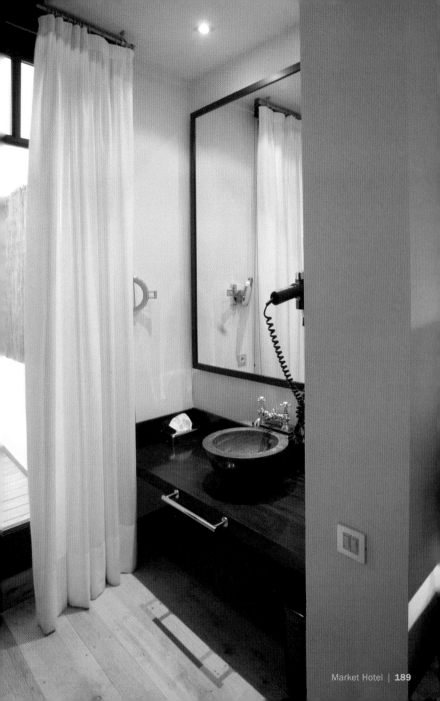

Blau Porto Petro

Address:	Avda. des far, 12 Porto Petro
	07691 Mallorca, Spain
Phone:	+34 97 164 8282
Fax:	+34 97 164 8283
Website:	www.blau-hotels.com
Located:	On the coast, by the beach
Style:	Mediterranean-modern
Family & kids tips:	Blaudi Mini&Maxi Club, special pool, mini club, children area, children menus, babysitters
Special features:	4 restaurants, 3 pools, spa, watersports, convention center
Rooms:	210 rooms, 99 suites, 10 villas with private pool or jacuzzi
Opening date:	2005

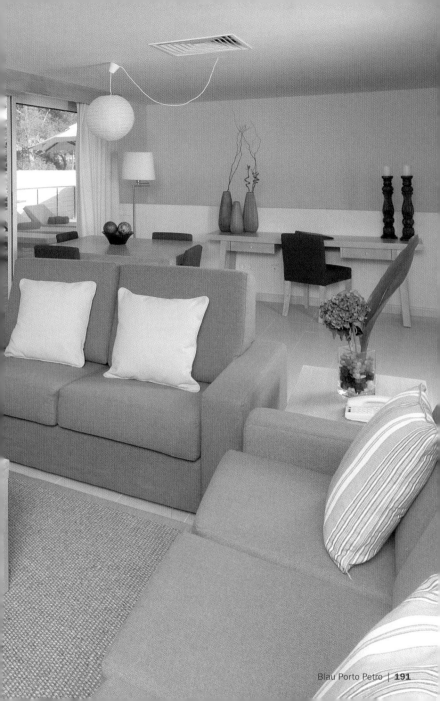

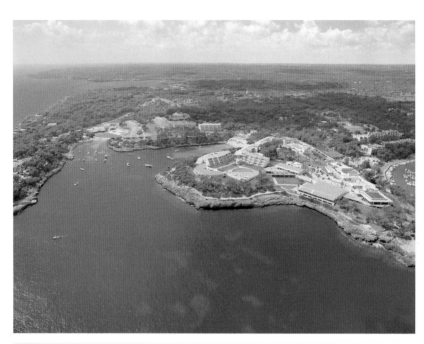

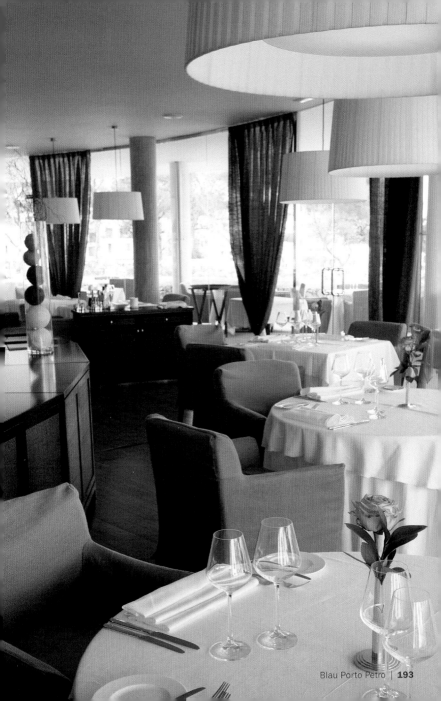

ArabellaSheraton Golf Hotel Son Vida

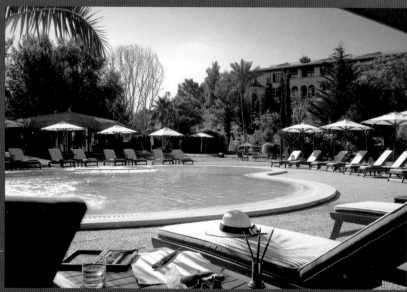

Address: Carrer de la Vinagrella, s/n
07013 Palma de Mallorca, Spain
Phone: +34 971 787 100
Fax: +34 971 787 200
Website: www.mallorca-resort.com

Located: 10 minutes away from the center of Palma, besides the golf course Son Vida
Style: Contemporary design
Family & kids tips: Kids area, kids pools, Kid's Club with professional child care, golf courses for kids
Special features: 2 restaurants, bar, spa
Rooms: 93 rooms including 22 suites

Opening date: 1992

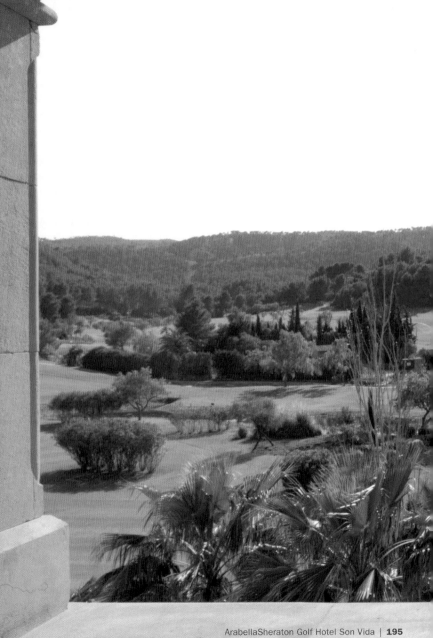

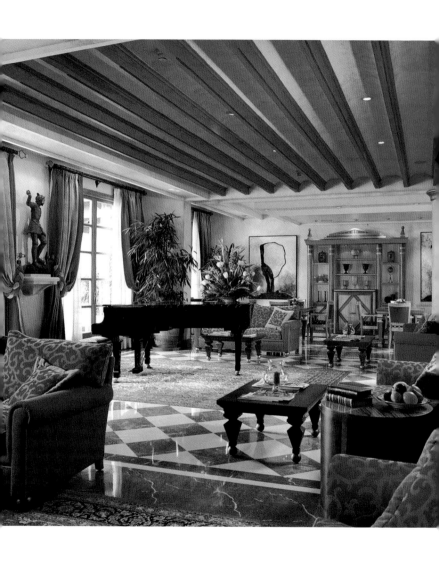

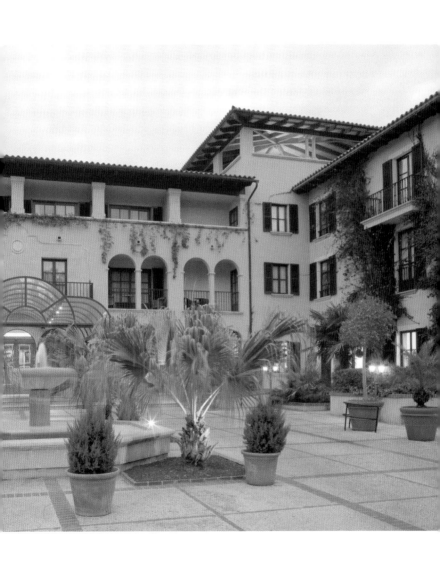

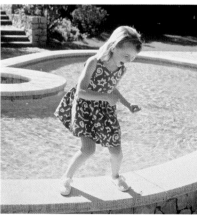

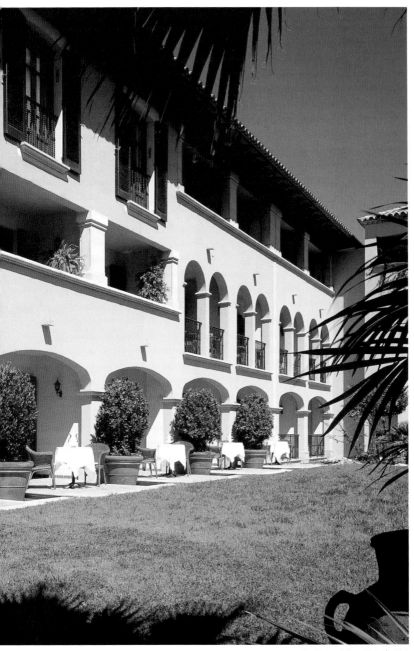

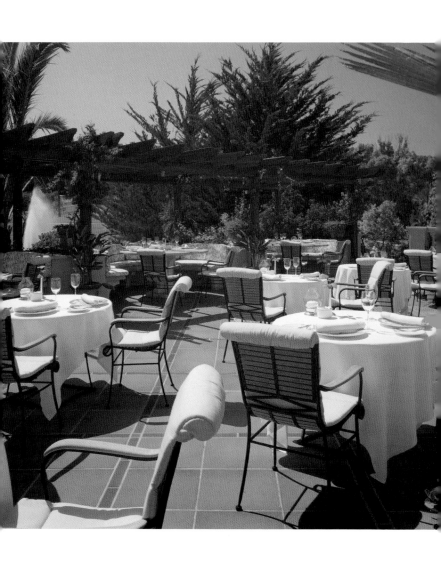

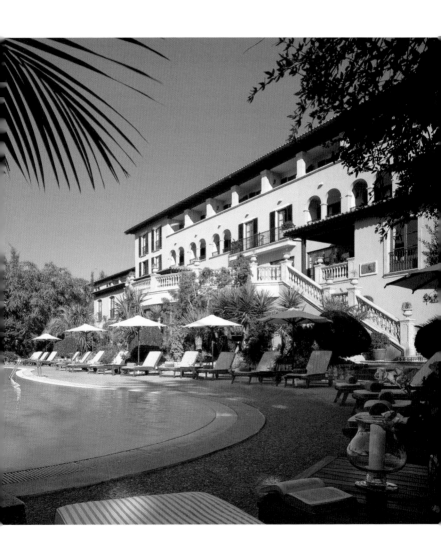

Mardavall Hotel & Spa

Address:	Passeig Calvià, s/n
	07181 Costa d'en Blanes (Calvià), Mallorca, Spain
Phone:	+34 971 629 629
Fax:	+34 971 629 630
Website:	www.mallorca-resort.com
Located:	On the waterfront, little bay, 15 minutes away from the center of Palma and 5 minutes from the marina Puerto Poertals
Style:	Contemporary design
Family & kids tips:	Kids area, kids pool, kids club with professional child care, golf courses for kids
Special features:	Restaurants, bars, spa
Rooms:	133
Opening date:	2002

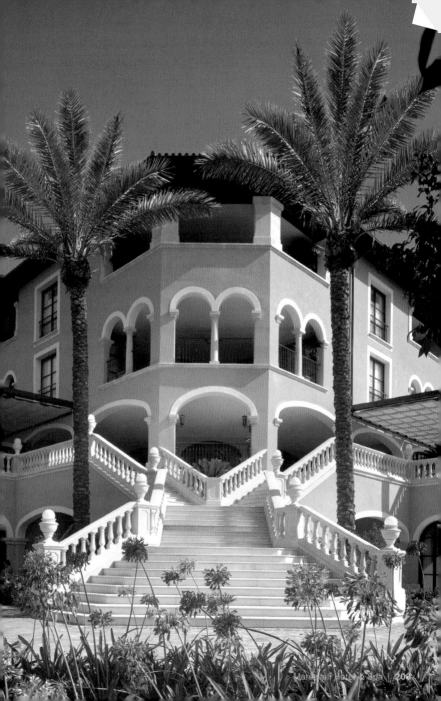

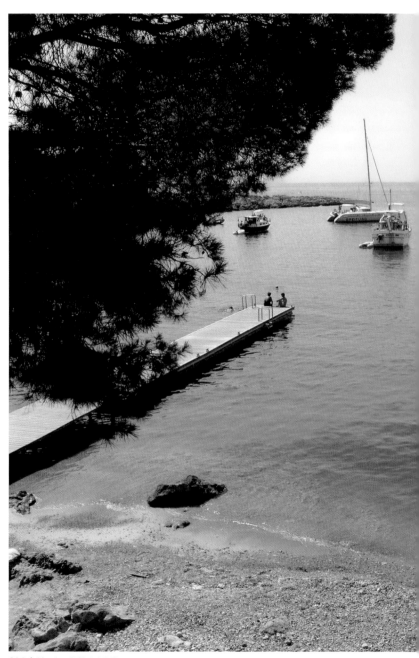

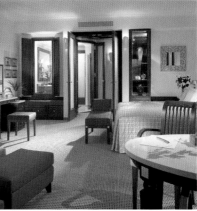

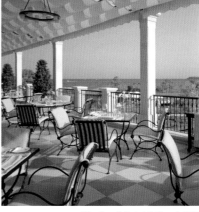

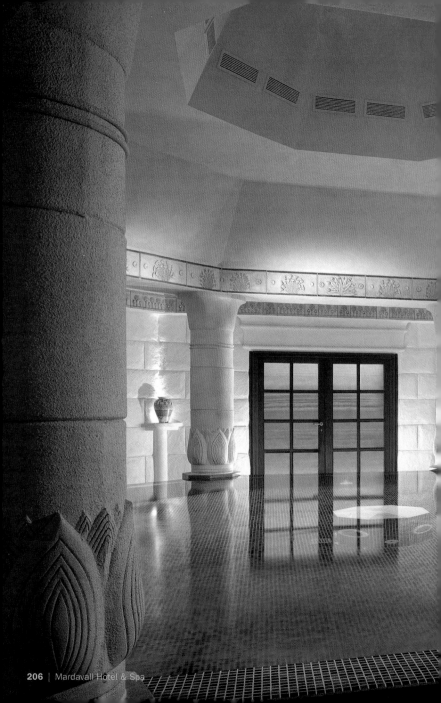

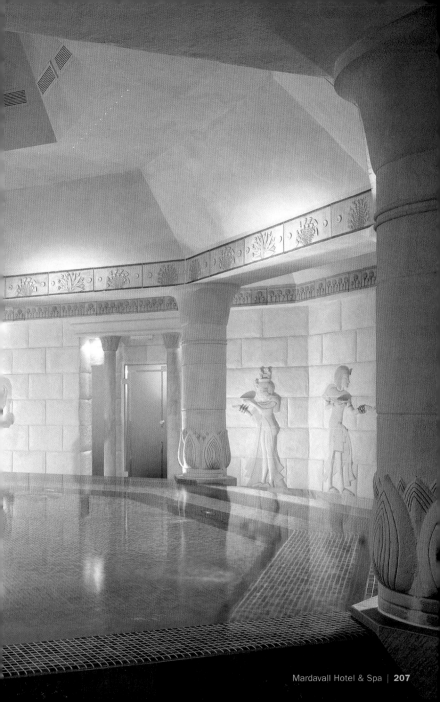

Choupana Hills

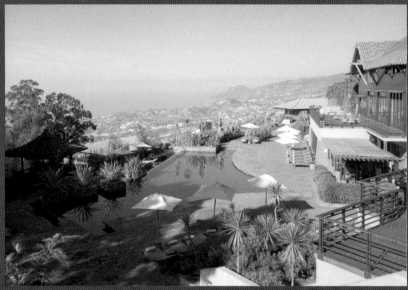

Address:	Travessa do Largo da Choupana
	9060 – 348 Madeira, Portugal
Phone:	+351 291 206 020
Fax:	+351 291 206 021
Website:	www.choupanahills.com
Located:	On a verdant hillside overlooking the bay of Funchal and the Atlantic Ocean
Style:	Contemporary design with exotic influences
Family & kids tips:	Family bungalows, children's menu, babysitting and baby listening service, child car seats available, water heater, baby chains and cots
Special features:	Restaurant, bar, pool, hammam, sauna
Rooms:	58 deluxe rooms, 4 suites and 3 family bungalows
Opening date:	2002

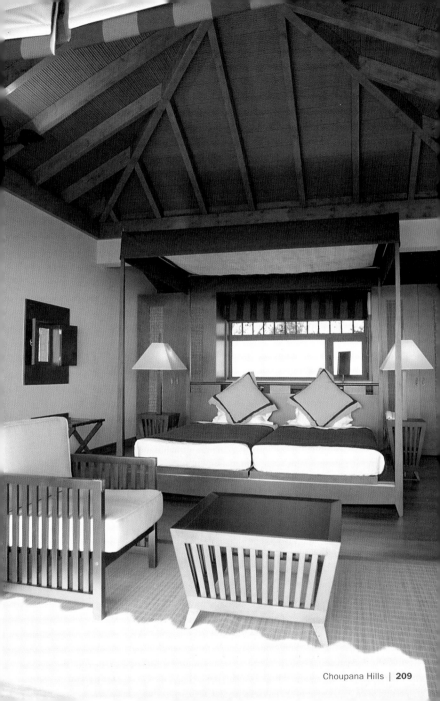

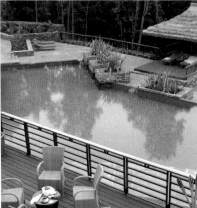

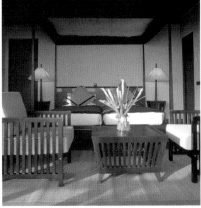

Almyra

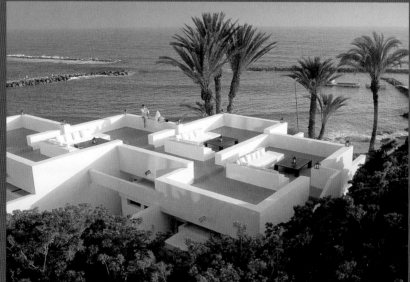

Address: Poseidonos Avenue
8042 Paphos, Cyprus
Phone: +357 26 888 700
Fax: +357 26 942 818
Website: www.thanoshotels.com

Located: Directly on the beach, guests have the advantage of direct access to extensively landscaped gardens and the sea, while also being within walking distance of the shops, castle, the house of Dionysos with its unparalleled Roman mosaics and many other attractions in and around the Paphos area
Style: Contemporary design
Family & kids tips: Children's playroom and playground, babysitting, Smiling Dolphin Kiddies' Club, Crèche
Special features: Restaurants, bars, freshwater pool especially for children
Rooms: 158

Opening date: 1972, renovated 2003

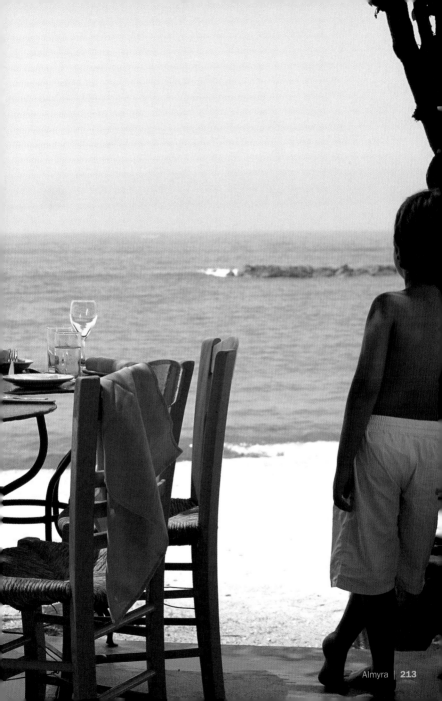

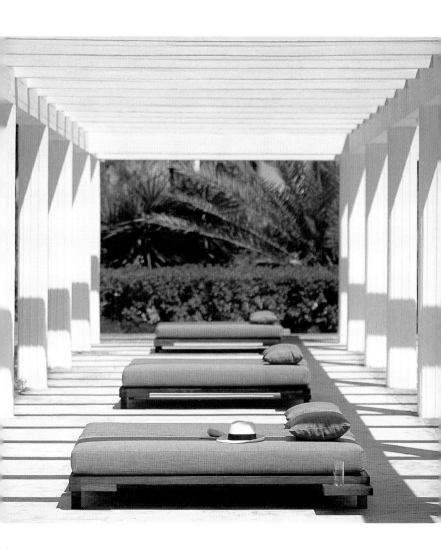

The Annabelle

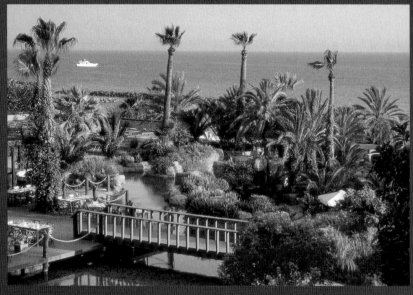

Address:	P.O. Box 60401
	8102 Paphos, Cyprus
Phone:	+357 26 938 333
Fax:	+357 26 945 502
Website:	www.theannabellehotel.com
Located:	Directly on the beach a few minutes from the old harbor
Style:	Classical
Family & kids tips:	Smiling Dolphin Children's Club, babysitting upon request, children's meals available, children's animator available in seasonal periods, folkloric shows
Special features:	4 restaurants, bars, barbecues, pools, tropical gardens, gym
Rooms:	218
Opening date:	1985

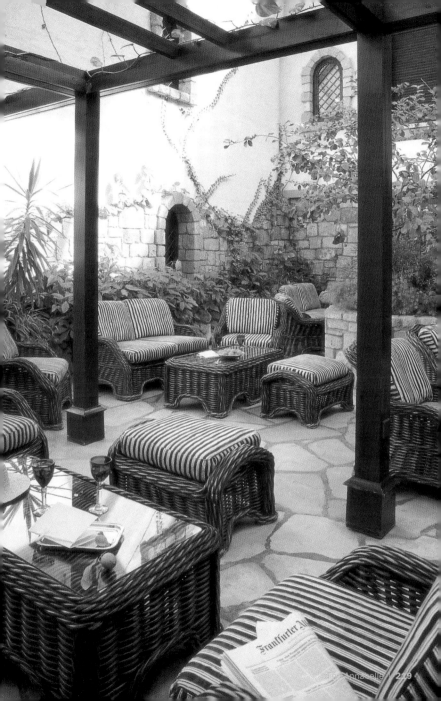

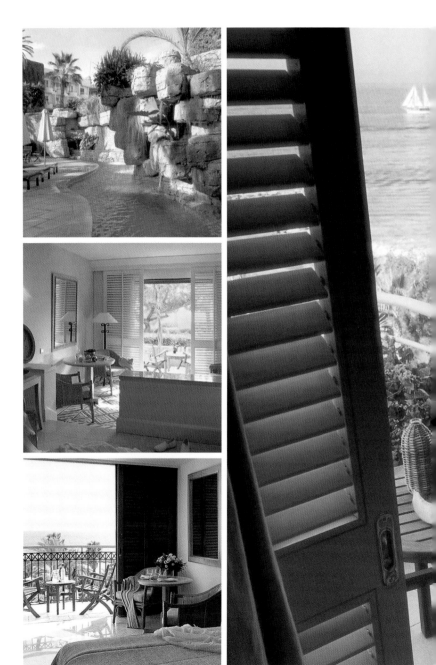

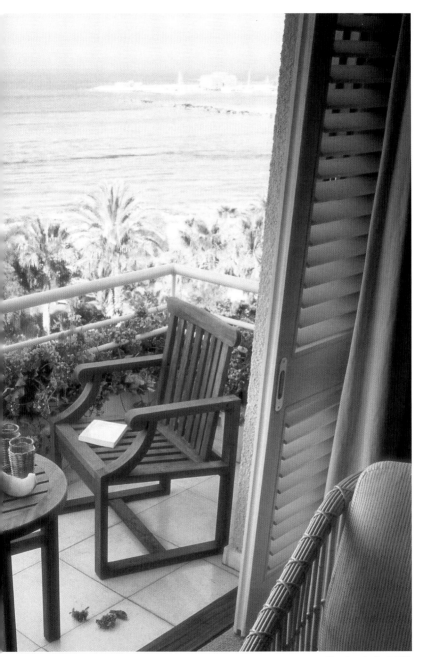

Mykonos Theoxenia

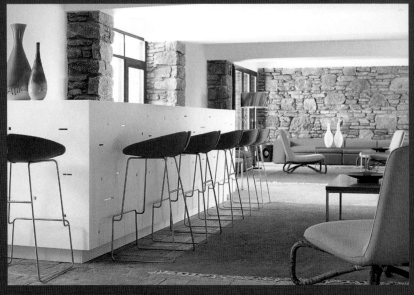

Address: Kato Milli
84600 Mykonos, Greece
Phone: +30 22890 22 230
Fax: +30 22890 23 008
Website: www.mykonostheoxenia.com

Located: On the cosmopolitan island of Mykonos
Style: Retro 1960s
Family & kids tips: Baby cots, baby chairs, babysitting service by experienced staff, baby meals can be arranged at the restaurant
Special features: Restaurant, bar
Rooms: 52 rooms

Opening date: 2007

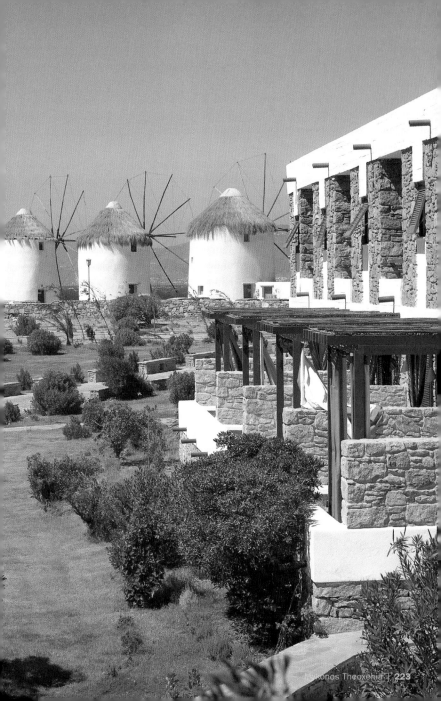

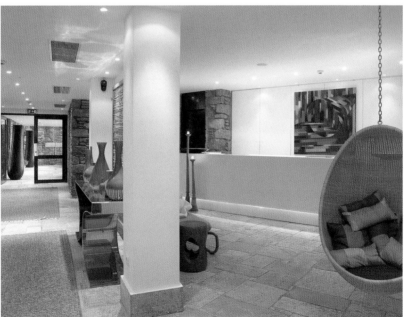

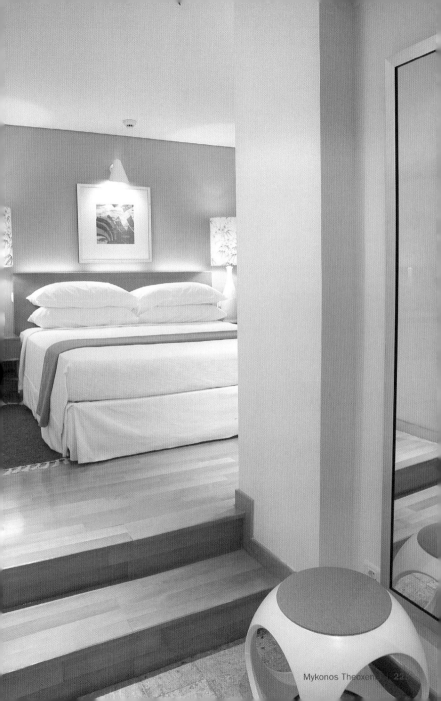

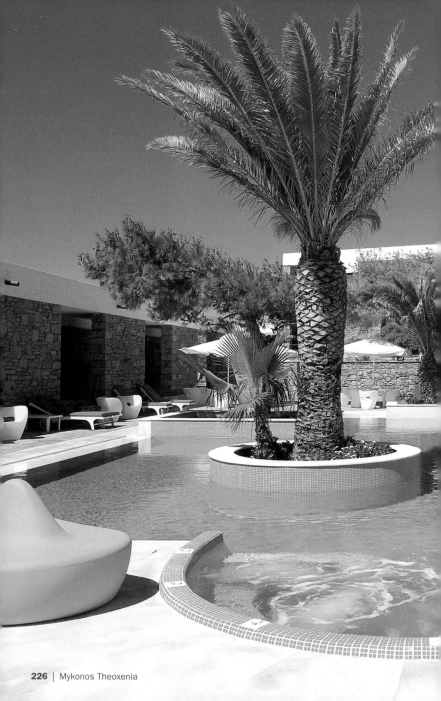

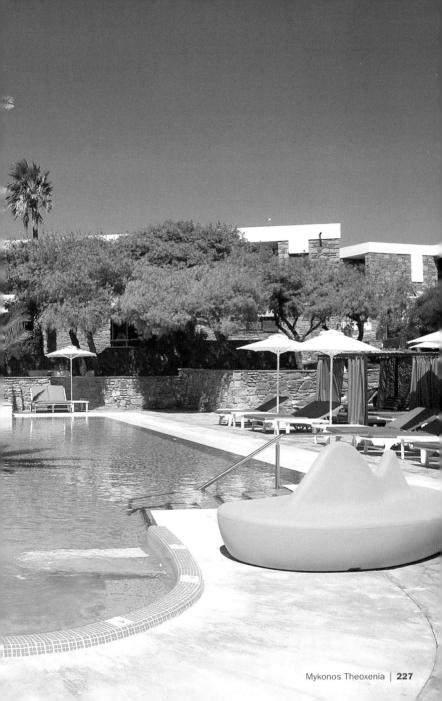

Porto Sani Village

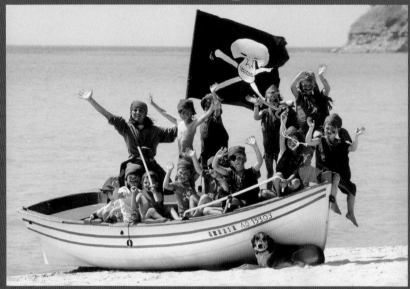

Address:	63077 Kassandra Chalkidiki, Greece
Phone:	+30 23740 99 500
Fax:	+30 23740 99 509
Website:	www.saniresort.gr

Located:	Around Sani Marina part of the Sani Resort
Style:	Mediterranean
Family & kids tips:	Melissa Miniclub & Crèche (from 4 months to 12 years), Teenagers' Club for teenagers 13 to 16 years, specially organized activities during high season, Babewatch program (30 minutes complimentary babysitting on the beach), children's pool, kids menu
Special features:	Dine Around program, The Spa Suite with indoor pool, jacuzzi, hammam, sauna and fitness studio, 2 restaurants: 1 à la carte gourmet restaurant, private beach awarded EU Blue Flag for cleanliness, free umbrellas and sun beds
Rooms:	113 rooms
Opening date:	1997

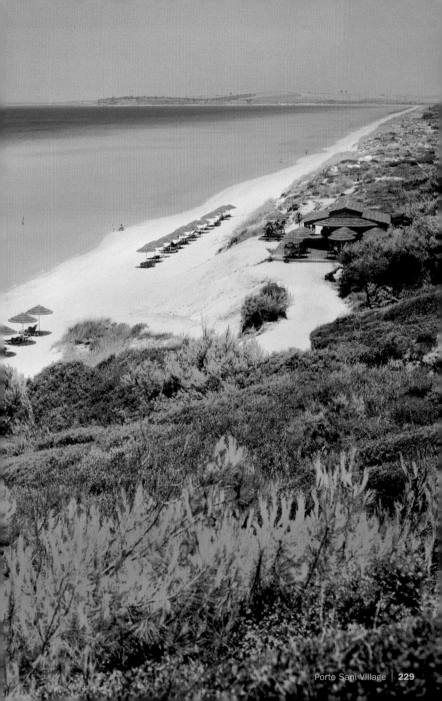

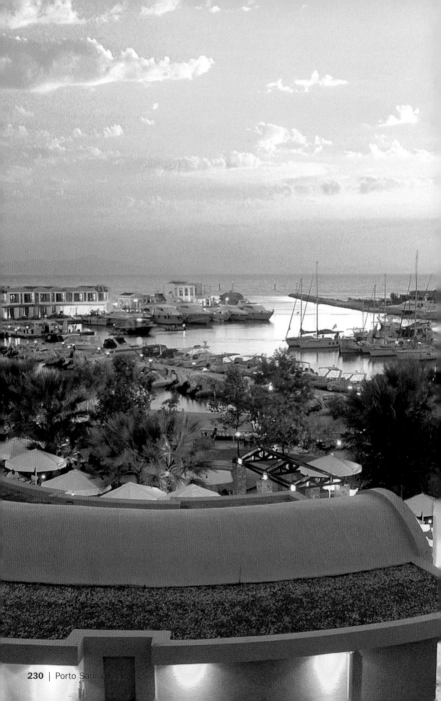

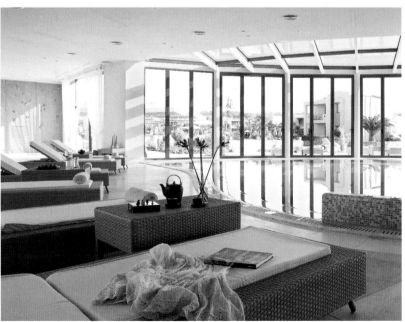

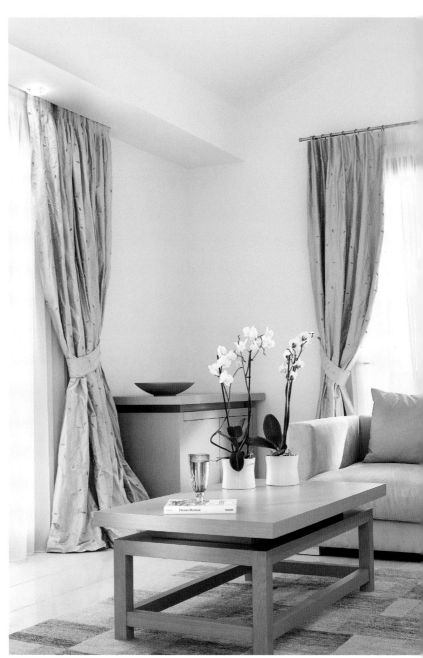

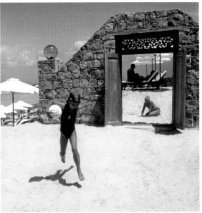

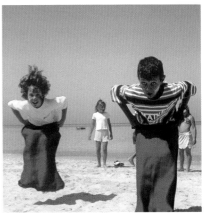

Club Orient Holiday Resort

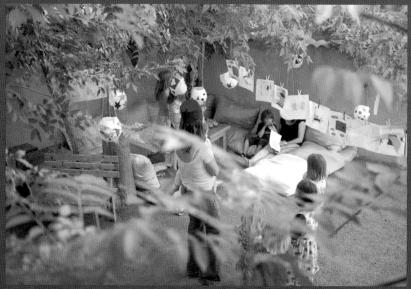

Address: Ören at the Bay of Edremit
10700 Ören-Burhaniye, Turkey
Phone: +90 266 416 3445
Fax: +90 266 416 4026
Website: www.cluborient.de

Located: At the Turkish west coast, directly at the Aegean Sea,
surrounded by famous antique sites, at the center
of the wide Bay of Edremit (Olive Riviera), just vis à
vis the Greek island of Lesbos
Style: Aegean style
Family & kids tips: Daily care, children's only dinner, mini club, children's
pool, beach with gradual slope into the sea
Special features: Table tennis/ping-pong, volleyball, tennis, canoes,
bikes and wonderful walking and jogging routes
Rooms: 60 rooms

Opening date: 1986

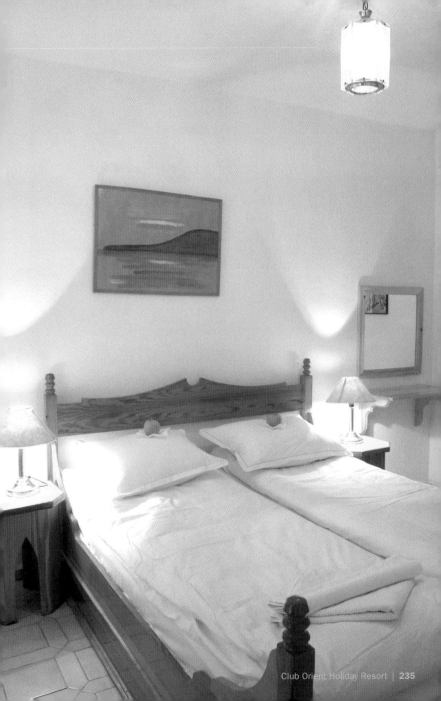

Hillside Beach Club

Address: Kalemya Koyu, P.O. Box 123
48300 Fethiye, Turkey
Phone: +90 252 614 8360
Fax: +90 252 614 1470
Website: www.hillsidebeachclub.com

Located: In the Kalemya bay, a 45-minute drive from Dalaman
International Airport and 4 km from the city center
of Fethiye
Style: Contemporary design
Family & kids tips: Kid Side for children aged 4 to 12 years, kids holiday
village with heated pool, small houses, bridges and
water playground, babysitting service, professional
multilingual staff for kids, baby phone
Special features: 3 restaurants, 9 bars, swimming pool, windsurfing,
catamaran, canouing, sailing, tennis, water polo,
tabletop soccer, extra room for handicrafts, archery,
internet café
Rooms: 330 rooms

Opening date: 1994

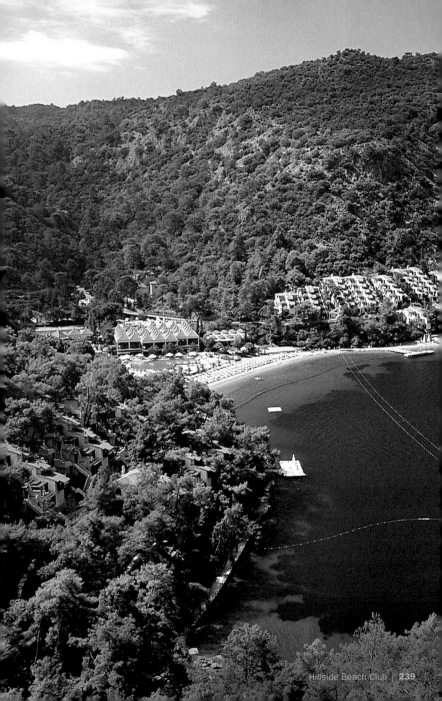

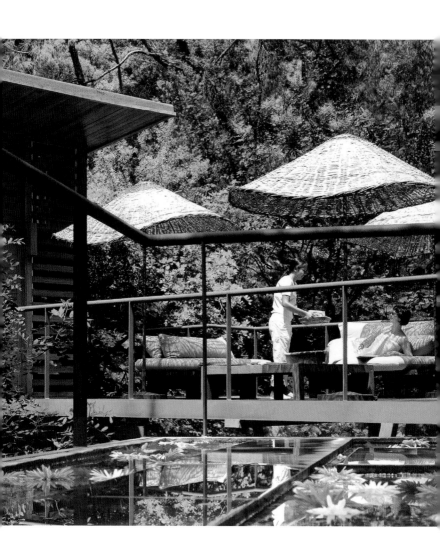

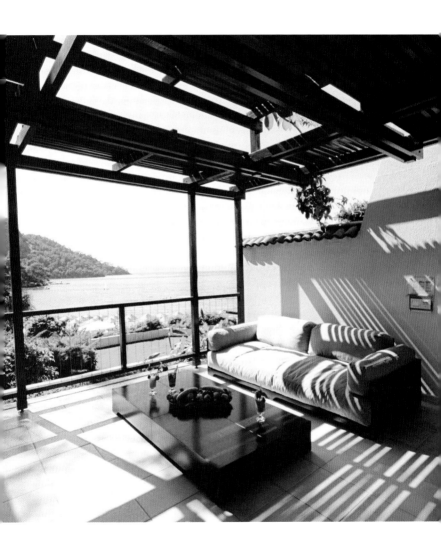

base2stay

Address: 25 Courtfield Gardens
London, SW5 0PG, United Kingdom
Phone: +44 20 7244 2255
Fax: +44 20 7244 2256
Website: www.base2stay.com

Located: In South Kensington, adjoining a quiet and charming central London garden square
Style: Budget boutique
Family & kids tips: Mini kitchen with microwave and fridge in all rooms, free Internet, fully air-conditioned rooms, flat screen television
Special features: Bunk beds, base directory of local attractions, restaurants and services
Rooms: 67 rooms

Opening date: 2006

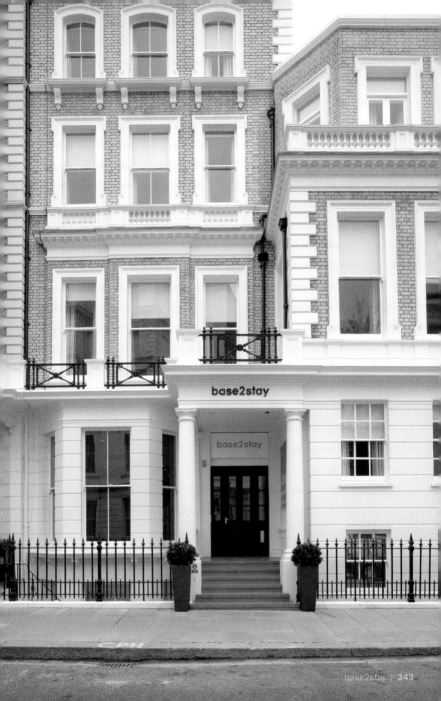

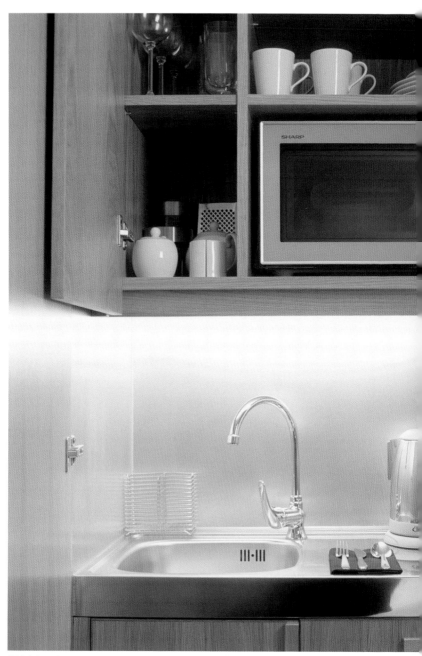

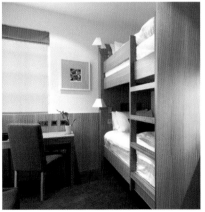

The Zetter

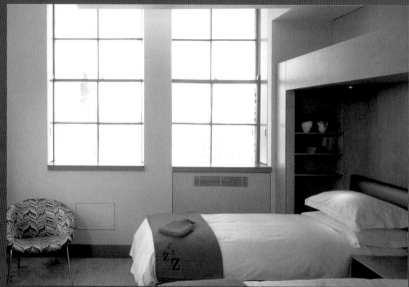

Address: St. John's Square, 86–88 Clerkenwell Road
London, EC1M 5RJ, United Kingdom
Phone: +44 20 7324 4444
Fax: +44 20 7324 4445
Website: www.thezetter.com

Located: 10-minute taxi ride away from the West End
Style: Modern contemporary
Family & kids tips: Babysitting services, menus for children, baby cots upon request, family rooms (interconnecting and adjoining)
Special features: Restaurant for 90 persons, bar, 2 private party rooms
Rooms: 59

Opening date: 2004

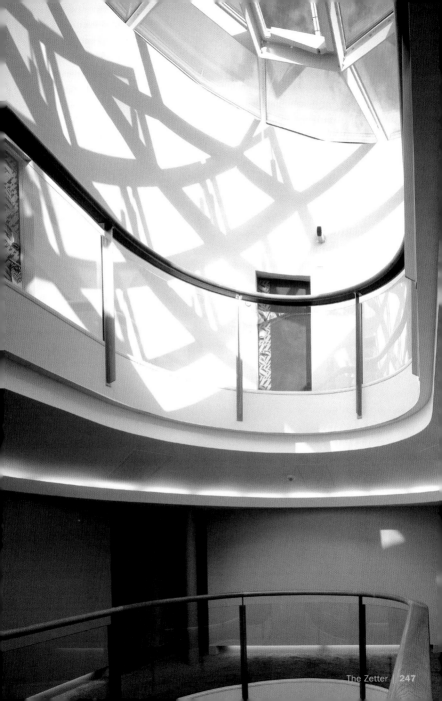

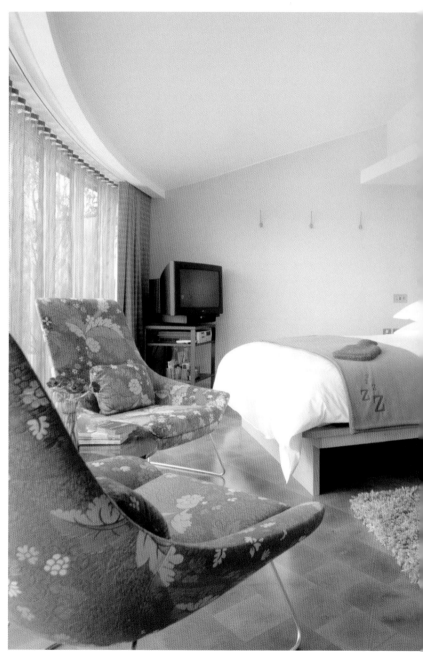

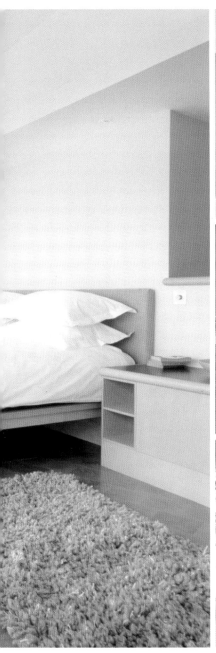

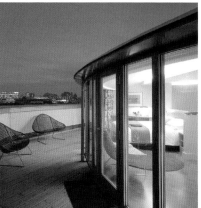

Africa & Middle East

Morocco
United Arab Emirates
Sultanate of Oman
Mauritius
South Africa
Tanzania
Namibia
Kenya
Seychelles

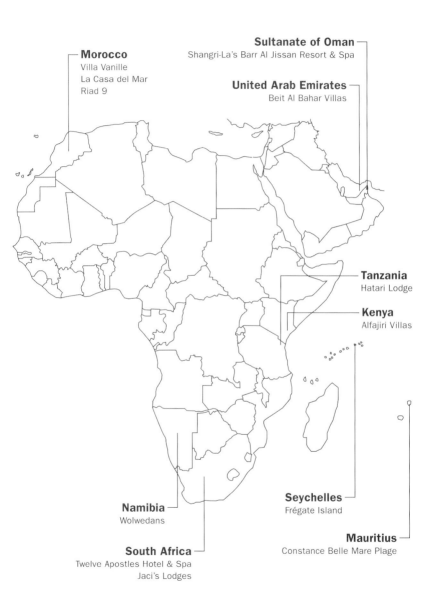

Morocco
Villa Vanille
La Casa del Mar
Riad 9

Sultanate of Oman ─
Shangri-La's Barr Al Jissan Resort & Spa

United Arab Emirates ─
Beit Al Bahar Villas

Tanzania
Hatari Lodge

Kenya
Alfajiri Villas

Namibia ─
Wolwedans

Seychelles ─
Frégate Island

South Africa ─
Twelve Apostles Hotel & Spa
Jaci's Lodges

Mauritius ─
Constance Belle Mare Plage

Villa Vanille

Address: Douar Bellaaguid
40000 Marrakech, Morocco
Phone: +21 22 431 0123
Fax: +21 22 431 0123
Website: www.villavanille.com

Located: In the heart of a vast garden in the "Palmeraie" of Marrakech
Style: Moroccan luxury and contemporary
Family & kids tips: Exterior games for children, board games, baby cot available, babysitting, house adapted to children
Special features: 2 pools, one of them heated and 200 square meters, hammam, gym, massage
Rooms: 5 family suites and 2 rooms for up to 24 people total

Opening date: 2004

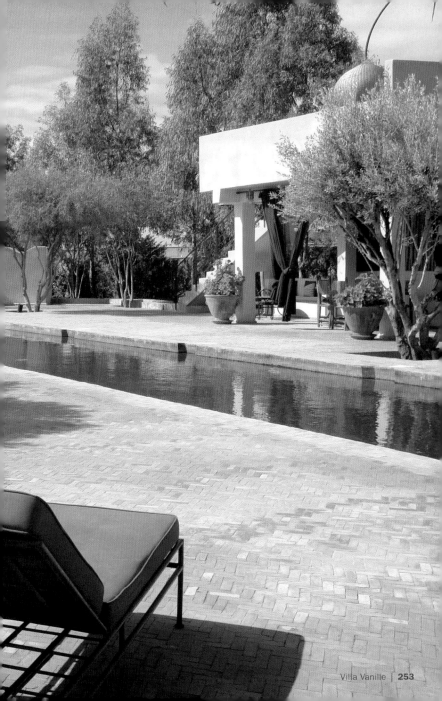

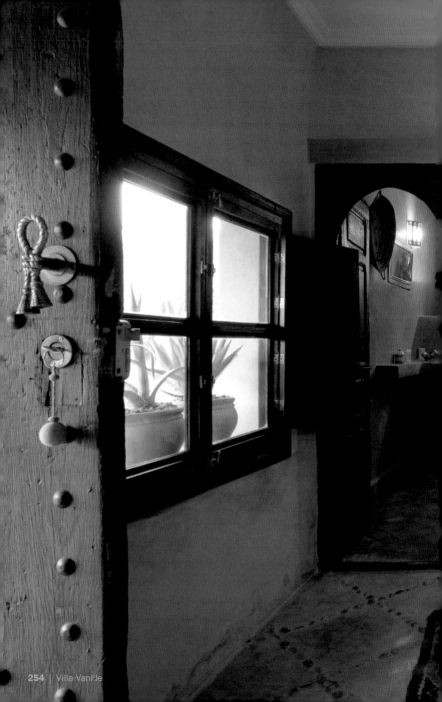

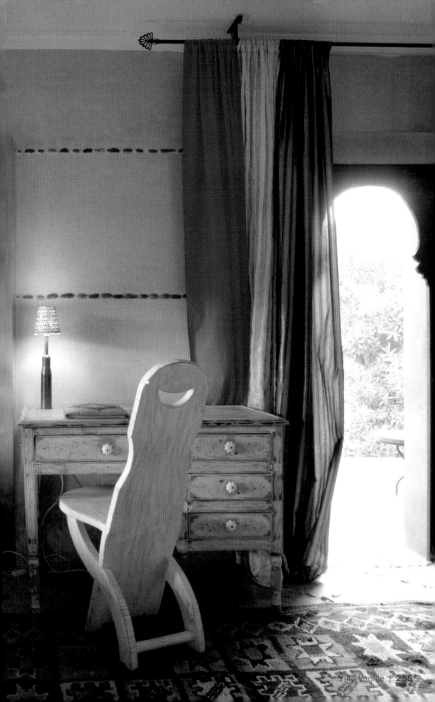

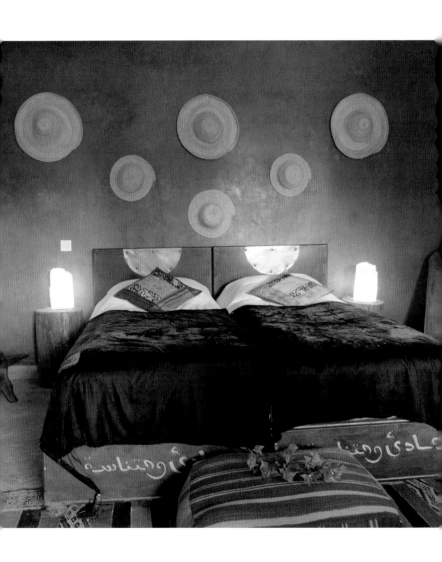

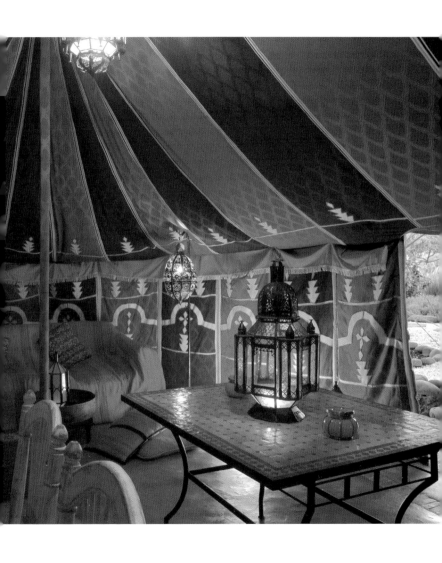

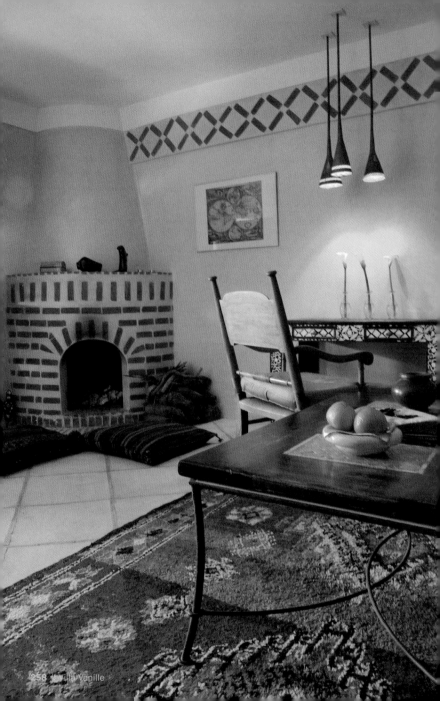

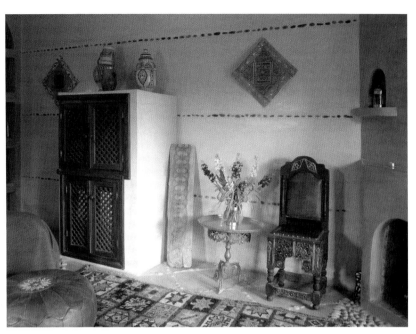

La Casa del Mar

Address: 35 Rue d'Oujda
44000 Essaouira, Morocco
Phone: +212 24 475 091
Fax: +212 24 475 091
Website: www.lacasa-delmar.com

Located: Situated overlooking the Atlantic Ocean in a quiet area of the medina
Style: African modern
Family & kids tips: Bicycle hire, camel rides, horse riding, guided walks, henna tattoos, children under 4 years of age stay free, nanny service, kids menu
Special features: Bed & breakfast, dinner on request, lounge with fireplace, patio, rooftop, massages, kite and wind surf classes or equipment hire, sky surf
Rooms: 5 spacious rooms with living room corners

Opening date: 2001

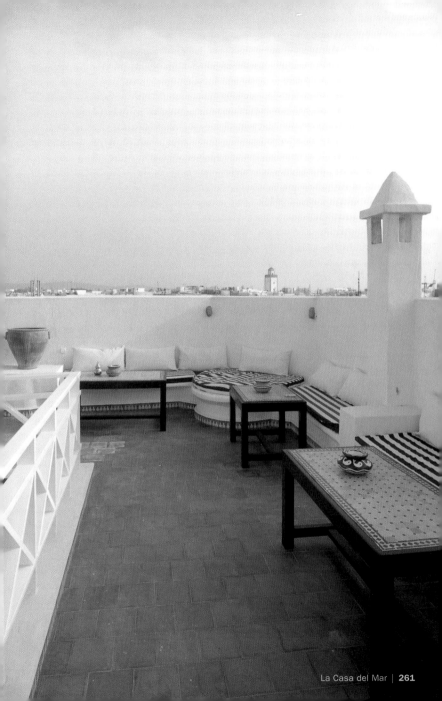

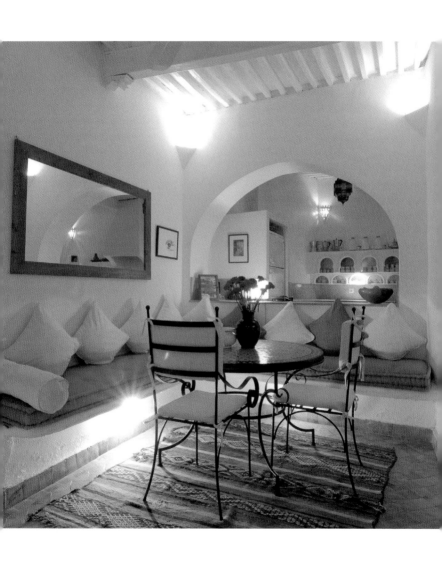

Riad 9

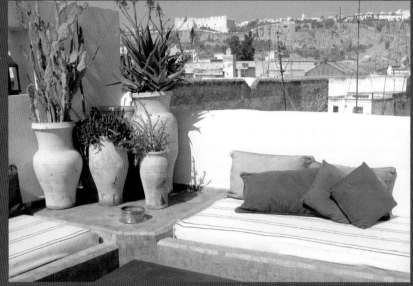

Address:	9 Derb el Masid
	30000 Fès, Morocco
Phone:	+212 35 634 045
Website:	www.riad9.com
Located:	In the medina of Fès, overlooking the town, UNESCO-protected
Style:	18th century riad restored and finished with Asian, French and English antiques, modern European design
Family & kids tips:	Ideal place for dicovering the medina with its different handcraft areas, individual service, the riad features a small collection of pets
Special features:	Tastefully decorated riad in the medina, Japanese dining area, traditional fresh food (guests only)
Rooms:	3 suites, 2 lounges, rooftop
Opening date:	2006

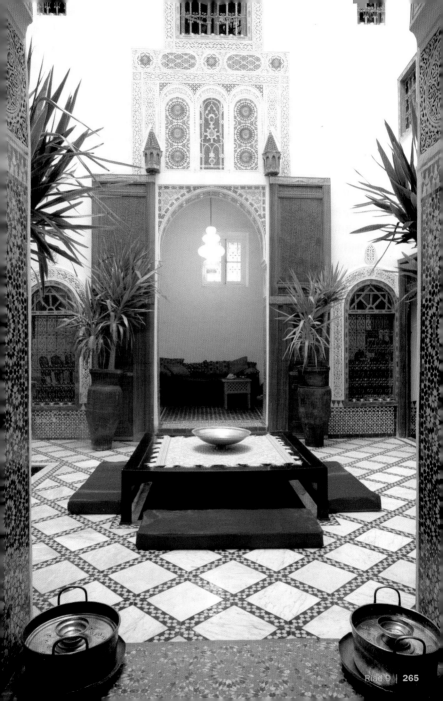

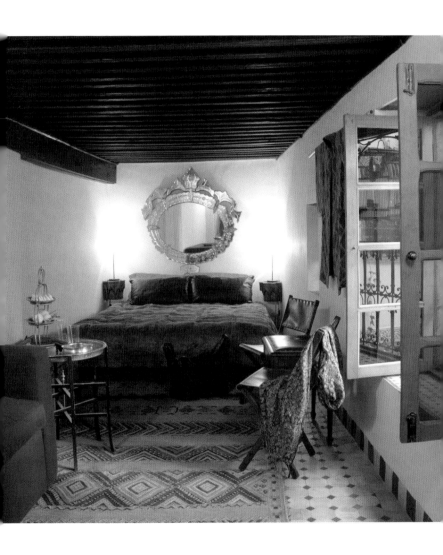

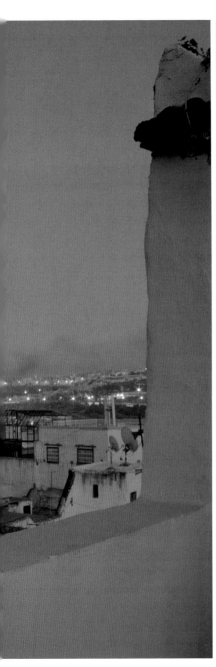

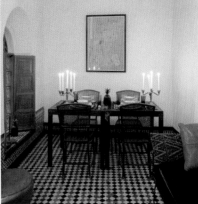

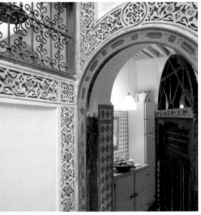

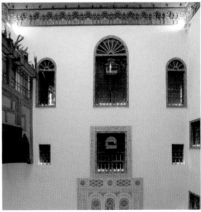

Beit Al Bahar Villas

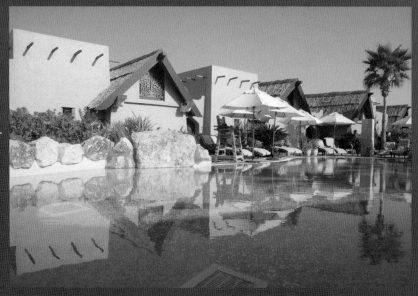

Address:	P.O. Box 11413
	Dubai, United Arab Emirates
Phone:	+971 4 348 0000
Fax:	+971 4 301 6800
Website:	www.jumeirah.com
Located:	At the Jumeirah Beach Hotel
Style:	Luxurious Arabian villas
Family & kids tips:	Sindbad's Kids Club, babysitting services, family pool, unlimited complimentary access to Wild Wadi Waterpark
Special features:	Over 20 restaurants and bars, gym, health suite, jacuzzi, sauna, 6 tennis courts, 1 multi court, 3 squash courts, 5 swimming pools, watersports, private beach, PADI Gold Palm, 5 star resort and National Geographic Dive Center, golf
Rooms:	19 villas
Opening date:	1999

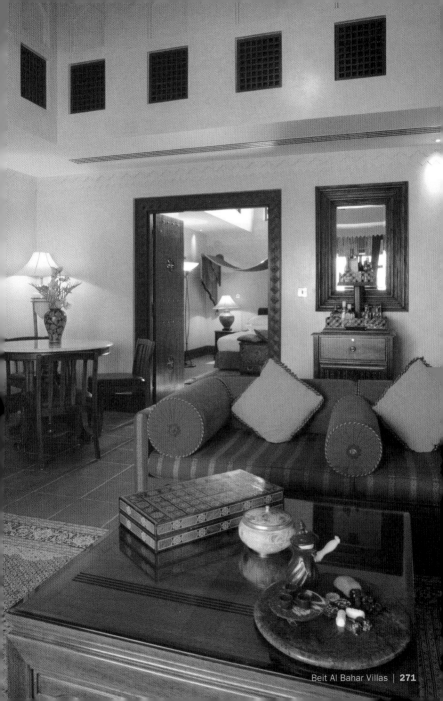

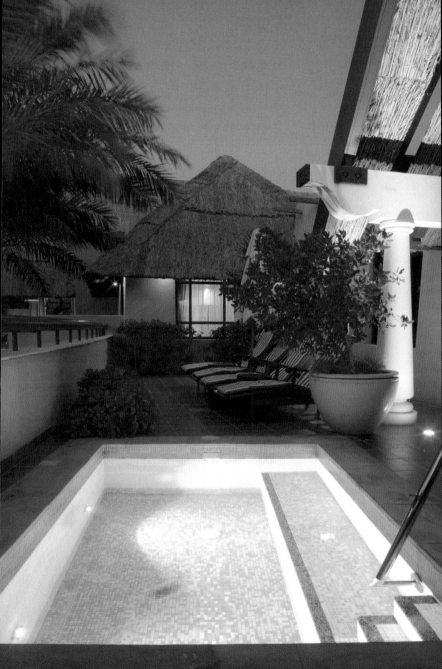

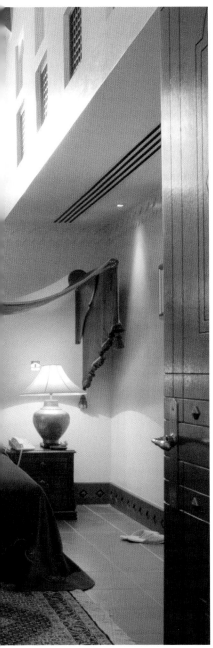
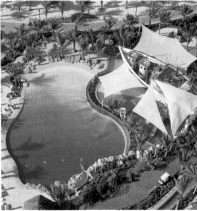
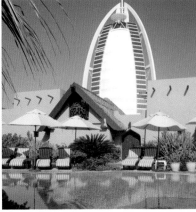

Shangri-La's Barr Al Jissah Resort & Spa

Address: P.O. Box 644, Postcode 113
Muscat, Sultanate of Oman
Phone: +968 2477 66 66
Fax: +968 2477 66 77
Website: www.shangri-la.com

Located: Between a backdrop of mountains and the waters of the Gulf of Oman Shangri-La's Barr Al Jissah Resort & Spa is home of three hotels
Style: Contemporary design
Family & kids tips: Little Turtles Kids Club, children's pool, games such as Treasure Hunt, henna painting, sand city competition, children can play in our safe, supervised environments, whilst parents relax and enjoy their own time together, lazy river
Special features: 19 restaurants, bars and lounges, CHI, the spa at Shangri-La is the largest and most luxuriously appointed spa in the Sultanate of Oman
Rooms: 690 rooms, 42 suites

Opening date: 2006

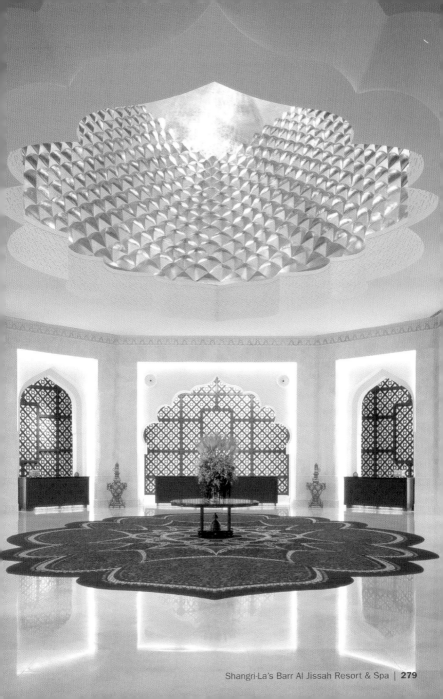

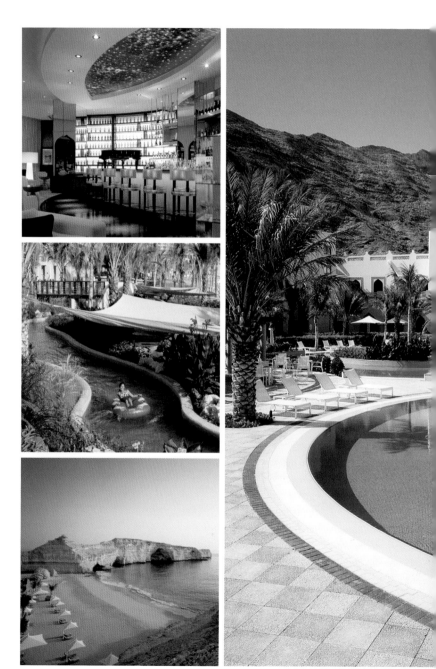

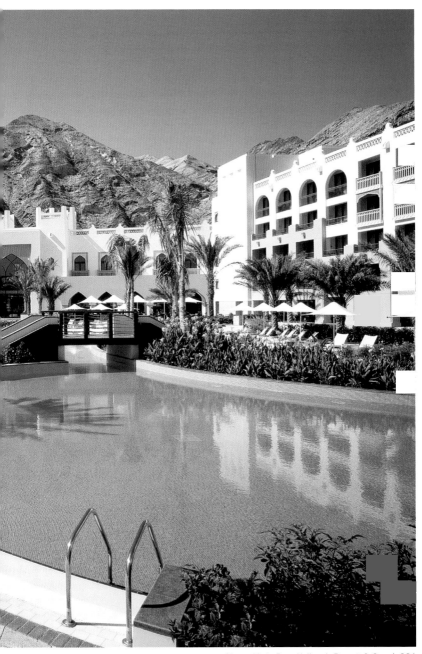

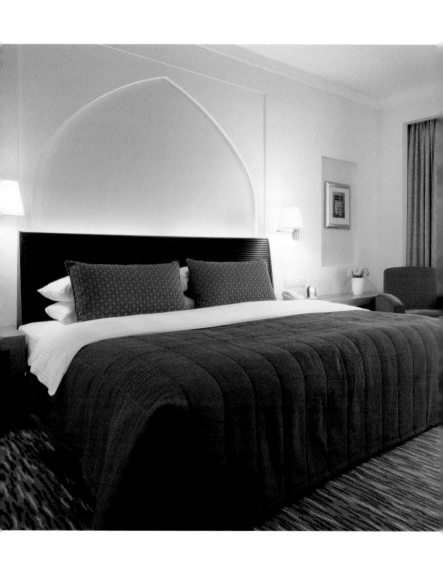

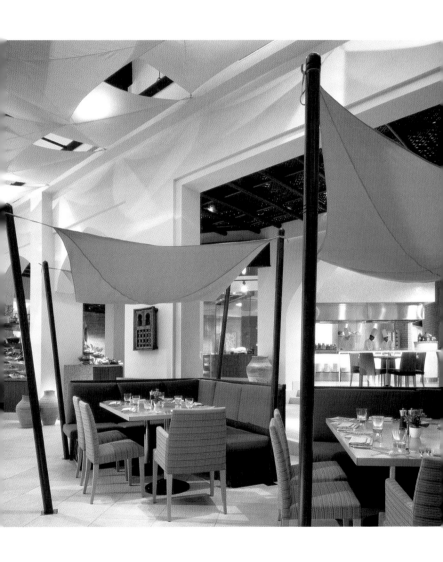

Constance Belle Mare Plage

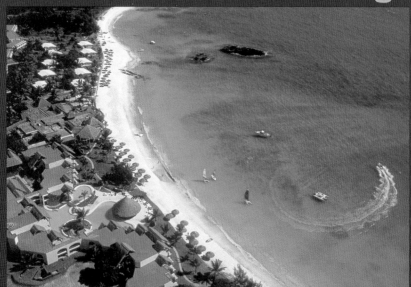

Address:	Poste de Flacq Belle Mare, Mauritius
Phone:	+230 402 26 00
Fax:	+230 402 26 16
Website:	www.bellemareplagehotel.com
Located:	The resort is situated directly on a 2 km long white sandy beach, set in tropical gardens of almost 15 hectares
Style:	Contemporary design
Family & kids tips:	Kakoo Club for children aged between 4 and 12 years with games room and a playground, indoor and outdoor activities are organized daily under supervision, dinner in buffet style available for children, babysitting facilities available on request
Special features:	7 restaurants and bars, 4 pools, fitness center, golf club, two 18-hole golf courses, tennis club, Shiseido Spa "Le Spa de Constance"
Rooms:	235 rooms and suites, 21 villas
Opening date:	2001

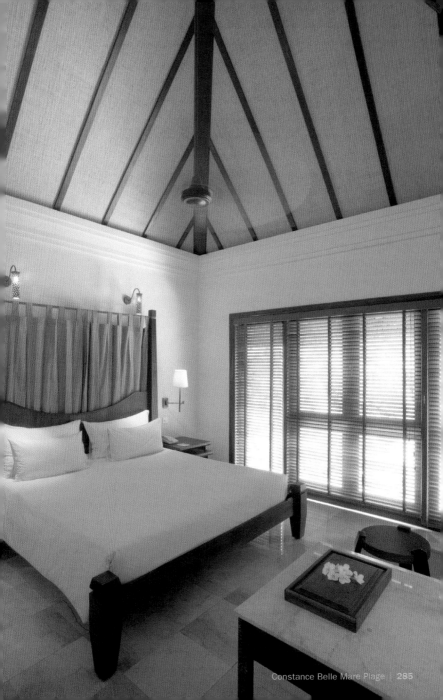

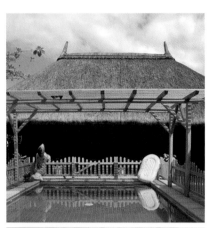

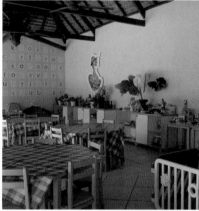

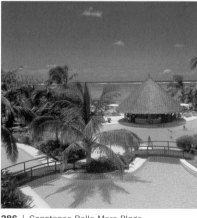

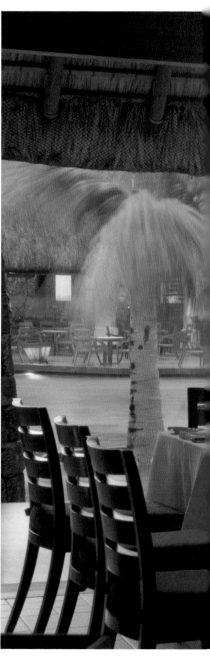

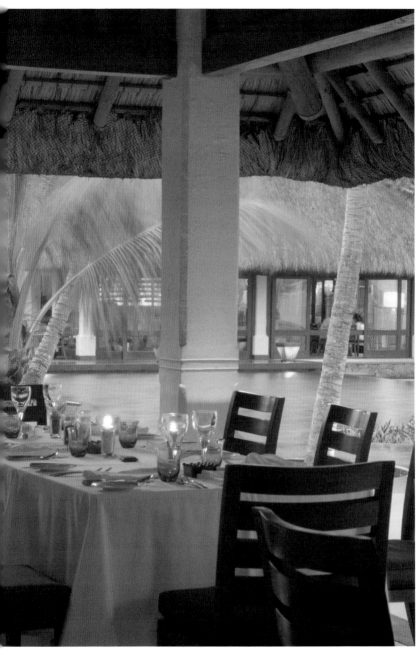

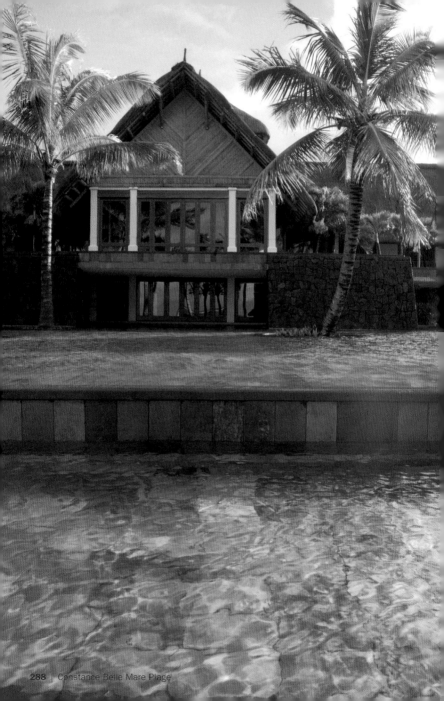

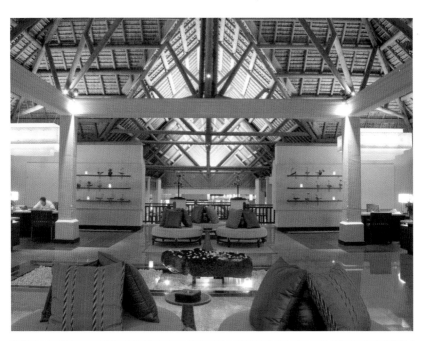

Twelve Apostles Hotel & Spa

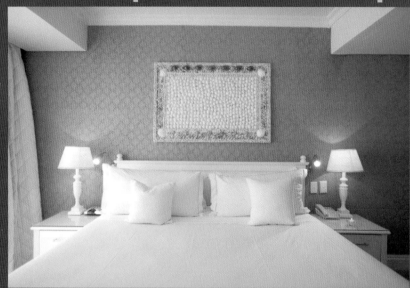

Address:	Victoria Road, Camps Bay
	8040 Cape Town, South Africa
Phone:	+27 21 437 9000
Fax:	+27 21 437 9055
Website:	www.12apostleshotel.com
Located:	Few minutes drive away from the city center of Cape Town in the suburbs of Camps Bay at the edge of the ocean
Style:	Classic-contemporary
Family & kids tips:	Tickets to the aquarium at the waterfront, a basket of toys to play with while you stay, free in-room movies from the hotel's collection, 3-hour babysitting
Special features:	Restaurant, bar, 16-seater cinema
Rooms:	55 deluxe guestrooms and 15 luxurious suites
Opening date:	2002

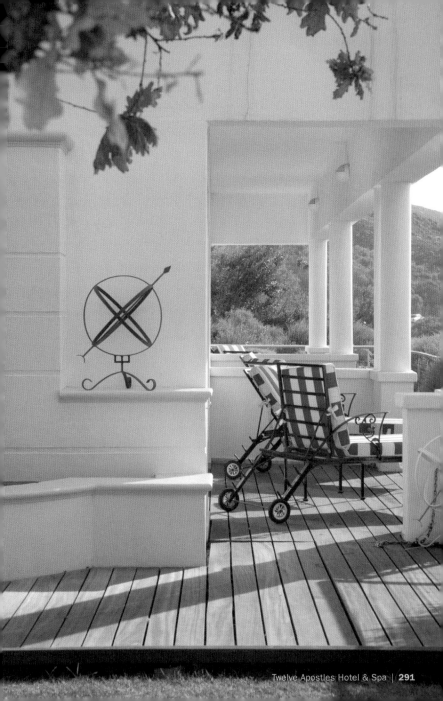

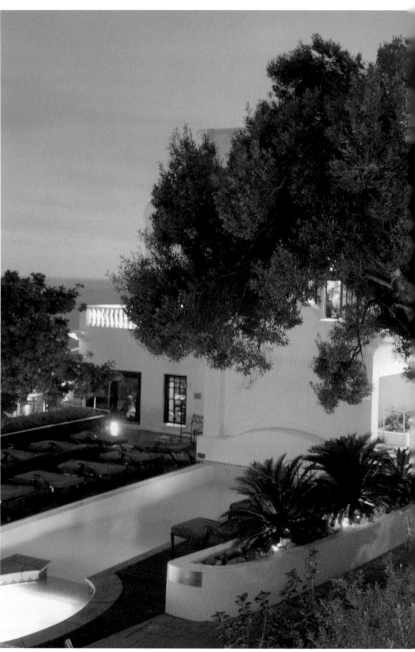

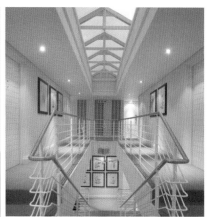
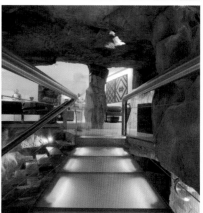
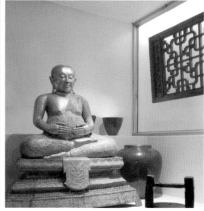

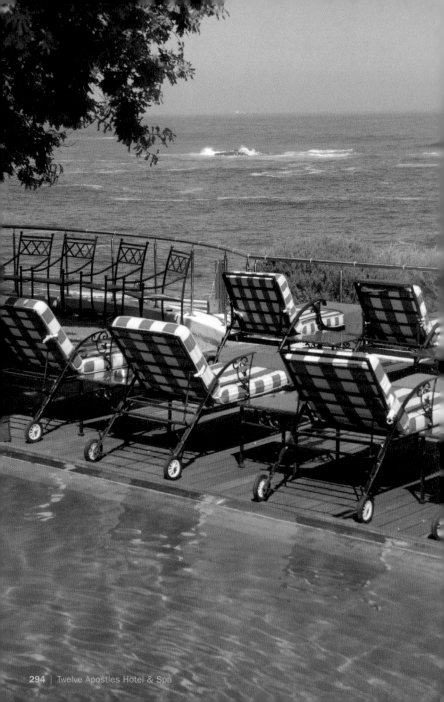

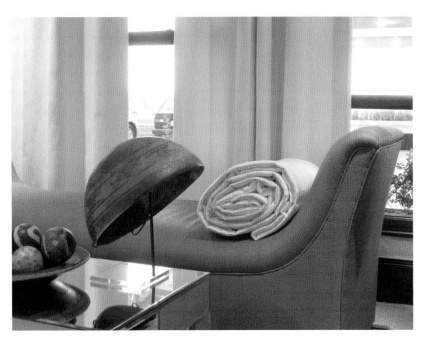

Jaci's Lodges

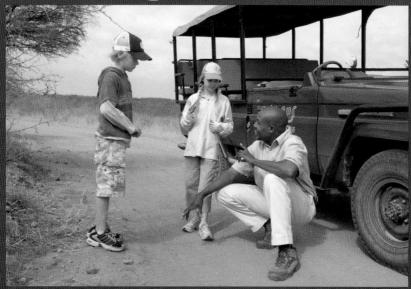

Address: Madikwe Game Reserve
Molatedi Village, South Africa
Phone: +27 14 778 9900/1
Fax: +27 14 778 9901
Website: www.madikwe.com

Located: Situated in the malaria-free Madikwe Game Reserve in the far north of South Africa, adjacent to the Botswana border
Style: Safari style
Family & kids tips: Babysitting service and special kiddies "jungle drive", children of all ages are welcome, babysitting is provided while parents are on game drives or enjoying their evening meal
Special features: Spacious lounge and open plan dining area with uninterrupted views of the bush, boma
Rooms: 8 double canvas and stone rooms

Opening date: 2002

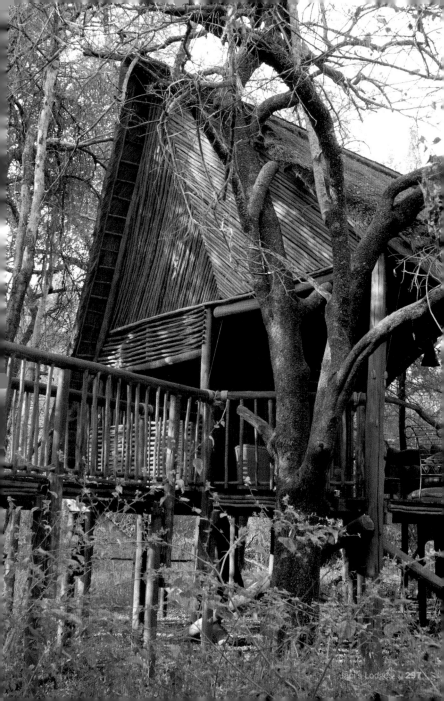

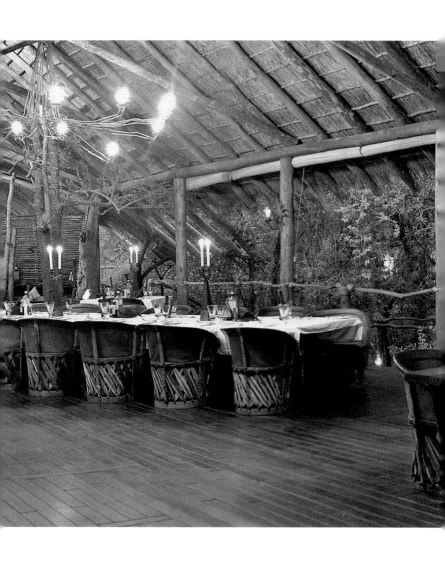

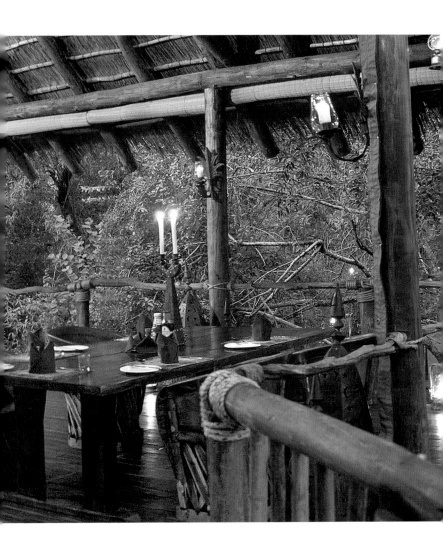

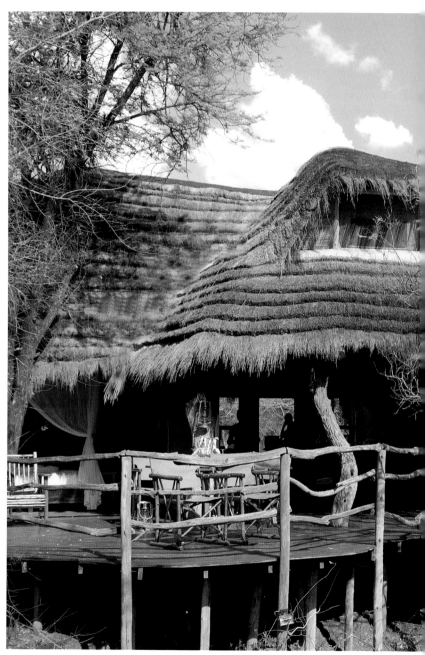

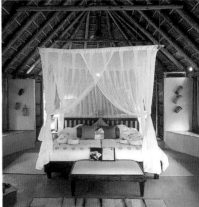

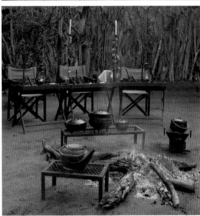

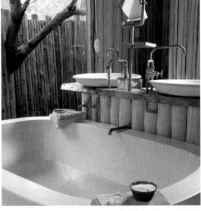

Hatari Lodge

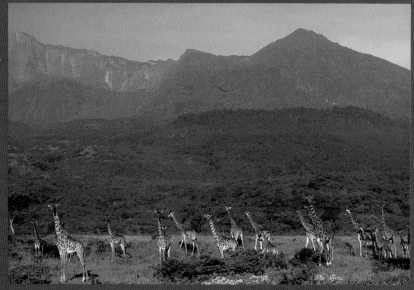

Address:	Hatari Lodge inside Arusha National Park Momella, Tanzania
Phone:	+255 27 255 3456
Fax:	+255 27 255 3456
Website:	www.hatarilodge.com
Located:	On the foot of Mt. Meru, beyond Kilimandjaro at the northern edge of Arusha National Park
Style:	African Modern Retro
Family & kids tips:	Medicinal plant trail, Masai visit, Mt. Meru Crater walk, canoeing on Little Momella, Masai game walk, various safaris to the Masai Savannah, night game drives, individual care, excursions
Special features:	Living and dining room, open fireplace, breakfast terrace, bar, library and wooden walkway for game viewing
Rooms:	9 rooms
Opening date:	2004

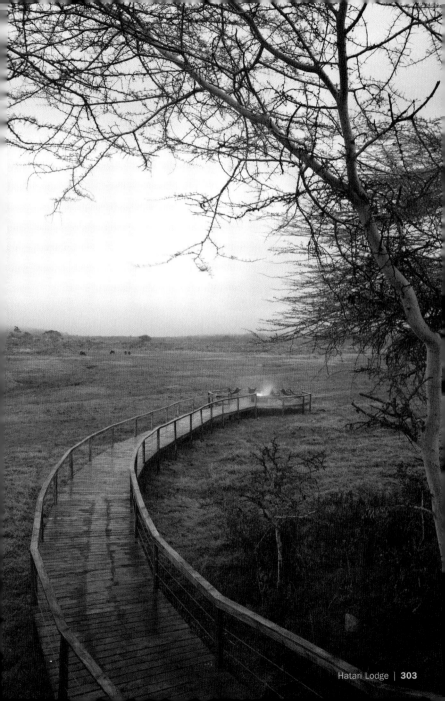

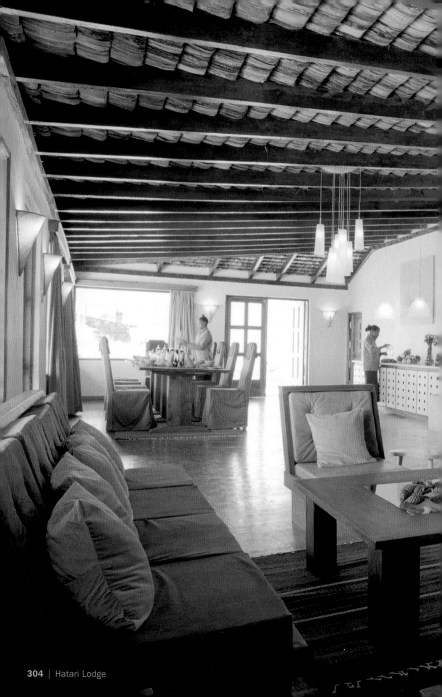

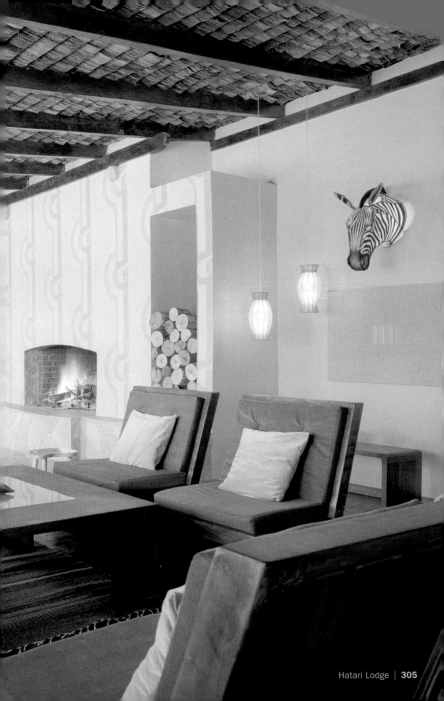

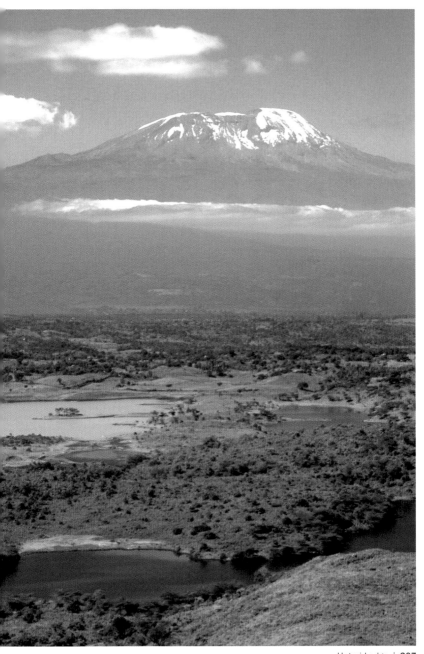

Wolwedans

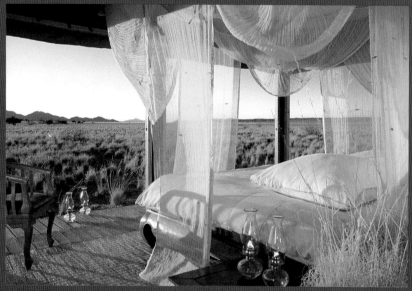

Address:	NamibRand Nature Reserve, Namibia
Phone:	+264 61 230 616
Fax:	+264 61 220 102
Email:	info@wolwedans.com.na
Website:	www.wolwedans.com
Located:	In the heart of NamibRand Nature Reserve, 60 km south of Sossusvlei
Style:	Classic safari chic
Family & kids tips:	Intimate atmosphere, unperilous adventure of nature, malaria free, Namib Desert Environment Education Trust nearby offering programs for children (www.nadeet.org)
Special features:	Hot-air ballooning, dune boarding, Private Camp and Dune Camp appropiate to families
Rooms:	Private Camp: on the edge of a 250 meter high dune, intimate atmosphere, maximum 12 guests
	Dune Camp: 6 tents on wooden platforms, furnished with standard beds, veranda, private bathroom
Opening date:	1994

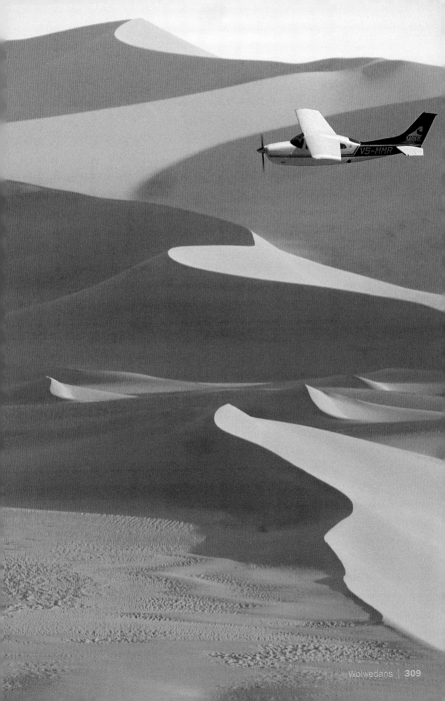

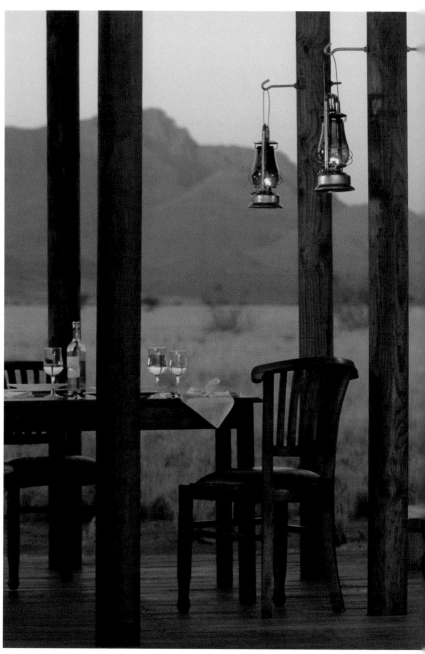

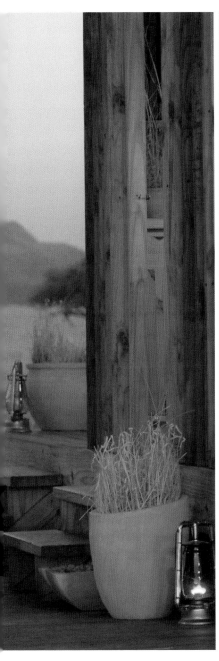

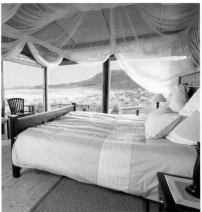
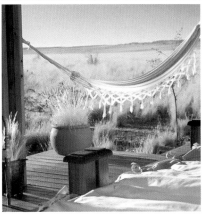

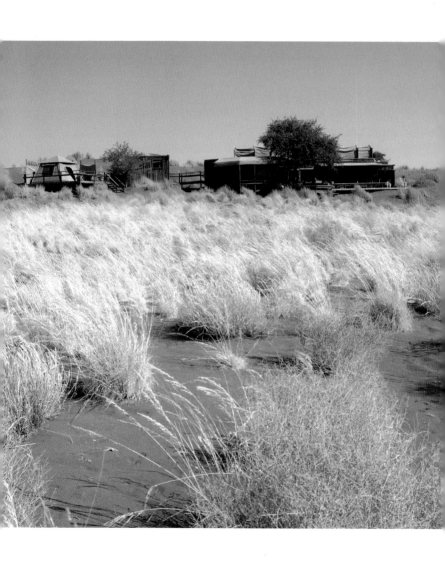

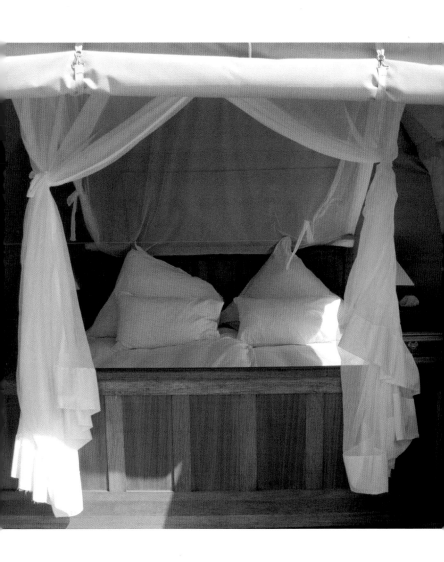

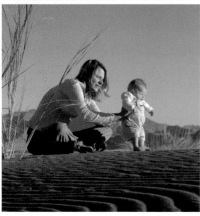

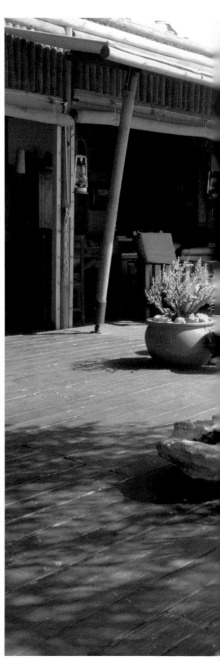

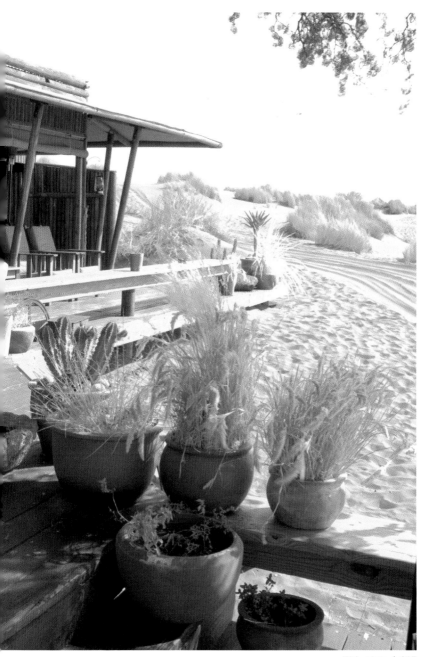

Alfajiri Villas

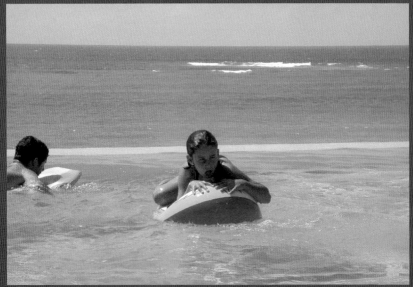

Address: Diani Beach
Diani Beach, Kenya
Phone: +254 403 202 630
Email: molinaro@africaonline.co.ke
Website: www.alfajirivillas.com

Located: Diani Beach
Style: Bright and airy Caribbean style
Family & kids tips: The house has been designed with children's need in mind. Two English speaking ayahs (nannies) available 24 hours a day. Games, TV and video. Alfajiri Cliff Villa is most suitable for families with small children and features absolute privacy.
Special features: Inclusive of 15 staff, all food and drinks, massage, and 18-hole golf course
Rooms: A total of 12 rooms in the 3 villas

Opening date: Cliff Villa 2000, Garden and Beach Villa 2004

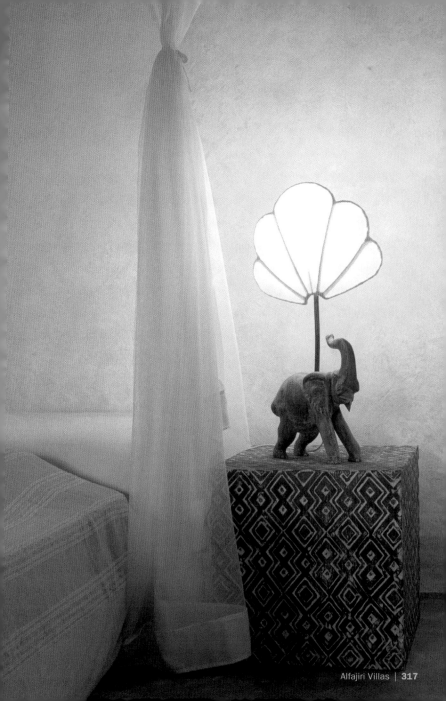

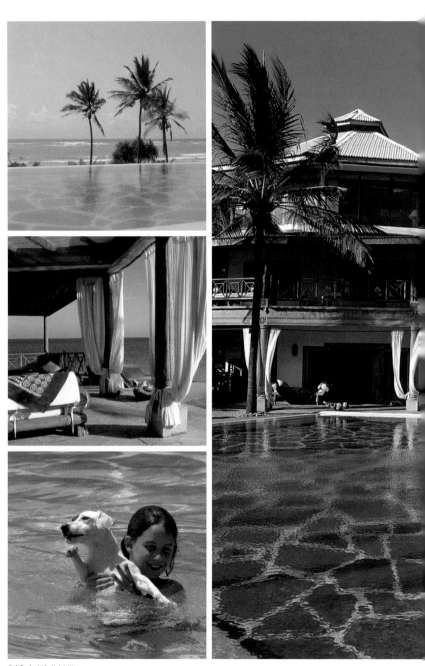

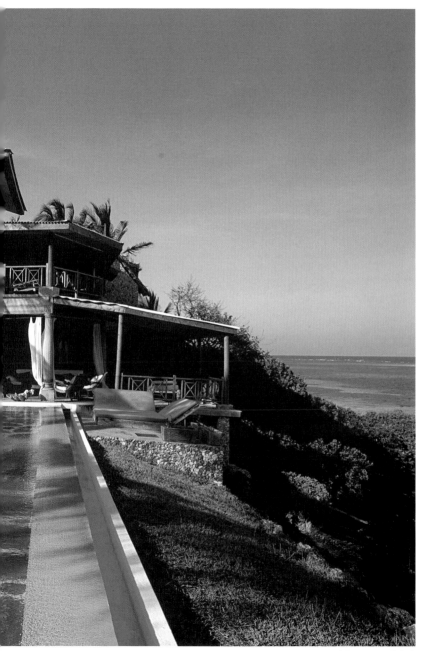

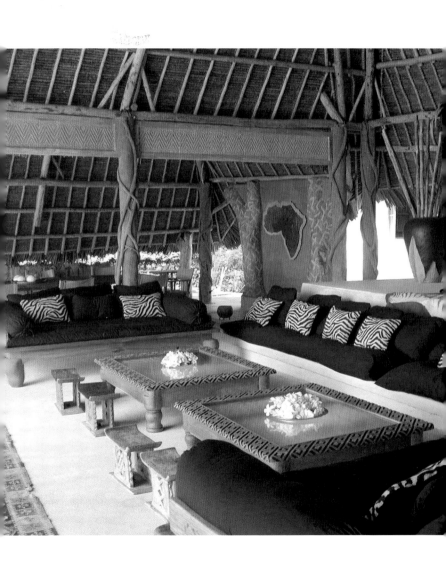

Frégate Island

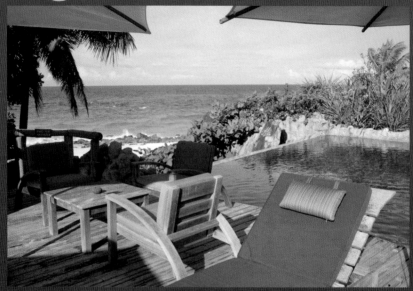

Address:	Frégate Island Private
	Frégate Island, Seychelles
Phone:	+49 69 8383 7635
Fax:	+49 69 8383 7636
Website:	www.fregate.com
Located:	20-minute flight from Mahé
Style:	Authentic Seychellois furniture
Family & kids tips:	Castaway Clubhouse, 2 villas nestled in private gardens for families with children
Special features:	2 restaurants, 2 bars, wine cellar, 7 beaches, 2 swimming pools, The Rock Spa & Sanctuary, fitness center, library, island museum, chapel, island marina, private butler, private island limited to max. 40 guests to protect the endemic wildlife (turtles, birds)
Rooms:	16 villas for a maximum of 40 guests
Opening date:	1998, Spa 2004

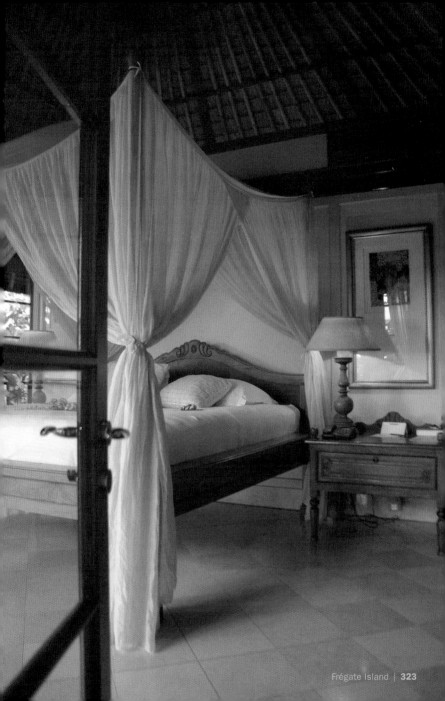

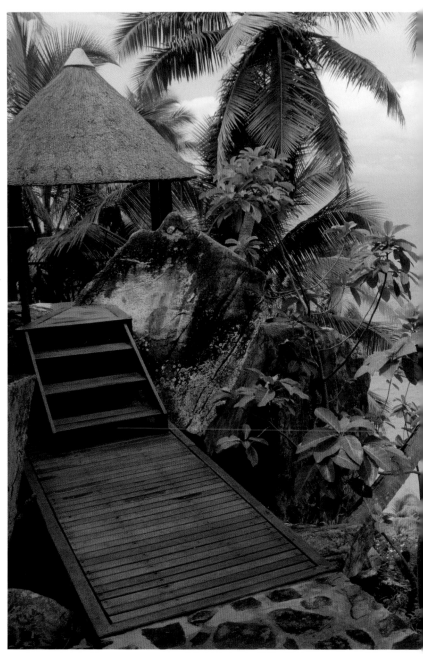

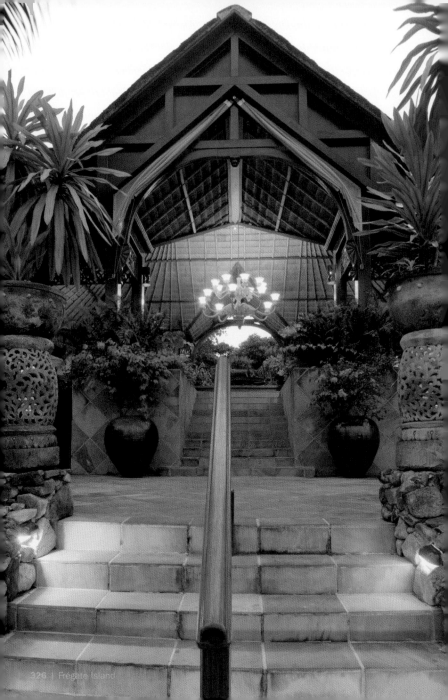

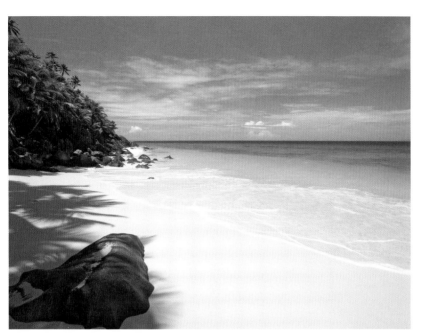

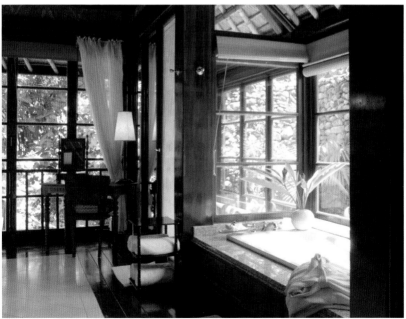

Asia & Pacific

Sri Lanka
India
China
Thailand
Malaysia
Australia
New Zealand

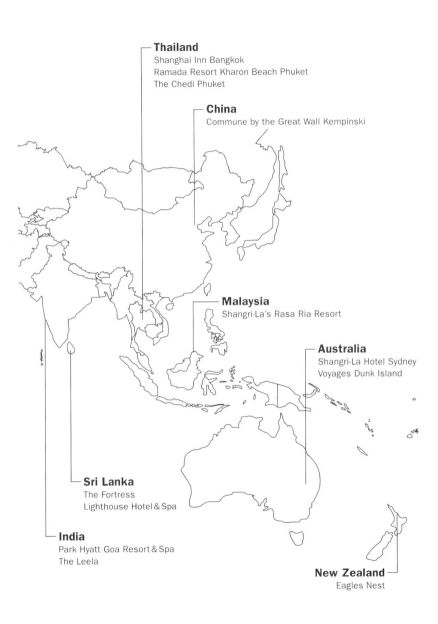

Thailand
Shanghai Inn Bangkok
Ramada Resort Kharon Beach Phuket
The Chedi Phuket

China
Commune by the Great Wall Kempinski

Malaysia
Shangri-La's Rasa Ria Resort

Australia
Shangri-La Hotel Sydney
Voyages Dunk Island

Sri Lanka
The Fortress
Lighthouse Hotel & Spa

India
Park Hyatt Goa Resort & Spa
The Leela

New Zealand
Eagles Nest

The Fortress

Address:	P.O. Box 126
	Galle, Sri Lanka
Phone:	+94 91 438 0909
Fax:	+94 91 438 0338
Website:	www.thefortress.lk
Located:	On the golden southern coast of Sri Lanka, The Fortress is minutes away from Sri Lanka's most historically interesting living city, Galle
Style:	Fusion of contemporary chic and five-star luxury
Family & kids tips:	Little Adventurers Club, bicycles for hire, turtle hatchery, large pool with kid's bathing area
Special features:	Spa featuring Ayurvedic treatments, a freeflow swimming pool, wine cellar, restaurants, boutiques and exquisitely appointed rooms, lofts, residences, wedding pavilion, yoga
Rooms:	49 rooms
Opening date:	2006

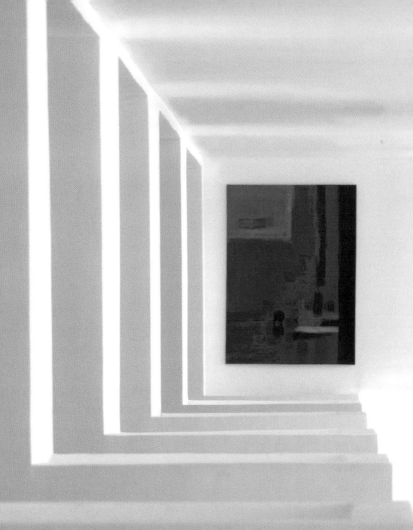

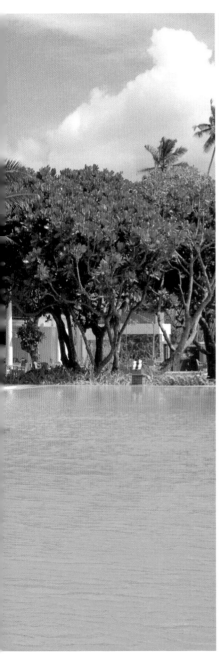

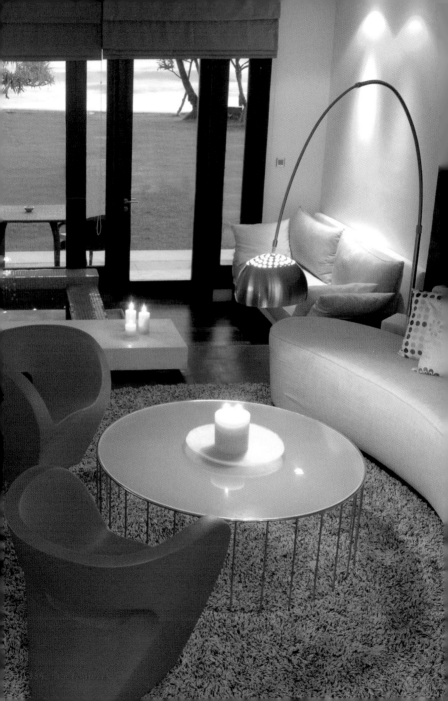

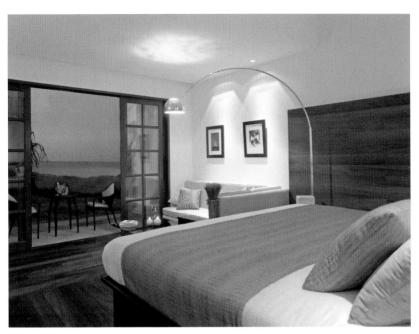

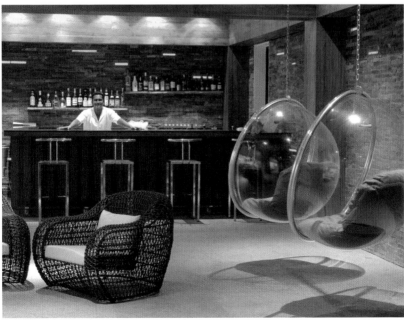

Lighthouse Hotel & Spa

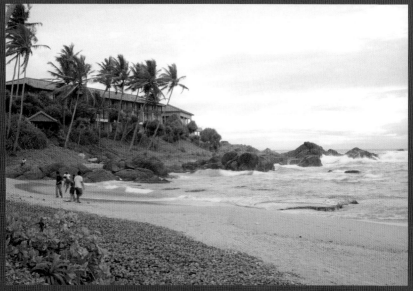

Address:	Dadella
	Galle, Sri Lanka
Phone:	+94 91 22 240 17, +94 91 22 237 44
Fax:	+94 91 22 240 21
Website:	www.slh.com
Located:	Atop a hillock overlooking the blue waters of the Indian Ocean. It is situated within 2 km of the Living World Heritage City of Galle
Style:	Contemporary, colonial
Family & kids tips:	Kids menu, kids pool
Special features:	Cardamon Café open 24 hours, indoor and outdoor dining, 2 swimming pools, tennis, squash, spa
Rooms:	63 rooms
Opening date:	1997

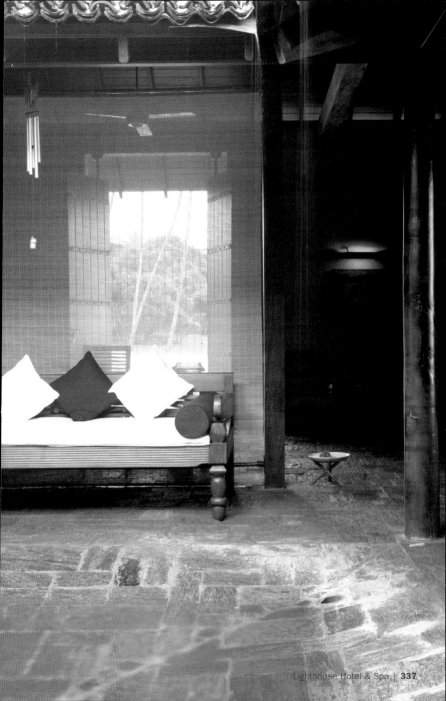

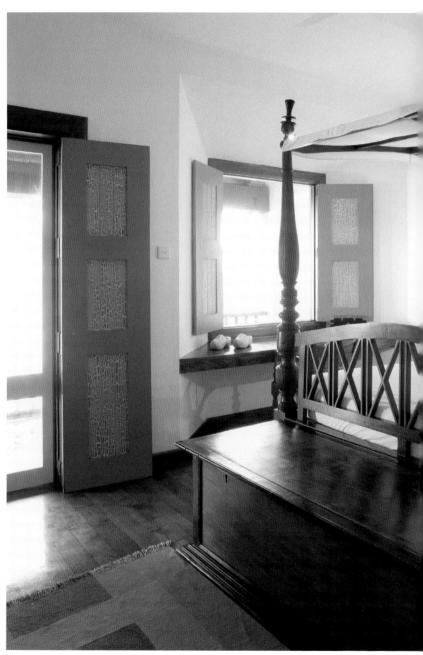

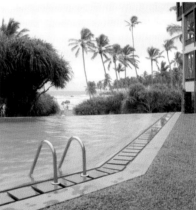

Park Hyatt Goa Resort & Spa

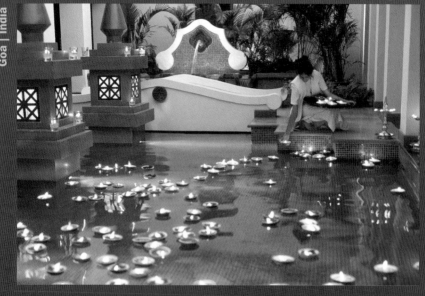

Address: Arossim Beach, Cansaulim
Goa 403712, India
Phone: +91 832 272 1234
Fax: +91 832 272 1235
Website: goa.park.hyatt.com

Located: In South Goa, a 15-minute drive from Goa's Dabolim airport
Style: Indo-Portuguese village
Family & kids tips: Babysitting services, bicycles available for hire, Camp Hyatt programs for children aged between 3 to 12 offering fun and educational activities
Special features: Lounge bar, North and South Indian restaurant, Goan restaurant, Italian restaurant, beach side sea food restaurant and pool side bar, 36000 square feet sereno spa, India's largest outdoor swimming pool and meeting facilities
Rooms: 249

Opening date: 2003

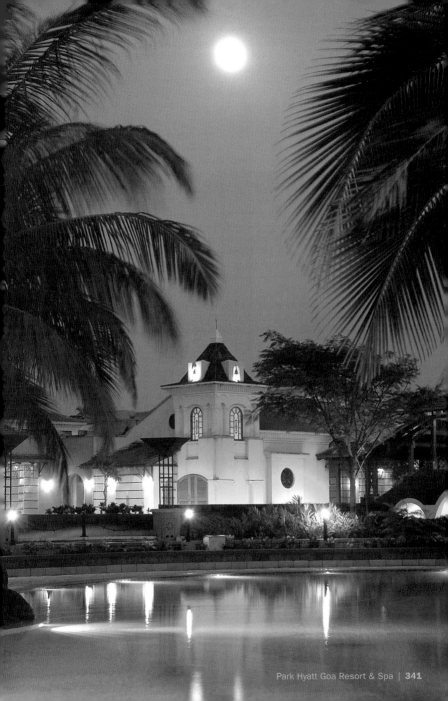

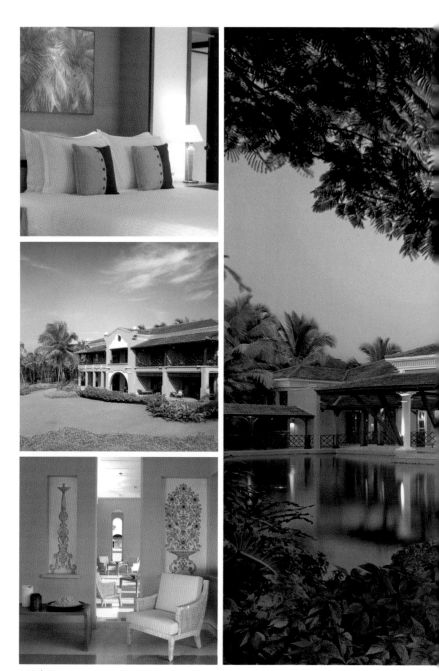

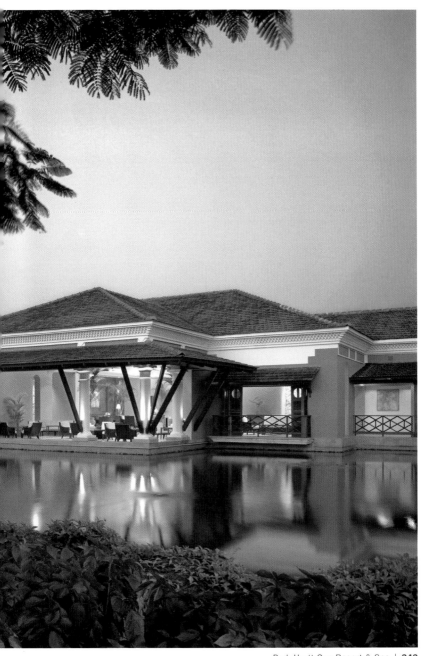

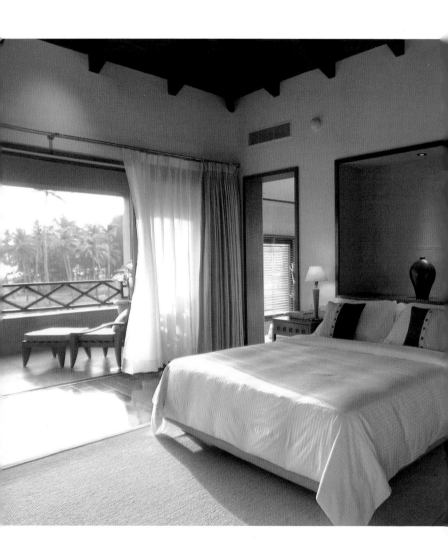

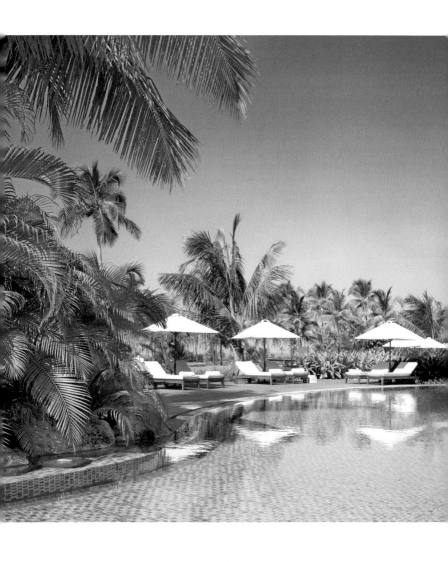

The Leela

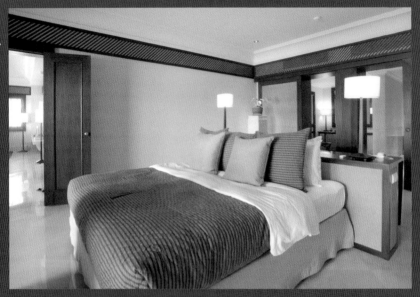

Address: Mobor, Cavelossim
Goa 403731, India
Phone: +91 832 287 1234
Fax: +91 832 287 1352
Website: www.ghmhotels.com, www.theleela.com

Located: Mobor Beach, 43 km from the airport and 17 km of the city center of Goa
Style: Hotel: combination of an ancient Indian summer palace residence with superior Portuguese-style villa accommodation, The Club: contemporary design
Family & kids tips: Babysitting, baby cots, badminton, children's activity center, kids swimming pool, yoga and meditation, cycling, orchid nursery, spice trail
Special features: Restaurant, café, lounge, pool bar, spa, golf, tennis, watersports
Rooms: 152 rooms and suites and villas

Opening date: 1991

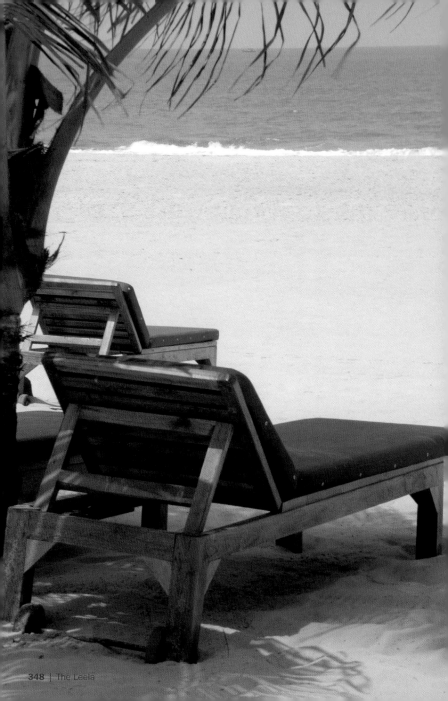

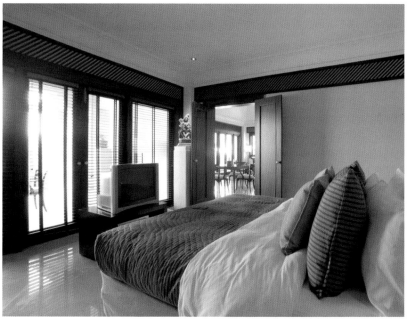

Commune by the Great Wall **Kempinski**

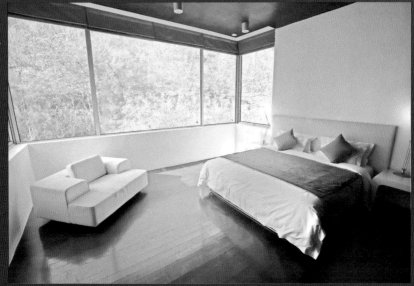

Address: The Great Wall Exit No 16 at Shuiguan
Badaling Highway
102102 Beijing, China
Phone: +86 10 8118 1888
Fax: +86 10 8118 1866
Website: www.kempinski-thegreatwall.com

Located: In the Shuiguan Mountains amidst 8 square kilometers of private land
Style: Contemporary design
Family & kids tips: Kids club features a kitchen, a garden with tent, a library and an outdoor pool. Furniture and facilities are designed according to children's heights. Activities including natural trail hiking, gardening, cooking, arts & crafts, star gazing, swimming and camping
Special features: Courtyard restaurant, a terrace lounge, a ball room, a gallery and a private cinema, 1000 square meters Anantara Spa
Rooms: 42 villas from 4 to 6 rooms, 10 chalets

Opening date: 2002, the kids club 2006

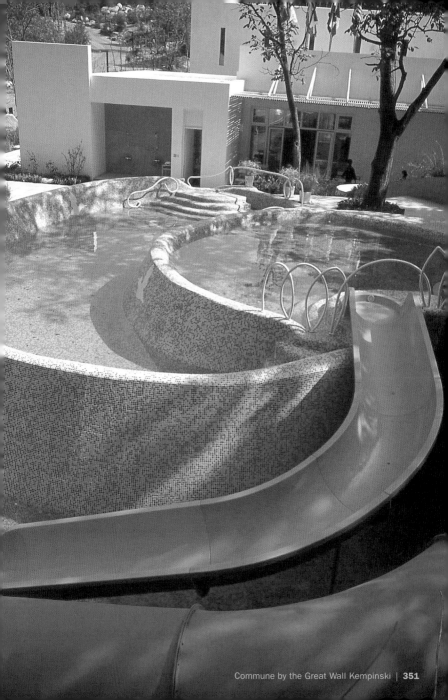

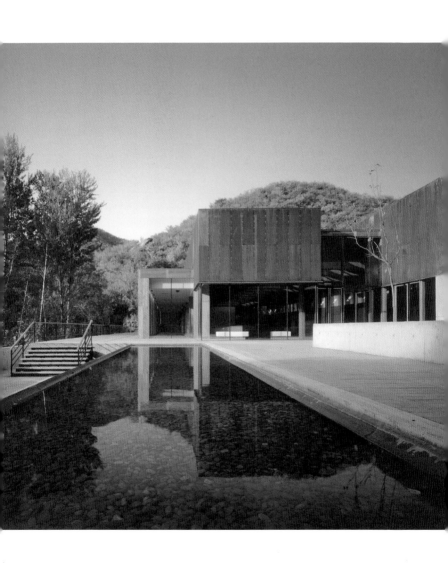

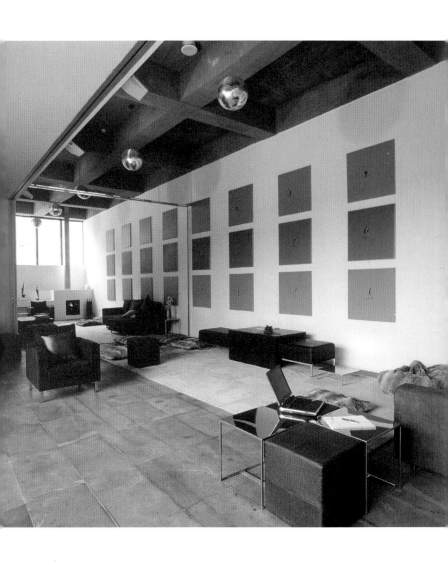

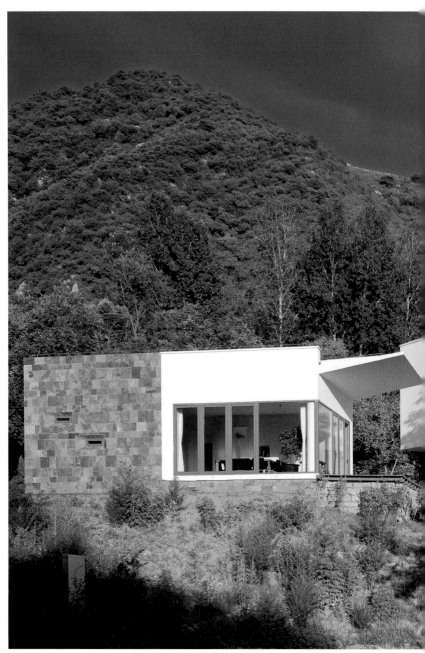

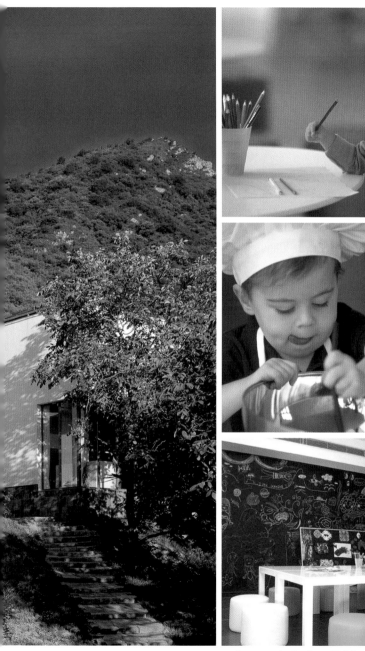

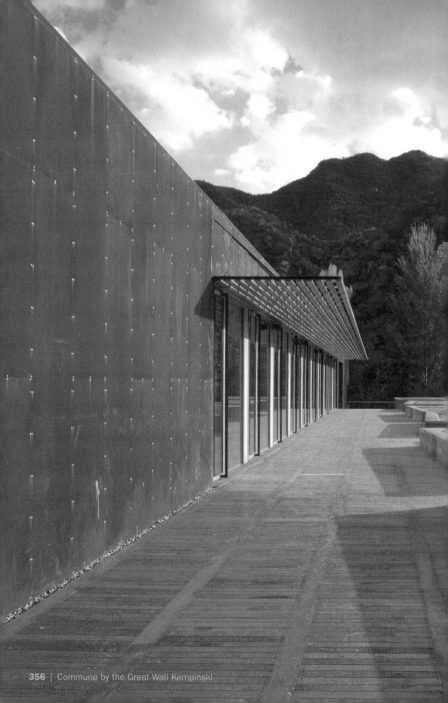

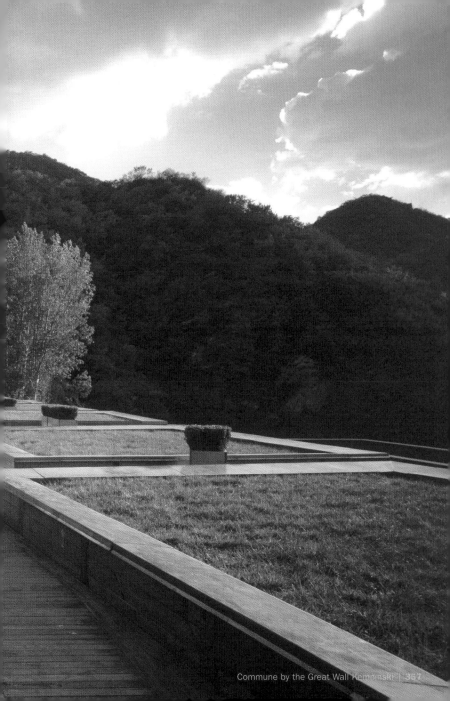

"these children are
the plants of the orchard,
the flowers of the meadow,
the roses of the garden..."

"这里的孩子们都是果园中的幼苗，
草原上的花朵，园中的玫瑰…"

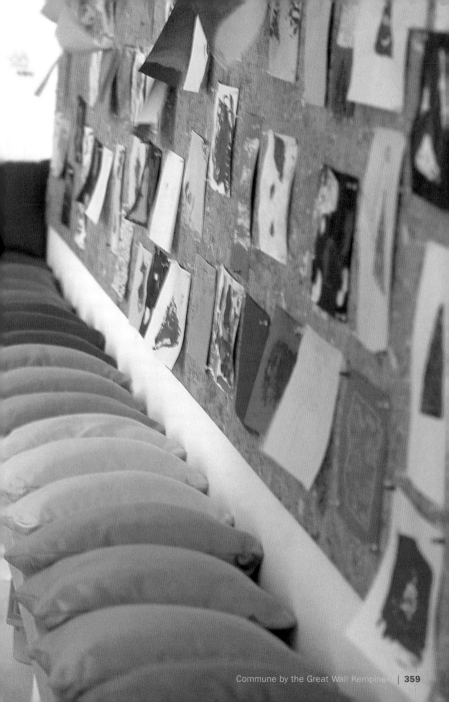

Shanghai Inn Bangkok

Address: 479–481 Yaowaraj Rd.
Bangkok 10100, Thailand
Phone: +66 2221 21 21
Fax: +66 2221 21 24
Website: www.shanghai-inn.com

Located: On the main road of the historic Bangkok Chinatown close to the Chao Phraya River
Style: Chinese
Family & kids tips: No charge for children under 12 sharing room with parents without an extra bed, individual service
Special features: Restaurant, massage and spa, airport transfer, library and Internet corner, complimentary TUK TUK shuttle service to different locations in town. All accommodations feature aircondition, satellite TV channels, complimentary wireless Internet access, a fridge and tea-making facilities
Rooms: 51 rooms, 4 junior suites

Opening date: 2006

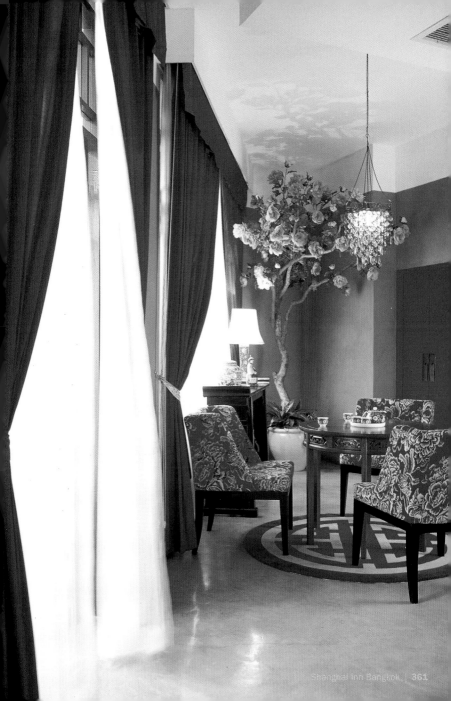

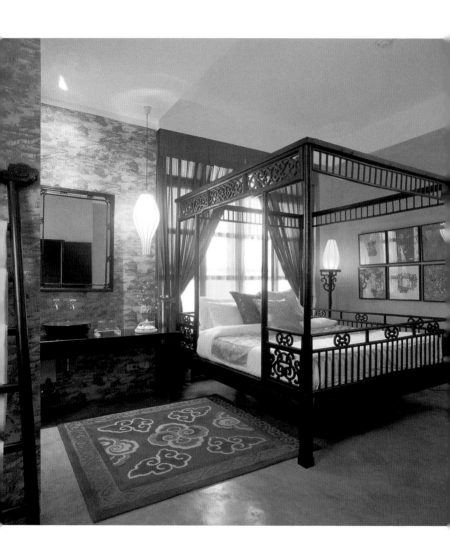

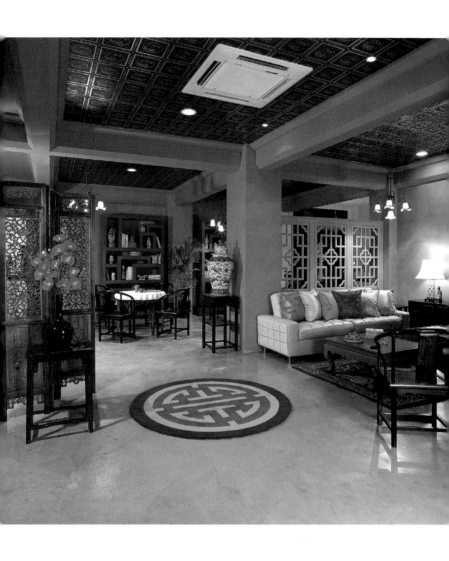

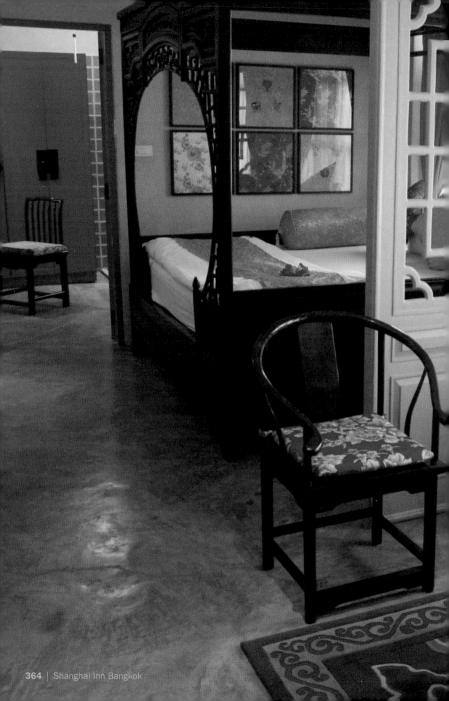

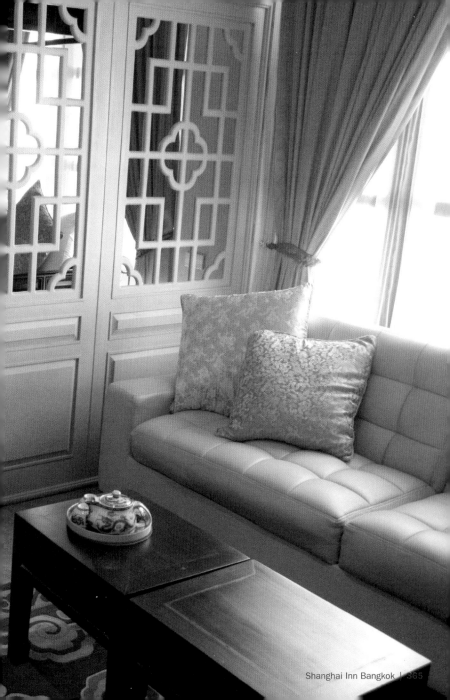

Ramada Resort Kharon Beach Phuket

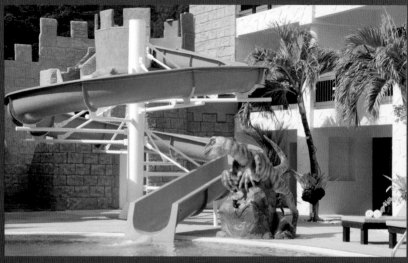

Address:	Karon Beach Phuket, 568 Patak Road Phuket 83100, Thailand
Phone:	+66 7639 66 66
Fax:	+66 7639 68 53
Website:	www.ramadaphuket.com
Located:	Situated on Karon Beach
Style:	Contemporary design
Family & kids tips:	Multi activity station KidzClub, 14 special kids rooms, Siam adventure club, dino pool, corner store
Special features:	2 restaurants, 2 bars, babysitting, gym/fitness center, handicap facilities
Rooms:	121 rooms and suites
Opening date:	2007

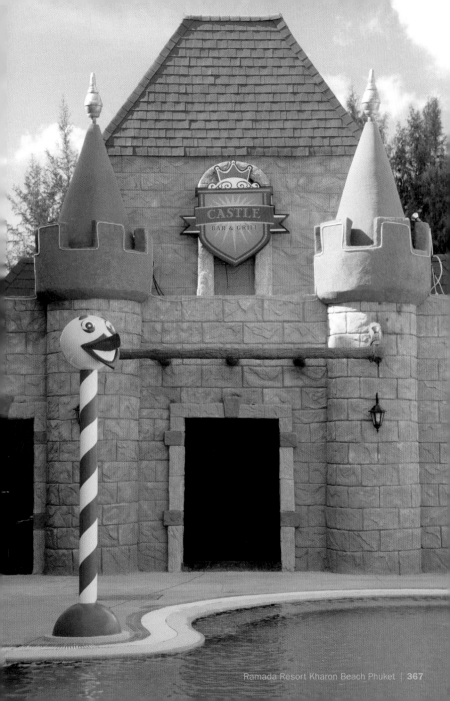

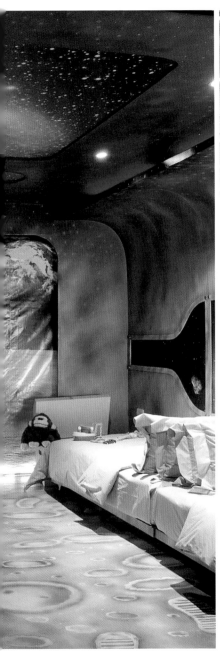

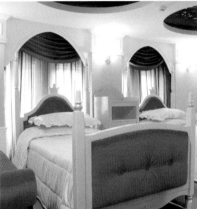

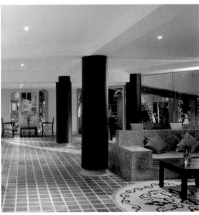

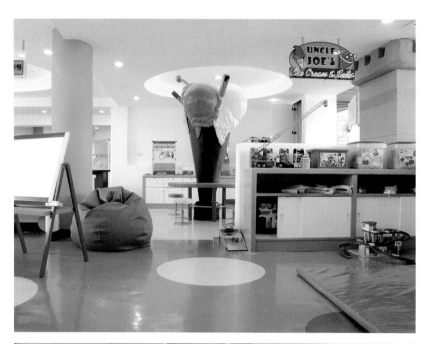

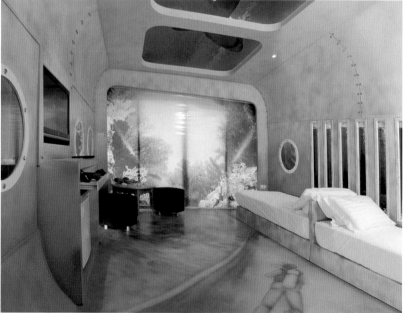

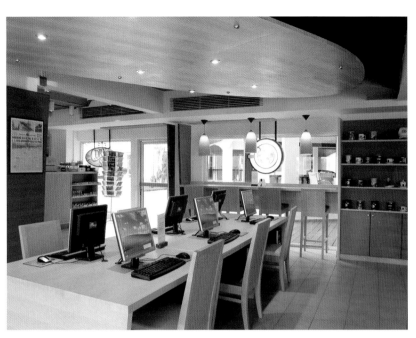

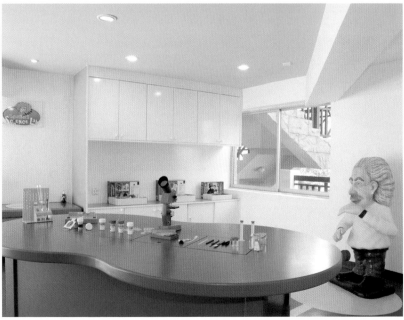

The Chedi Phuket

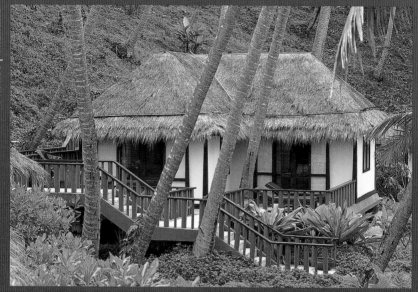

Address:	Pansea Beach, 118 Moo 3 Choeng Talay Phuket 83110, Thailand
Phone:	+6676 324 017 20
Fax:	+6676 324 252
Website:	www.ghmhotels.com
Located:	20 minutes from the nightlife of Patong, yet offers an utterly relaxing escape on a semi-private headland
Style:	Luxury Thai style
Family & kids tips:	Kid's corner, babysitting service
Special features:	Restaurant, café, bar, library, spa with in- and outdoor treatments and plunge pool, swimming pool, poolside sun decks with sun-beds, 2 tennis courts, water sports, 5 golf courses within a 30-minute drive, wireless Internet available at the lobby, Lomtalay Thai Restaurant and in all suite rooms free of charge
Rooms:	108 thatched cottages with private verandas, sun decks and teak floors linked by walkways
Opening date:	1987 first opening, 2006 reopened after renovation

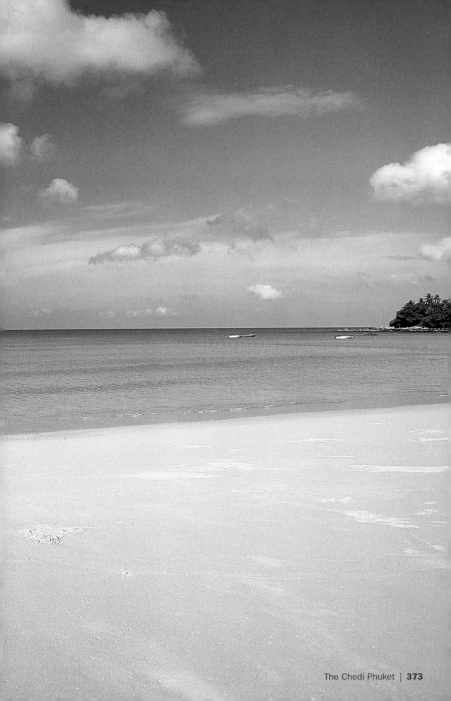

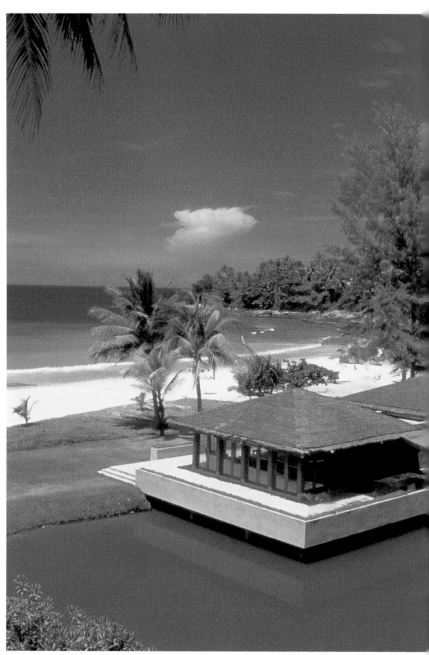

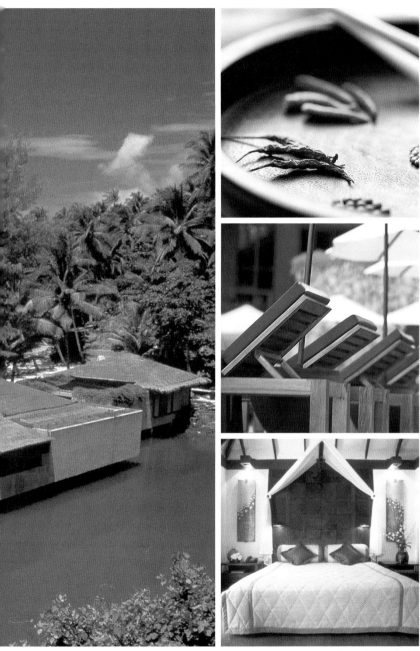

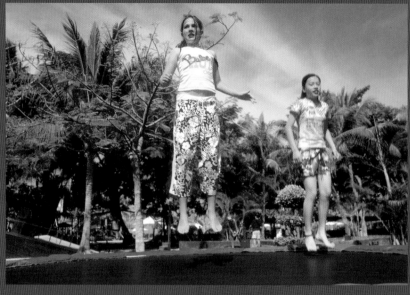

Address: Pantai Dalit Beach
89208 Tuaran, Sabah, Borneo, Malaysia
Phone: +6088 792 8 88
Fax: +6088 792 7 77
Website: www.shangri-la.com

Located: On the unspoilt Pantai Dalit beach whithin 400 acres of tropical vegetation
Style: Contemporary design
Family & kids tips: Children's Club, babysitting, children's pool, affiliated own nature reserve for baby orang-utans
Special features: 4 restaurants, 2 bars including pool bar, lounge, in-room dining, spa, business center, sailing, windsurfing, cat boat tours, waterskiing, fishing, diving, horse riding, cycling and nature walks, orang-utan sanctuary, access to Dalit Bay Golf Club for hotel guests, 400-acre tropical setting, pristine beach
Rooms: 330 rooms including 10 suites

Opening date: 2005

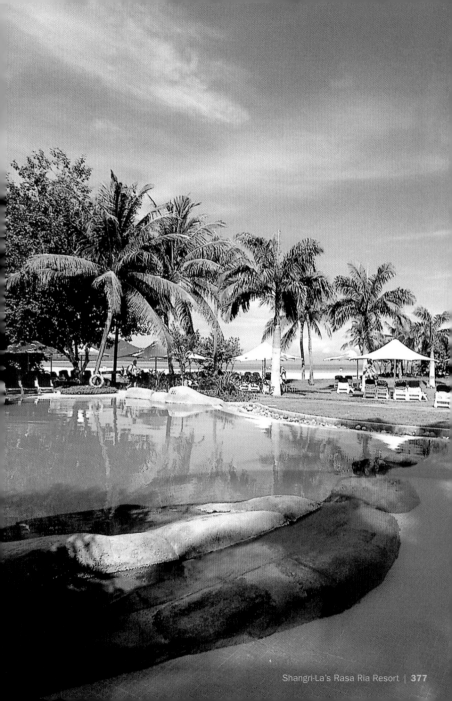

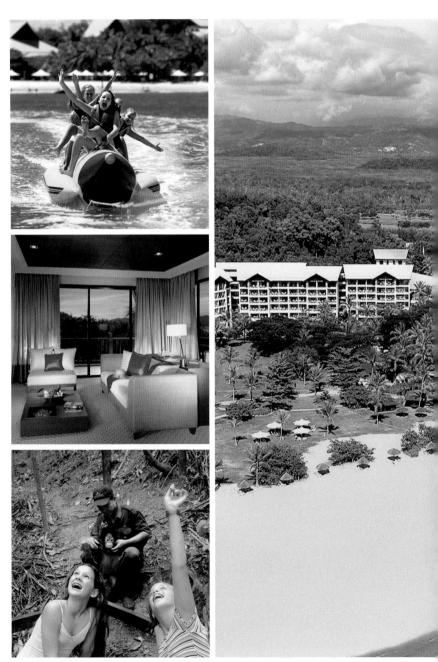

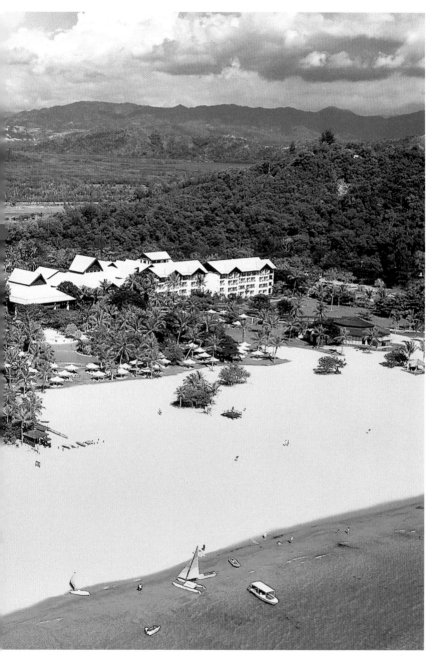

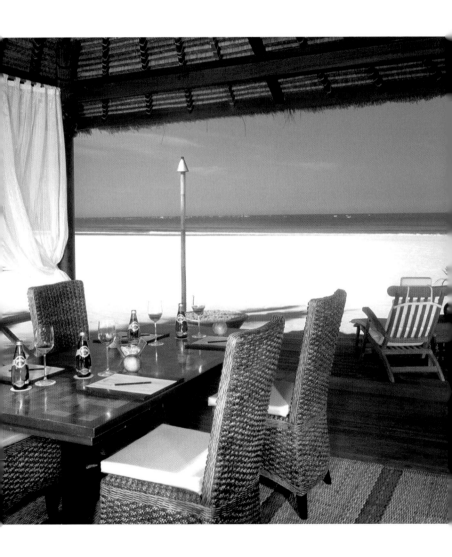

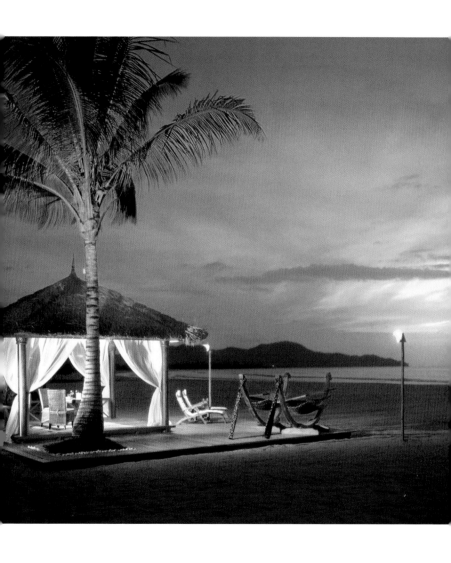

Shangri-La Hotel Sydney

Address:	176 Cumberland Street Sydney, NSW 2000, Australia
Phone:	+61 2 9250 6000
Fax:	+61 2 9250 6250
Website:	www.shangri-la.com
Located:	In the historic Rocks district between the Sydney Opera House and Harbour Bridge
Style:	Contemporary design
Family & kids tips:	Nanny Service, special packages
Special features:	Restaurants, bars, indoor heated swimming pool, sun deck, spa, doctor on call 24-hours a day, harbor view from 95% of all guest rooms
Rooms:	563 rooms and suites
Opening date:	2005

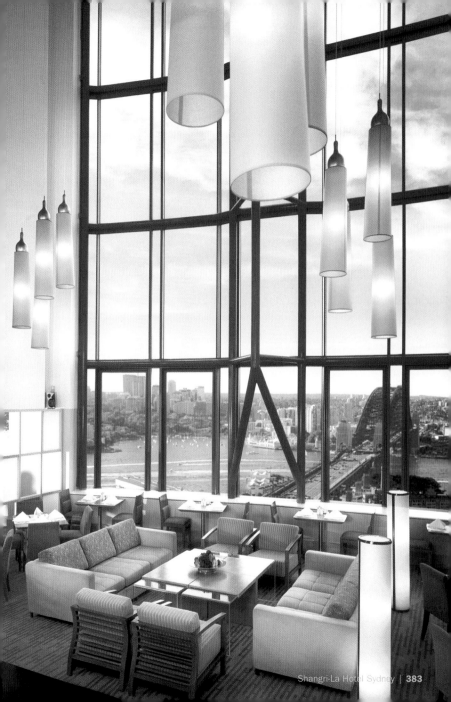

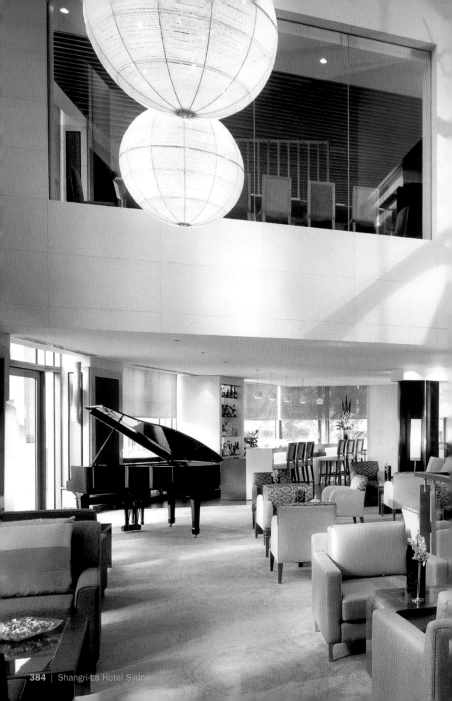

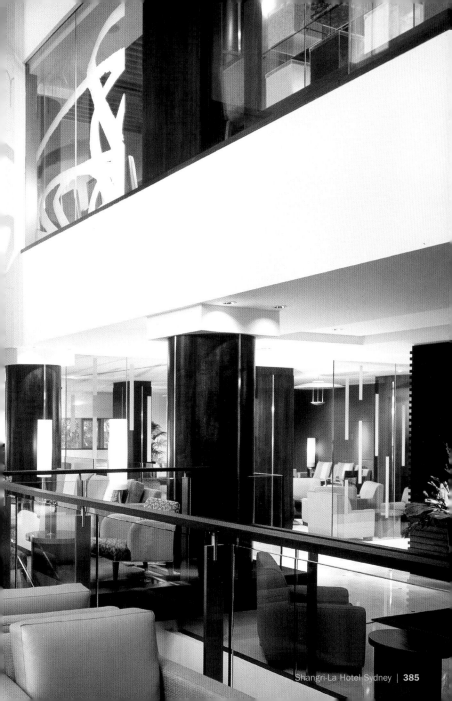

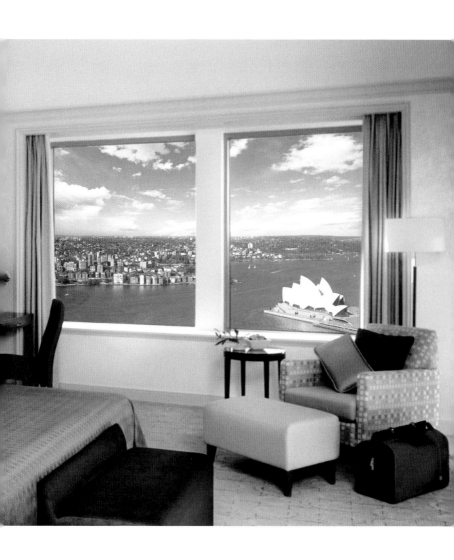

Voyages Dunk Island

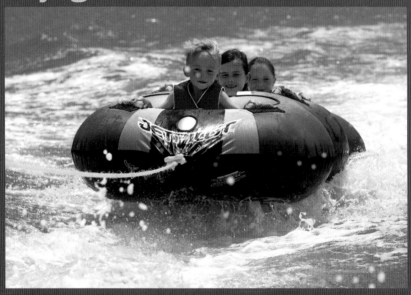

Address: Great Barrier Reef, Australia
Phone: +61 2 8296 8010
Fax: +61 2 9299 2103
Website: www.dunk-island.com

Located: 5 km off Mission Beach in Far North Queensland, Australia
Style: Mix of contemporary and tropical design
Family & kids tips: Kids Ranger Programs (Kids Club) with fun and educational activities for kids from 3 to 14, kids under 12 stay and eat for free with a full paying adult, family horse ride along the beach at sunset
Special features: 4 restaurants, 2 bars, barbecue dining, spa, gymnasium, 2 swimming pools, 3 floodlight tennis courts, squash courts, 6-hole golf course, snorkelling, many other water sports
Rooms: 160 rooms

Opening date: Opened 1934

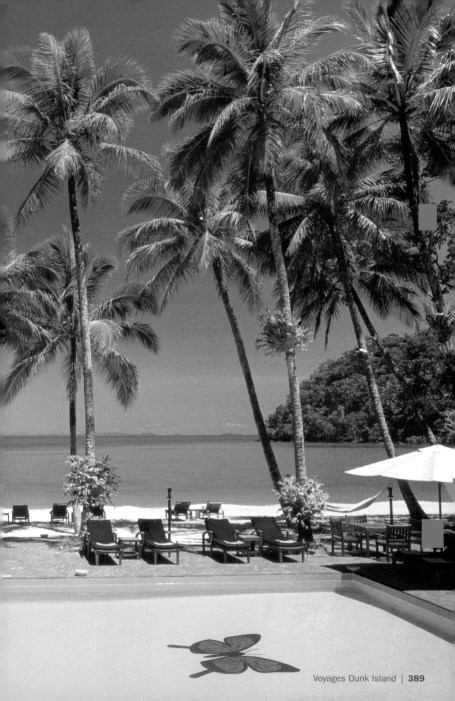

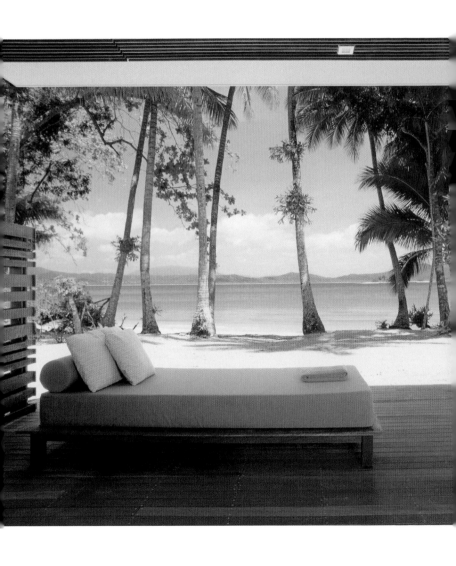

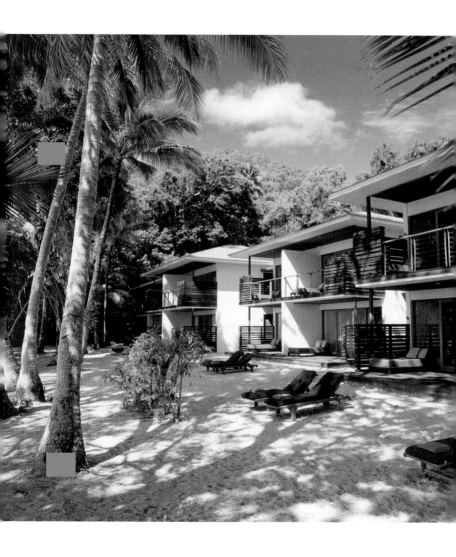

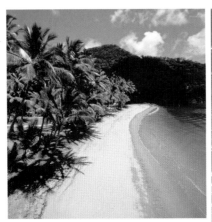

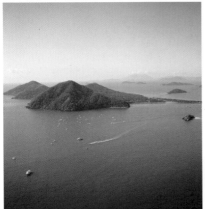

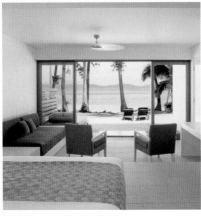

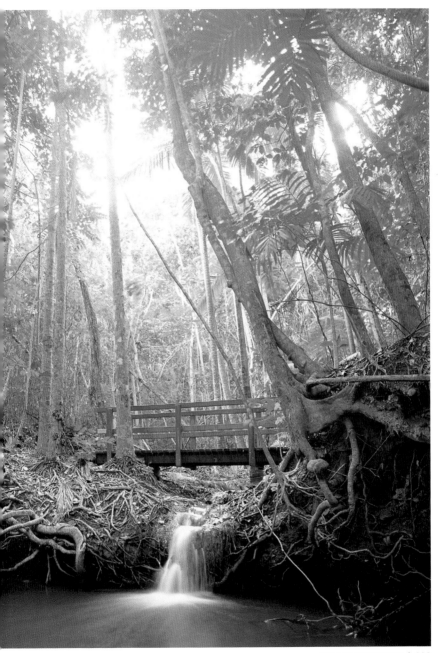

Eagles Nest

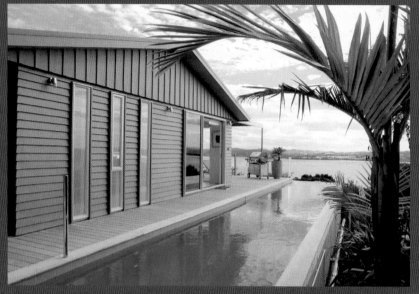

Address:	60 Tapeka Road, Russell
	Bay of Islands, New Zealand
Phone:	+64 9 403 8333
Fax:	+64 9 403 8880
Website:	www.eaglesnest.co.nz
Located:	Seaside, North Island, New Zealand
Style:	Contemporary design
Family & kids tips:	Parent and child friendly, each villa features its own heated horizon edged lap pool and jacuzzi with spectacular views over the Bay of Islands
Special features:	Each villa features plasma televisions, home cinemas, gourmet kitchens and wireless Internet access
Rooms:	5 luxury villas
Opening date:	2000

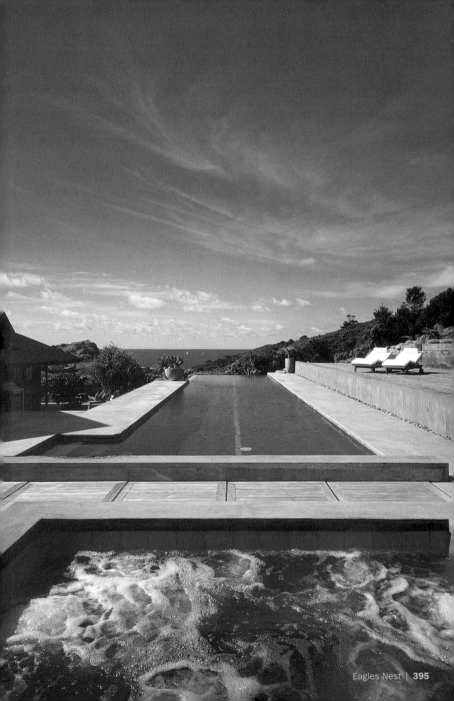

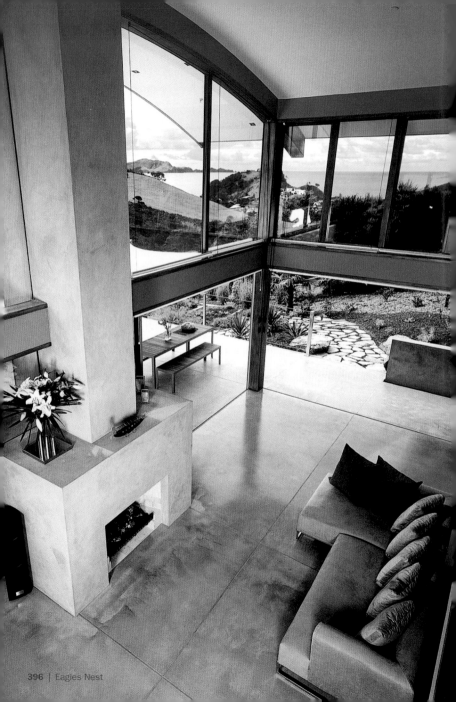

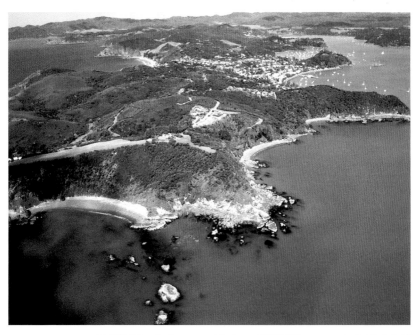

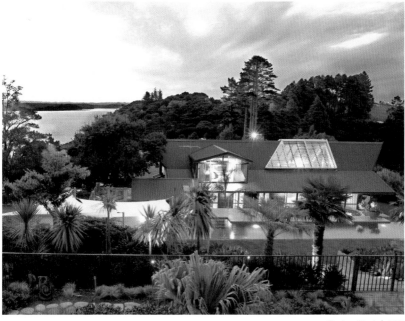

Photo Credits

COOL HOTELS CITY

Cool Hotels London
ISBN 978-3-8327-9206-0

Cool Hotels New York
ISBN 978-3-8327-9207-7

Cool Hotels Paris
ISBN 978-3-8327-9205-3

Size: **15 x 19 cm**, 6 x 7 ¹/₂ in., 160 pp., **Flexicover**, c. 200 color photographs,
Text: English / German / French / Spanish / Italian

Published in the COOL HOTELS Series

ISBN: 978-3-8327-9105-6

ISBN: 978-3-8327-9051-6

ISBN: 978-3-8238-4565-2

ISBN: 978-3-8238-4581-2

ISBN: 978-3-8327-9134-6

ISBN: 978-3-8327-9135-3

ISBN: 978-3-8238-4582-9

ISBN: 978-3-8327-9203-9

ISBN: 978-3-8327-9136-0

Size: **13.5 x 19 cm**, 5 $^1/_4$ x 7 $^1/_2$ in., 400 pp., **Flexicover**, c. 400 color photographs,
Text: English / German / French / Spanish / Italian

Cool Restaurants

ISBN 978-3-8238-4588-1

ISBN 978-3-8327-9103-2

ISBN 978-3-8327-9146-9

ISBN 978-3-8327-9019-6

ISBN 978-3-8327-9068-4

ISBN 978-3-8327-9102-5

Other titles from the
COOL SERIES

Cool Spots

ISBN 978-3-8327-9154-4

ISBN 978-3-8327-9123-0

ISBN 978-3-8327-9153-7

ISBN 978-3-8327-9177-3

Size: **14.6 x 22.5 cm**, 5 $^3/_4$ x 8 $^3/_2$ in., 136 pp., **Flexicover**, c. 130 color photographs,
Text: English / German / French / Spanish / Italian